THRILLS
AND SPILLS

CELEBRATING IRISH JUMP RACING

HEALY RACING
With words by Donn McClean

THE O'BRIEN PRESS
DUBLIN

First published in 2020 by The O'Brien Press Ltd,
12 Terenure Road East, Rathgar,
Dublin 6, D06 HD27, Ireland.
Tel: +353 1 4923333; Fax: +353 1 4922777
E-mail: books@obrien.ie
Website: www.obrien.ie
Reprinted 2021.
The O'Brien Press is a member of Publishing Ireland.

ISBN: 978-1-78849-135-8
Copyright for photographs © Healy Racing 2020
Copyright for text © Donn McClean 2020
Copyright for typesetting, layout, design © The O'Brien Press Ltd.

**Healy Racing would like it noted that all horses and riders shown falling
in the following photographs were fine after their spills.**

10 9 8 7 6 5 4 3 2
24 23 22 21

Cover and internal design by Emma Byrne.
Printed and bound in Poland by Białostockie Zakłady Graficzne S.A.
This book is produced using pulp from managed forests.

Cover photographs:
Front: Cooling down as steam rises ... returning to the parade ring at Leopardstown.
Back (from top left): A worm's eye view of *Stonemaster* and Ian McCarthy, Troytown Chase, Navan, County Meath, November 2011; *Shalamzar* and Davy Russell go their separate ways at Fairyhouse, April 2014; The big wheel and runners at Listowel for the 154th Harvest Festival, 2012; The Online Discounts@Fairyhouse.ie Mares' Maiden Hurdle, Fairyhouse, January 2016.

Title page: *Two Rockers* is washed down after his win in the Arctic Tack Stud Hunters' Chase, Thurles, January 2016.
Page 4: The Daily Mirror Hunters' Chase, Down Royal, March 2015.

Racing photographer supremo **Pat 'Cash' Healy** is known to many in the horse-racing world. His father Liam senior began the family horse-racing photography business in the 1970s, and today Pat Healy and the other members of the HEALY RACING team, including his brother Liam, his nephews, Kevin and Sean, and his son, Jack, are familiar figures at racetracks around the country and the big race meetings abroad. From following trainers, horses, owners and jockeys, HEALY RACING has captured thousands of precious moments in the great sport of horse racing, many of which can be viewed on their website healyracing.ie.

One of the go-to experts in the horse-racing world, **Donn McClean** is an award-winning journalist and author. A three-time nominee for the Horserace Writers' and Photographers' Association's (HWPA) Racing Writer of the Year Award in the UK, his expert reputation has led him to ghost-write four racing autobiographies, most recently that of twenty-time champion jockey Sir Anthony McCoy. He writes columns on racing for *The Sunday Times* and *The Irish Field*, is a regular guest on Racing TV and RTÉ, and shares his extensive knowledge on his website donnmcclean.com.

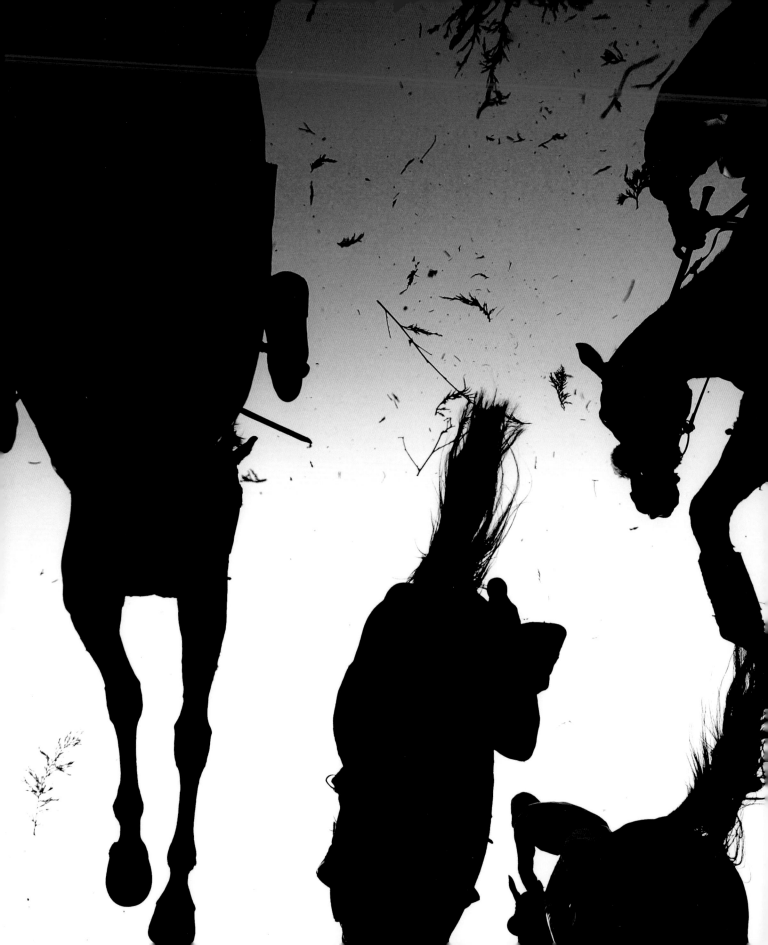

A THOUSAND WORDS ...

The majesty of the horse is unparalleled. The strength. The beauty. The poetry of the gallop.
The splendour of a horse over an obstacle. The unity of horse and rider. As one.
The intensity of the race. The flared nostril of competition.

The HEALY RACING team have been taking photographs of racehorses for decades. It was Liam Healy who established HEALY RACING in the 1970s, and it has grown into the position that it occupies today, as the pre-eminent provider of racing photographs to the media in Ireland and further afield.

It's a team thing, involving brothers Pat and Liam junior, along with sisters Cathy and Lisa, Pat's son Jack, Liam junior's son Sean and Lisa's son Kevin O'Carroll. And the HEALY RACING team extends beyond the family circle, with valuable contributions from Jane Hurley, Stephen O'Doherty, Paul Porter, Aidan Dullaghan, Dan Abraham and Noel Breen.

The HEALY RACING team have traversed Ireland, every corner, and have travelled to the major racing nations of the world in search of the best pictures.

They say that each one is worth a thousand words.

Some of the best National Hunt racing photographs that the HEALY RACING team have taken over the course of the last decade have been put together in these pages. It is not a comprehensive account; it is not a narrative of the racing decade. Instead, each picture captures a moment: an expression, a gesture, an athletic achievement. Euphoria in victory, despair in defeat. Pain and anguish, as well as joy and jubilation. Big races, well-known faces, famous moments, as well as horses and occasions and people that may not be so well known. Each instant captured on camera, and a story behind every single one.

Renowned horse-racing writer Donn McClean has provided the words to each picture, a description of the incident or a synopsis of the story that is behind it. The hope is that together, the pictures and the words will bring the reader on a unique and memorable journey through a decade of National Hunt racing.

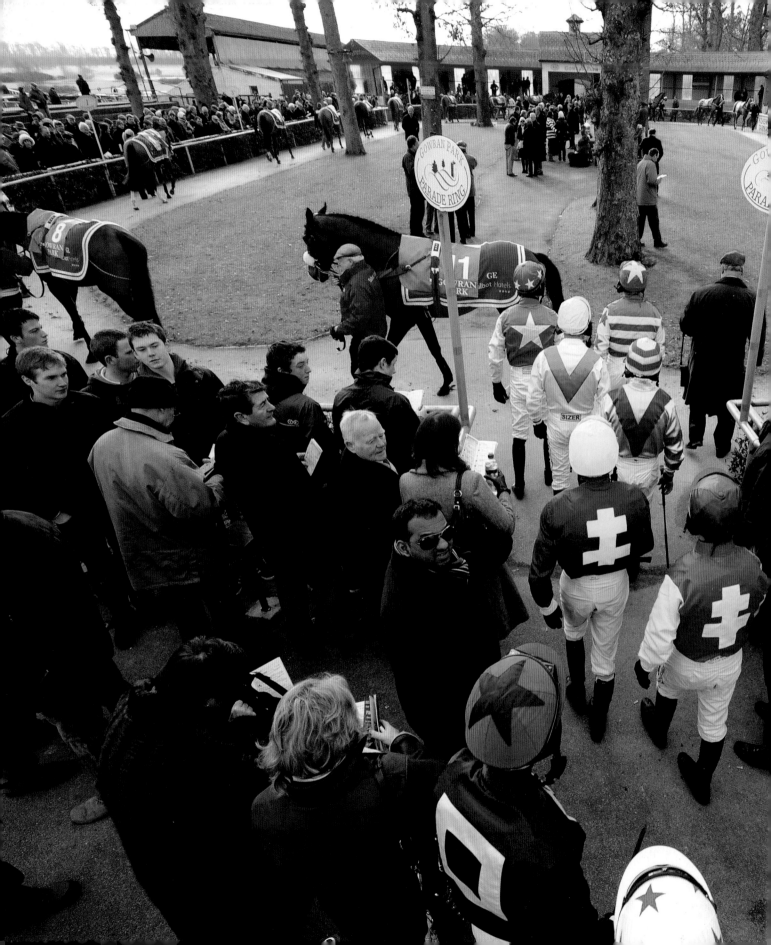

2011

Jockeys make their way into the parade ring at Gowran Park, County Kilkenny, before the opening maiden hurdle on Thyestes Chase day: Michael Darcy and Barry Cash, followed by Andrew Lynch, Robbie Colgan, David Evans and Paul Carberry (red silks with yellow sleeves and yellow Cross of Lorraine), who won the race on the Gordon Elliott-trained *Plan A* (on left, number 8).

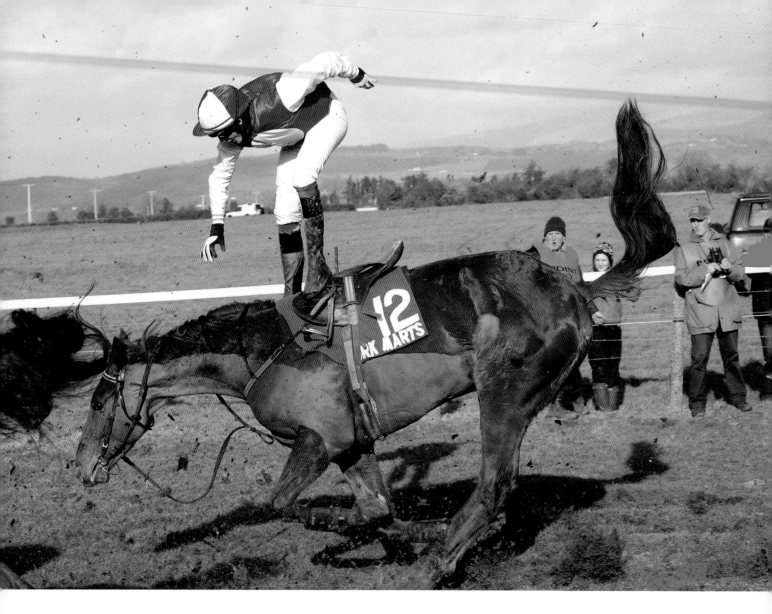

Coolykereen Castle, running in his first point-to-point, unseats Barry
John Foley at the first fence at Dungarvan, County Waterford.

Kempes and David Casey soar over the final fence on their way to victory in the Irish Gold Cup at Leopardstown.

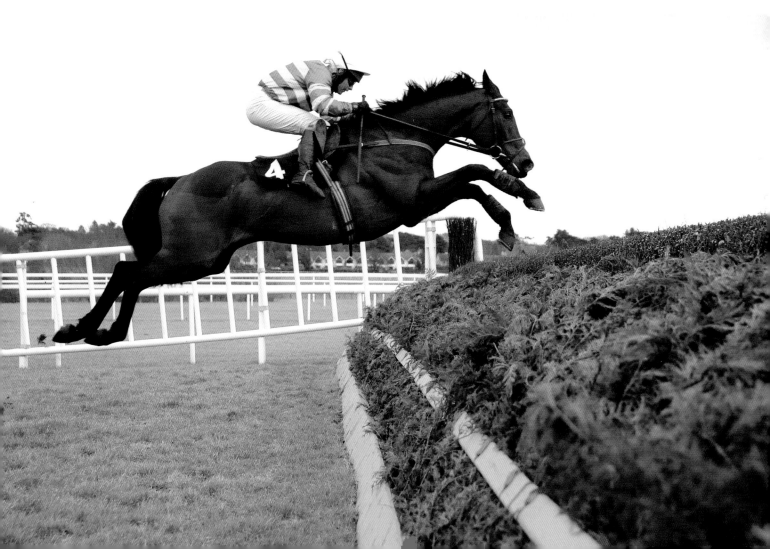

Mind the head! Johnny Barry takes cover as hooves fly, after his
fifth-fence fall from *Glensheisken* at Killeagh point-to-point in Cork.

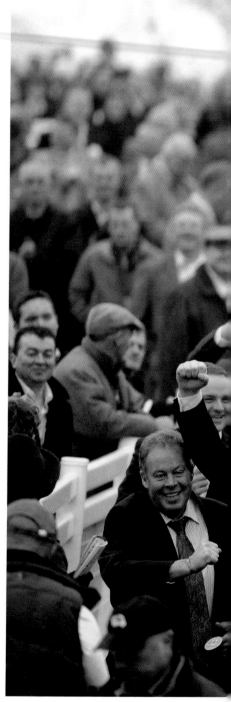

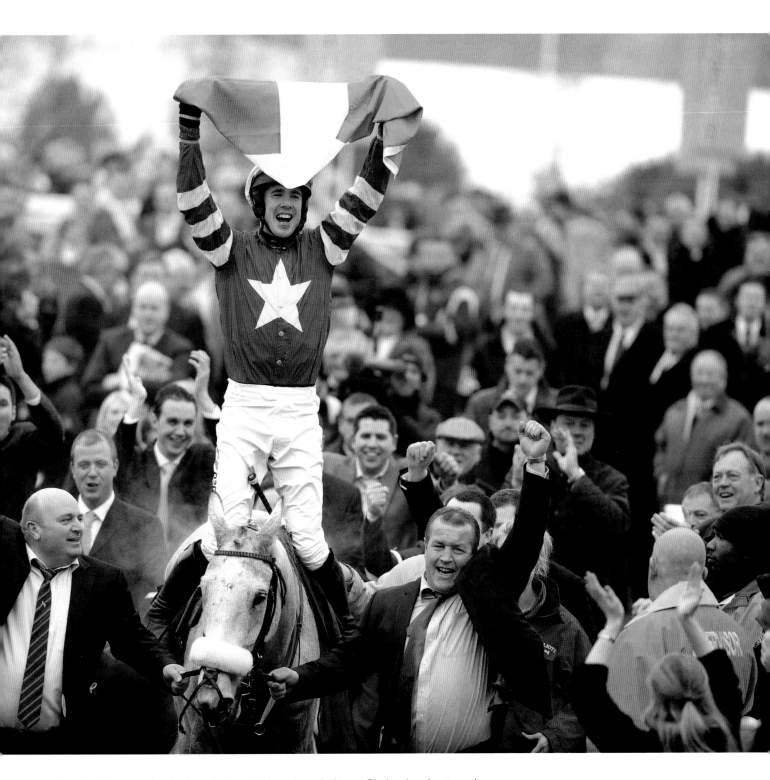

Derek O'Connor holds the tricolour high as he is led into Cheltenham's winner's enclosure by owner John Earls (on left) and Pádraig King (on right), after winning the National Hunt Chase on *Chicago Grey*, trainer Gordon Elliott's first-ever Cheltenham Festival winner.

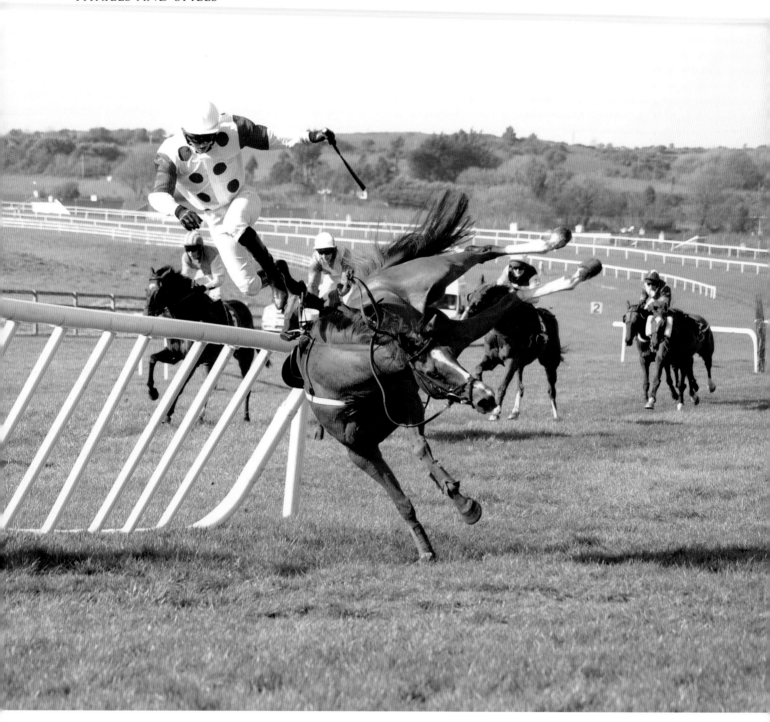

Tim Carroll's intention is to jump the fence at Tramore, but *Ballyvoile* has other ideas.

'I take my hat off to you.' Trainer Arthur Moore lends his hat to *Organisedconfusion* for the winner's enclosure photographs after Mrs Dunlop's horse and Nina Carberry, the trainer's niece, had powered to victory in the Irish Grand National.

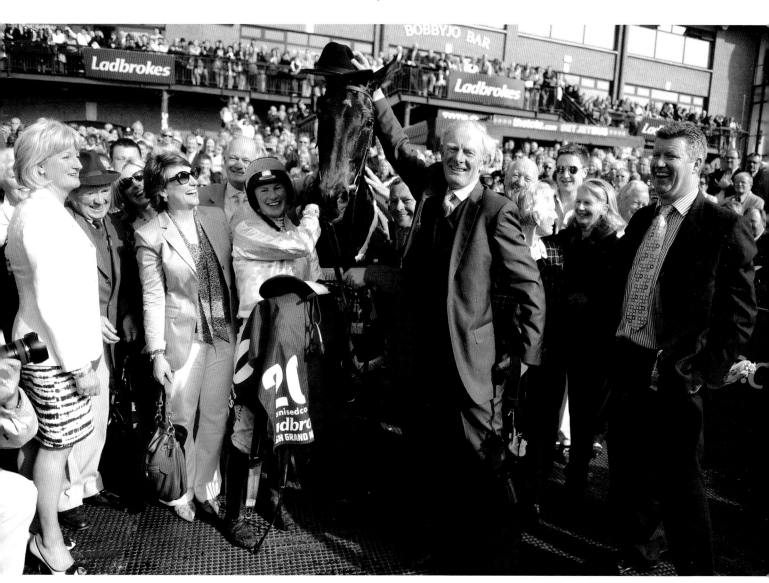

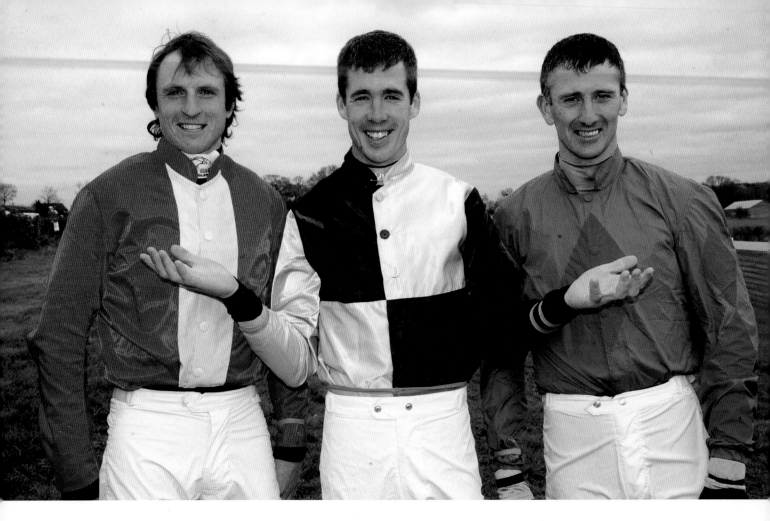

Above: Three of the best amateur riders ever: Derek O'Connor (centre) with Jamie Codd (left) and the late 'JT' McNamara (right) at Largy, County Antrim.

Right: *Quevega* and Ruby Walsh, both all smiles in the Punchestown winner's enclosure after the pair of them had battled to victory in the World Series Hurdle.

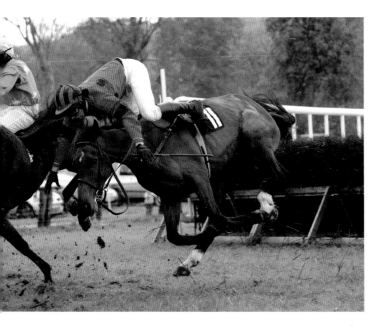

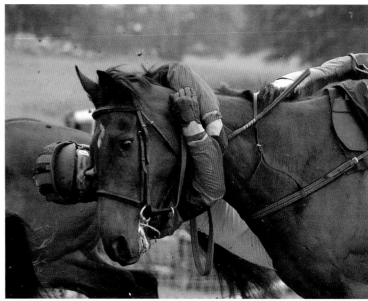

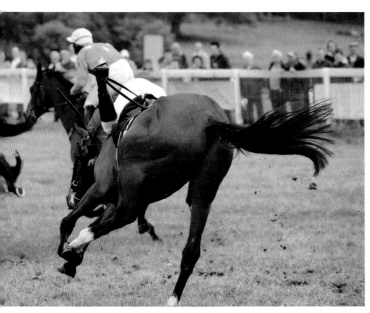

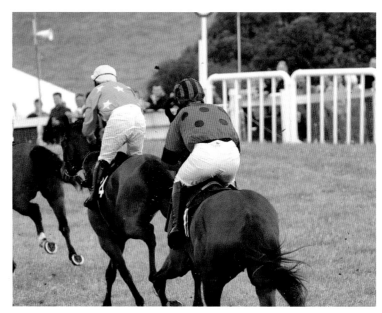

First fence error: JD Moore holds on tight before, remarkably, climbing back into the saddle on *Buster* after a bad mistake at the first fence at Toomebridge, County Antrim.

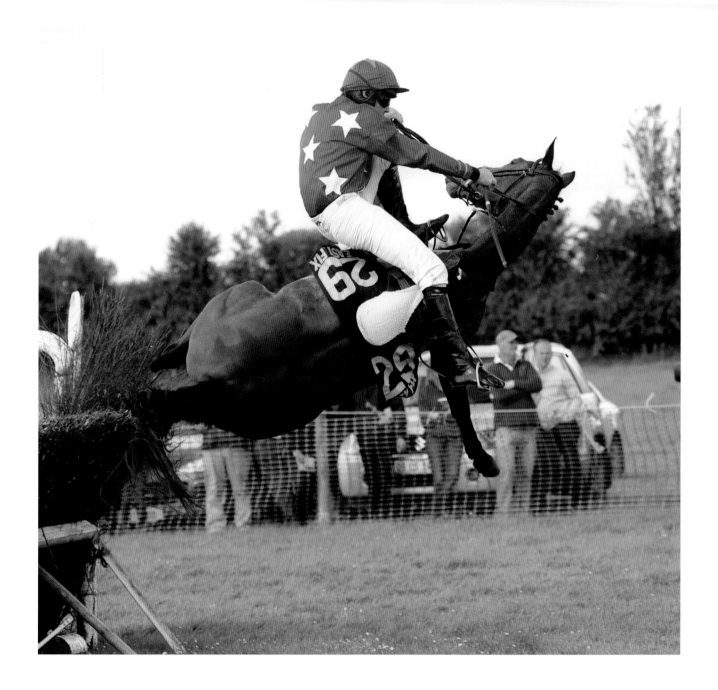

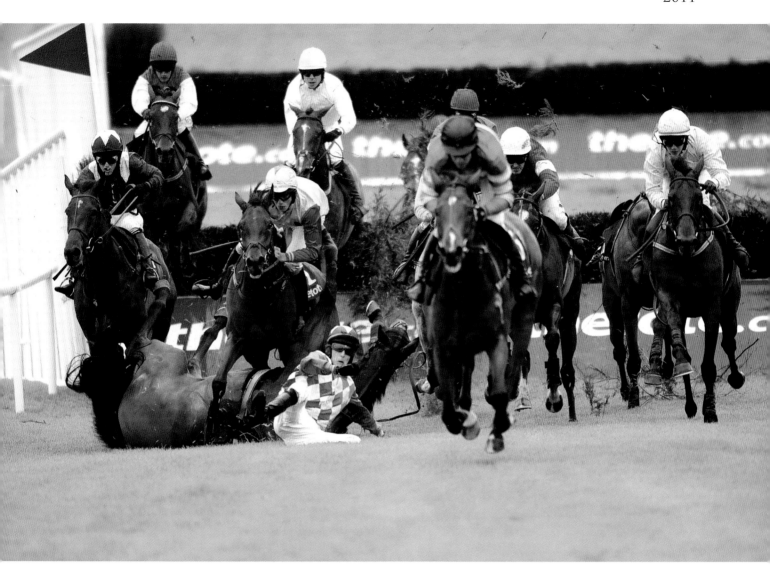

Lucky Wish and Eddie O'Connell come down at the final fence in the Galway Plate, bringing down *Matuhi* and *Hadden Frost* (blue sleeves). The race is won by *Blazing Tempo* and Paul Townend (on right in pink silks with green spots).

Opposite: *Littlehillofbrian* turns sideways as he and David Byrne part company at Ballingarry, County Tipperary.

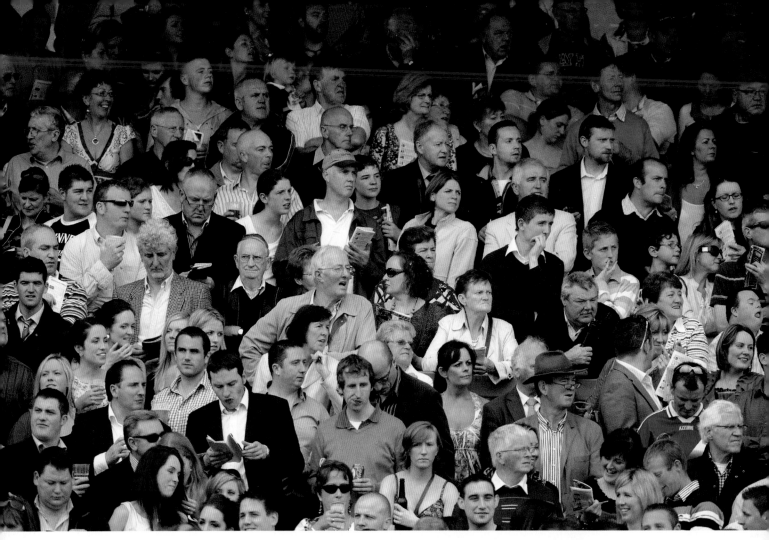
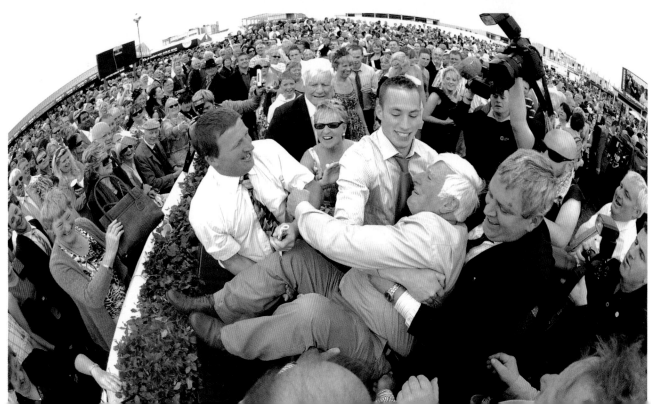

Opposite top: All eyes on the prize. A packed stand at the Galway Races.

Opposite bottom: Flying high. Seamus Freyne, a member of the Three Friers Cross Syndicate, is lifted across the rail and into the winner's enclosure after their horse, *Moon Dice*, had won the Galway Hurdle.

Below: *Alfa Beat* with groom Jackie Ring in the winner's enclosure after winning the Kerry National at Listowel.

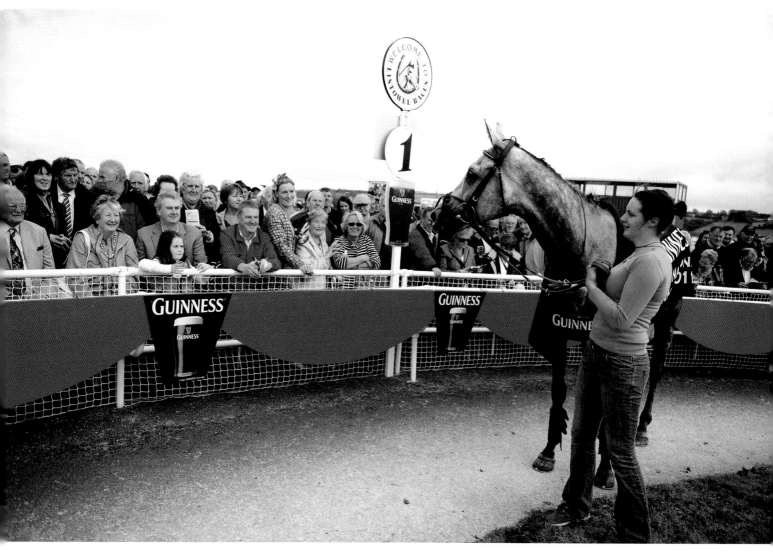

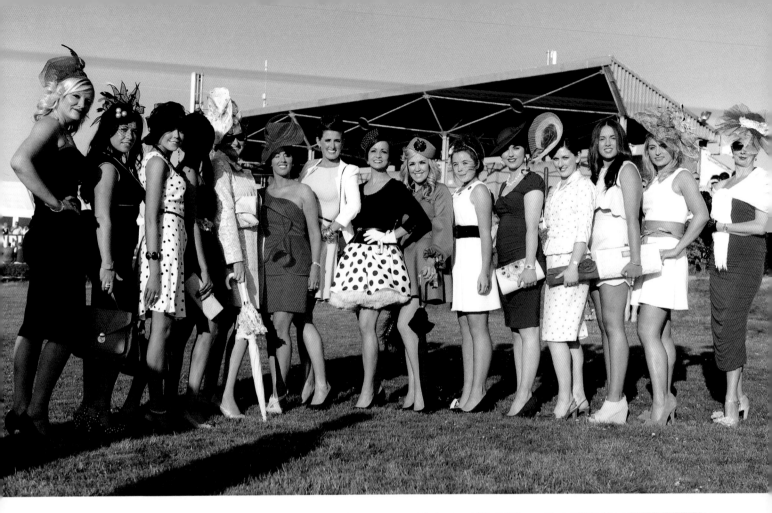

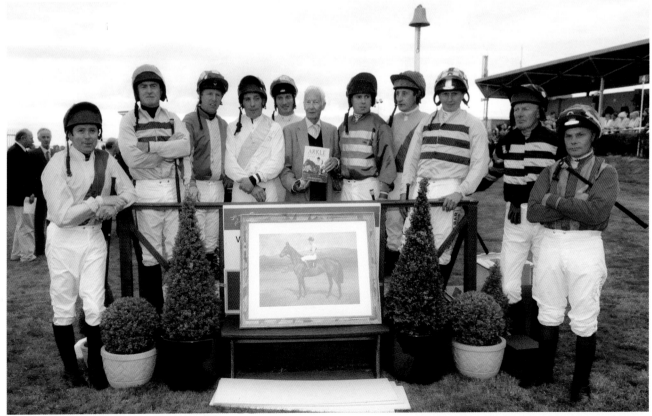

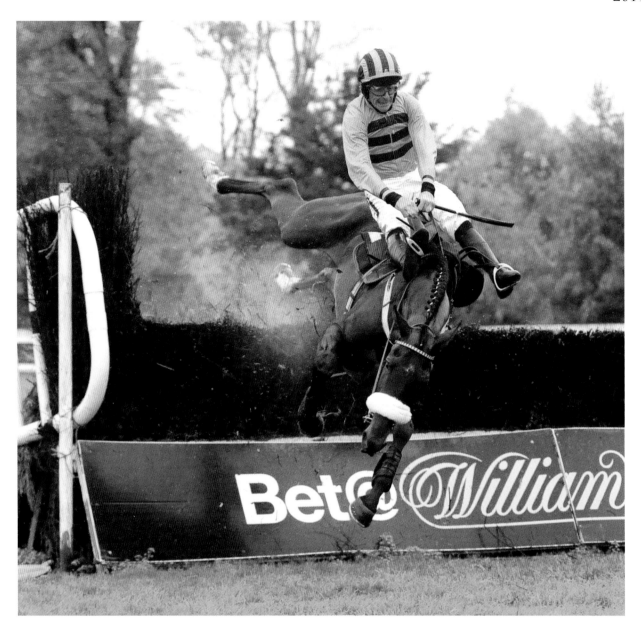

With the race in the bag, *Rubi Light* and Davy Russell come down at the final fence in the Champion Chase at Gowran Park. They subsequently remounted and completed to take third place behind *Sizing Europe* and *Coolcashin*.

Opposite top: The sun shines on the best-dressed ladies at Bellewstown in County Meath.

Opposite bottom: The Legends line up with Lester Piggott (centre) at Bellewstown: Conor O'Dwyer, Gerry Dowd, Charlie Swan, Jason Titley, Norman Williamson, Dermot McLoughlin, Joe Byrne, Robbie Hennessy, Arthur Moore, Adrian Maguire.

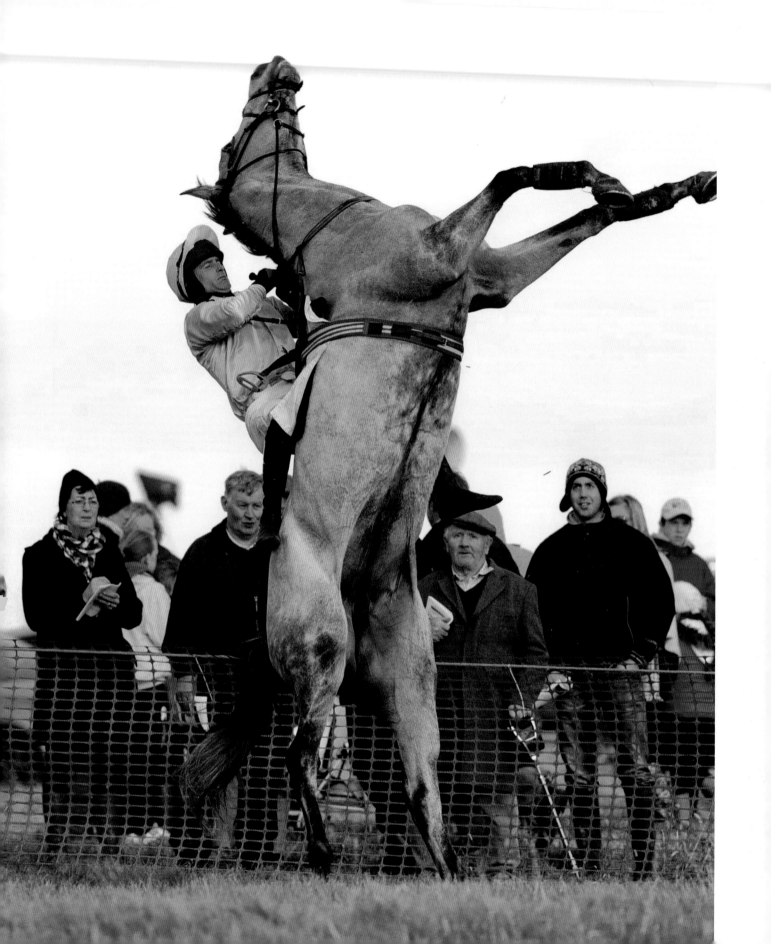

Opposite: *Artic Palm* stands tall at Loughrea as Lenny Flynn sits tight!

Below: Trainer Jonjo O'Neill's *Synchronised* and AP McCoy hit the front and fly the final fence on their way to victory in the Lexus Chase at Leopardstown, with *Rubi Light* and Andrew Lynch (light blue silks), *Quito De La Roque* and Davy Russell (maroon and white colours) and *Noland* and Ruby Walsh (yellow silks) in behind.

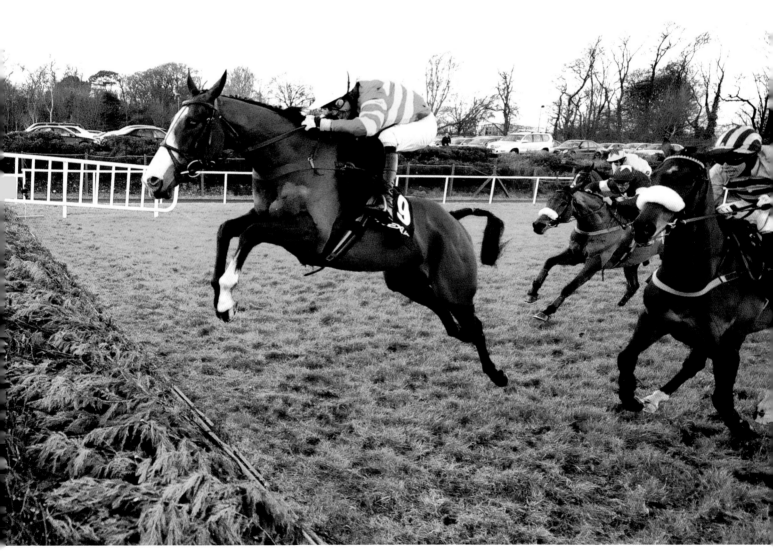

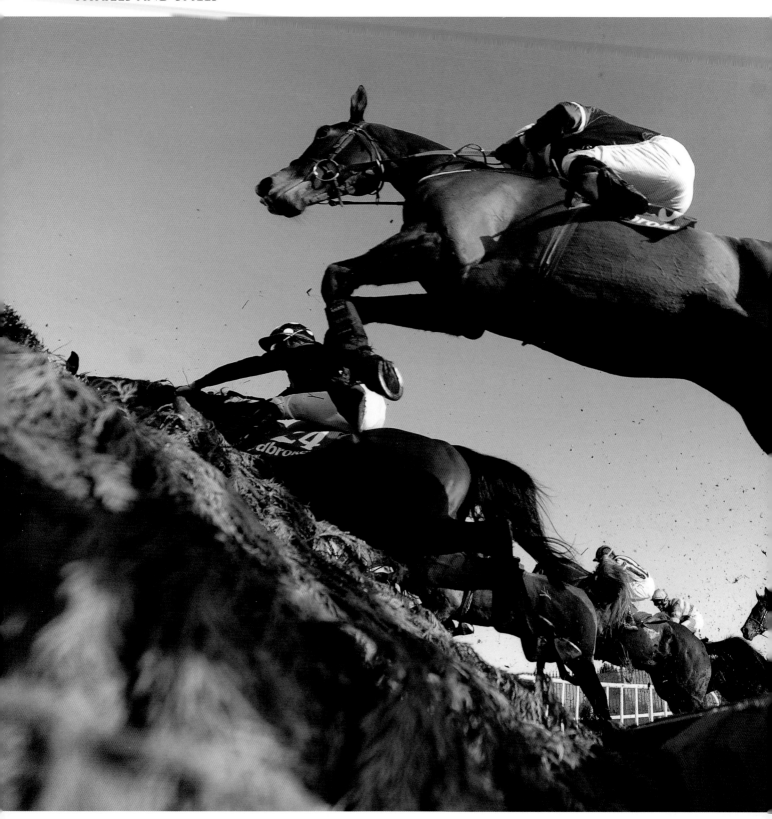

A worm's eye view of *Stonemaster* and Ian McCarthy as they clear the open ditch in the Troytown Chase at Navan, County Meath.

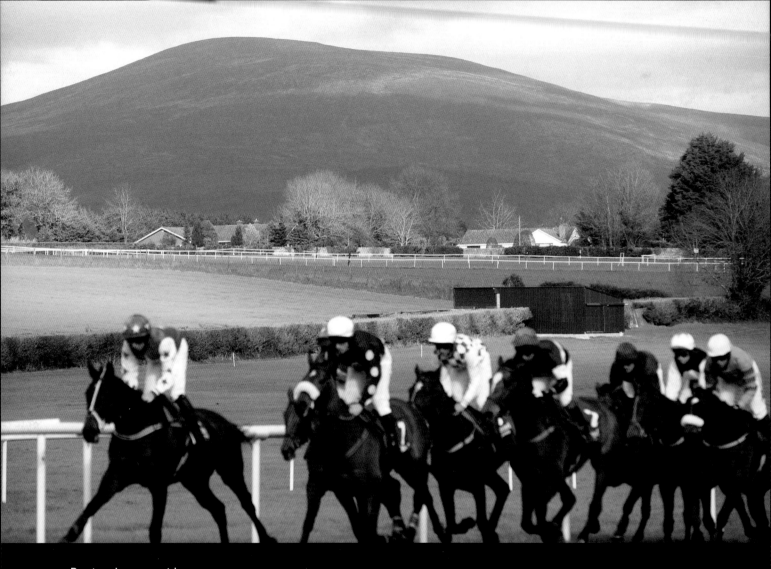

Passing the post with a
circuit to go at Clonmel,
County Tipperary.

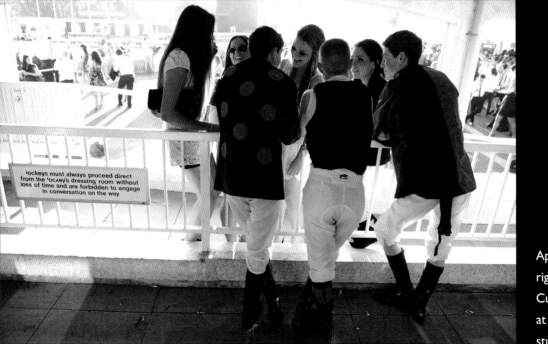

jockeys must always proceed direct
from the 'ockey's dressing room without
loss of time and are forbidden to engage
in conversation on the way

Apprentice jockeys (left to
right): Conor Hoban, Ben
Curtis and Ross Coakley
at Leopardstown, enjoying
student racenight

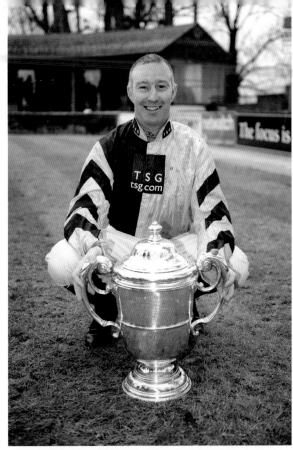

Left: David Casey with the Thyestes Chase trophy, after he had guided *On His Own* to an impressive victory in the Gowran Park feature.

Below: 'There's something in my eye.' Trainer Peter Casey is the focus of attention after *Flemenstar's* victory in the Powers Gold Cup at Fairyhouse.

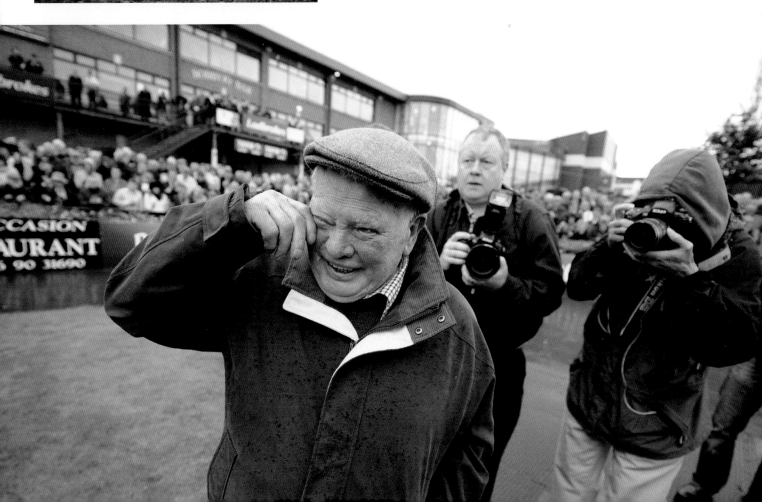

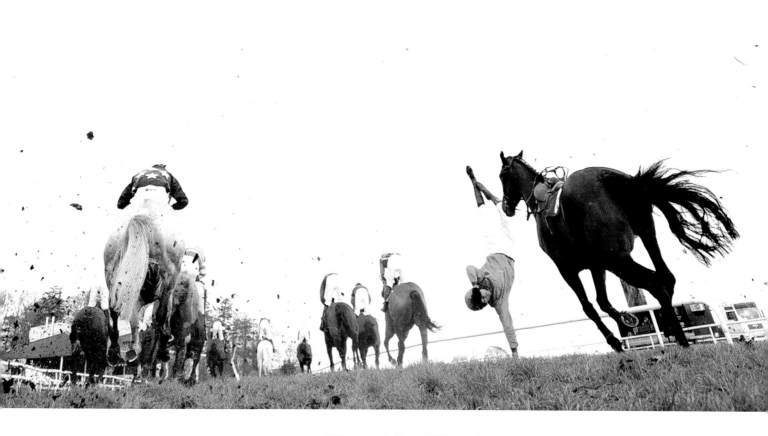

Kilflora sends Brian O'Connell groundwards at the fourth fence at Gowran Park, in the Irish Stallion Farms European Breeders Fund Handicap Steeplechase.

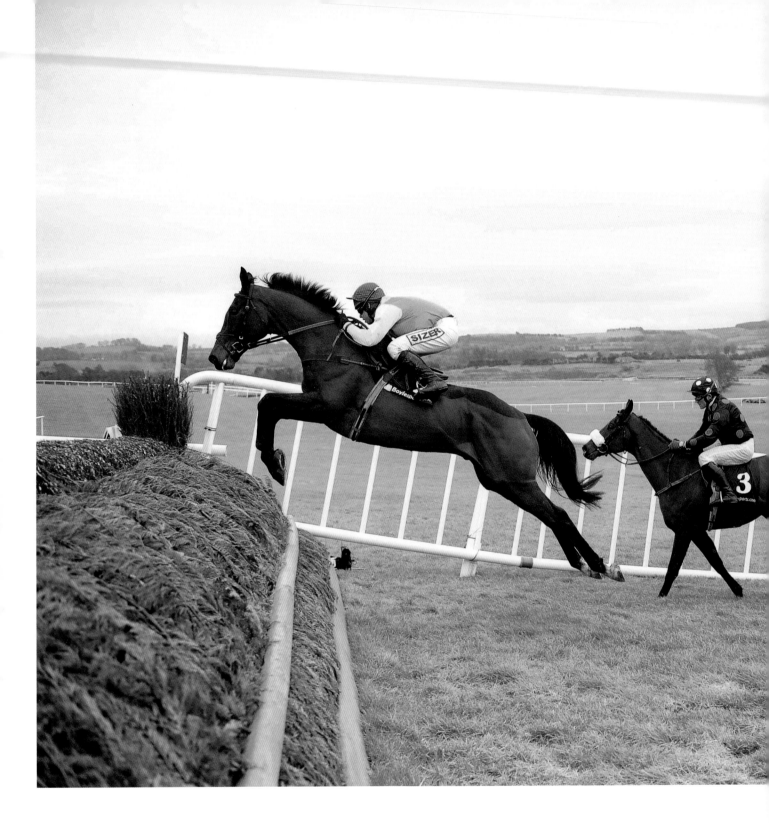

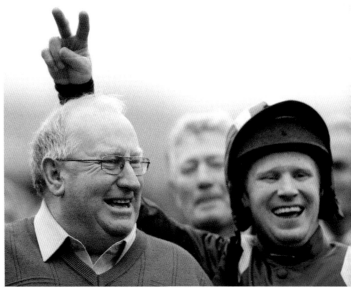

Father and son, Rodger Sweeney (left) and Colman Sweeney, all smiles after *Salsify's* victory in the amateur jockeys' version of the Gold Cup, the Christie's Foxhunter Chase at Cheltenham.

Opposite: *Sizing Europe* and Andrew Lynch are smooth as silk through the air in the Tied Cottage Chase at Punchestown, as *Imperial Shabra* (number 3) and *Big Zeb* (number 1) follow.

Below and opposite: AP McCoy drives *Synchronised* home
from *The Giant Bolster* and Tom Scudamore (red and white
check) and *Long Run* and Sam Waley-Cohen (orange sleeves) in
the Cheltenham Gold Cup, and afterwards with *Synchronsied's*
owner JP McManus and the owner's wife, Noreen McManus,
Synchronised's breeder. Coincidentally, *Synchronised's* dam, *Mayasta,*
was the first winner that AP McCoy rode in the JP McManus silks.

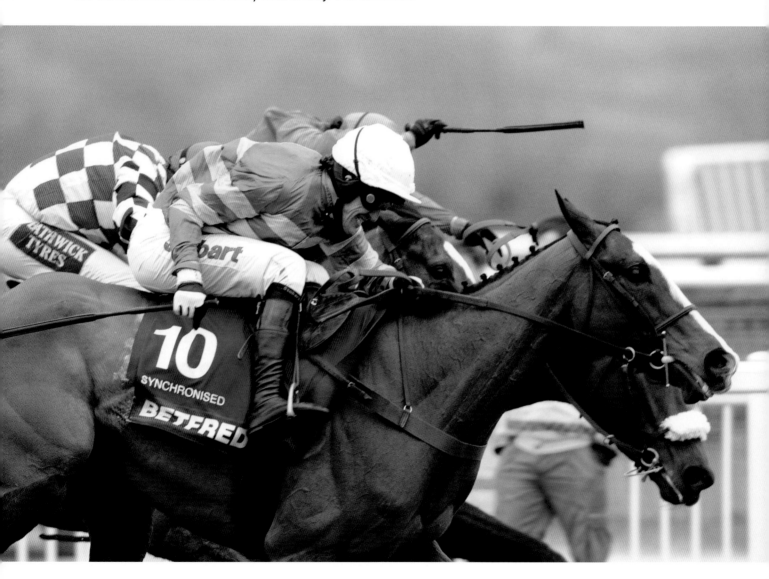

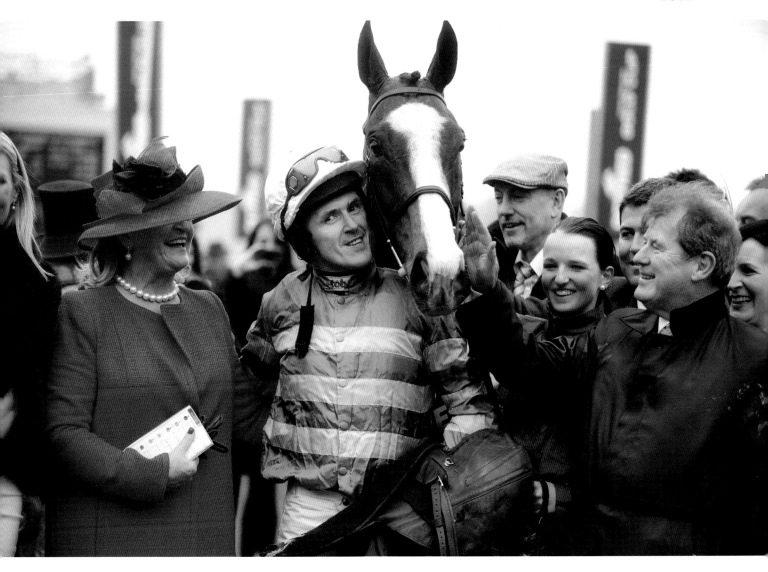

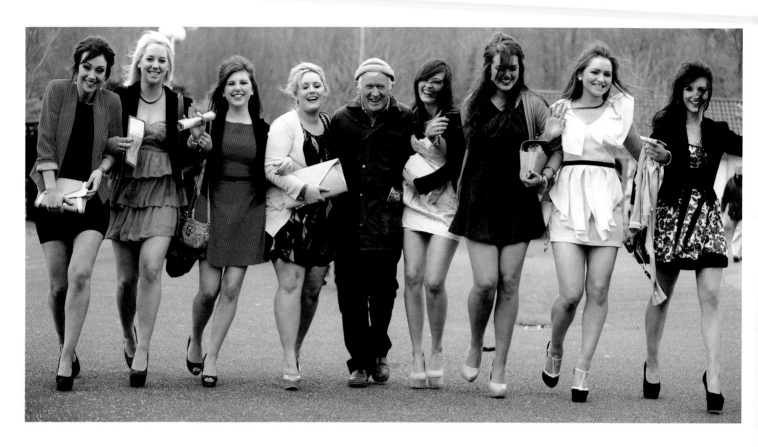

'Here come the girls ...' Student day at Cork. Trainer Jimmy Mangan and his 'trademark' hat are accompanied into the racecourse by students Anita Kelleher, Rachel Wallace, Norma O'Sullivan, Suzanne Gannon, Jess O'Neill, Niamh Moran, Susan Windsor and Sally Ann Delmar.

Opposite top: Rough landing! Lenny Flynn and *Mount Sion* part company on the landing side of The Big Double at Punchestown.

Opposite bottom: Flying low: Mick Butler is dislodged at the first flight at Ballinrobe as *Fast Exit* makes a quick getaway.

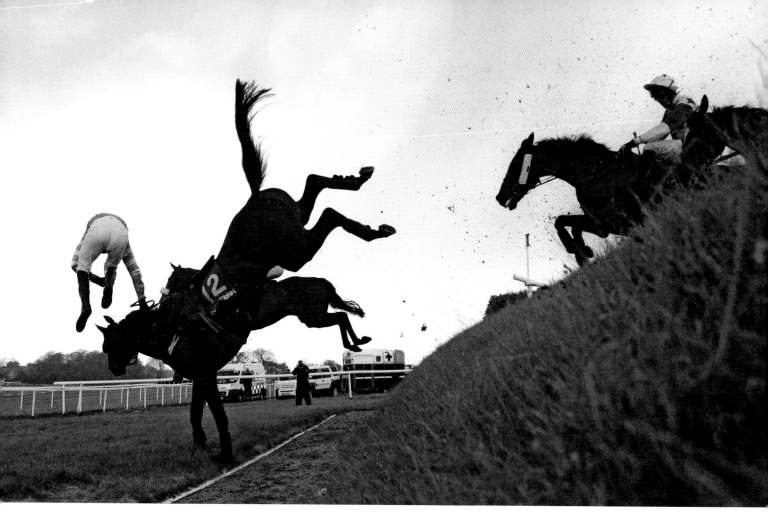
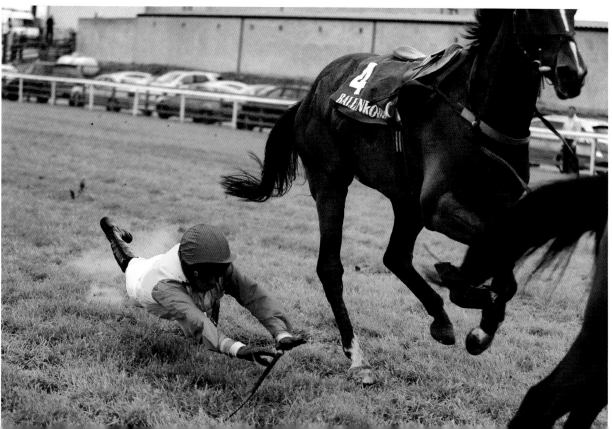

Trainer Thomas Gibney, rider Andrew Thornton and owners, the
Lock Syndicate, celebrate in the winner's enclosure at Fairyhouse
after their horse *Líon Na Bearnaí* has won the Irish Grand National.

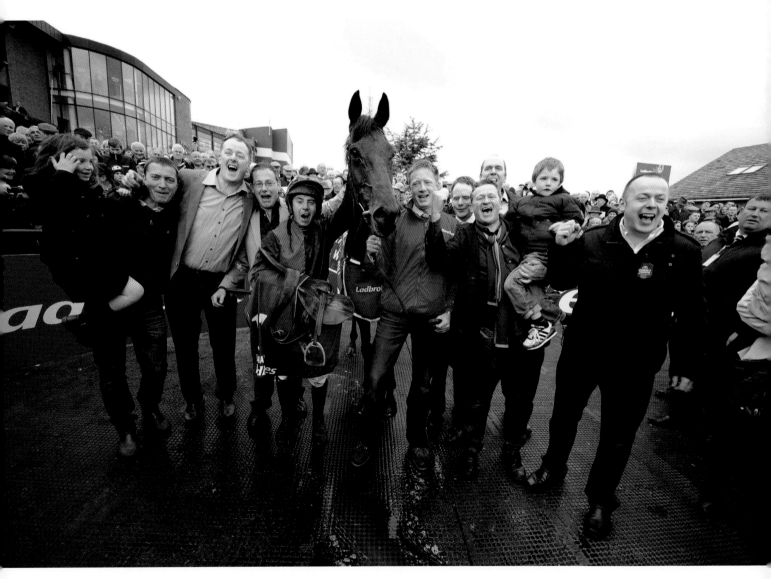

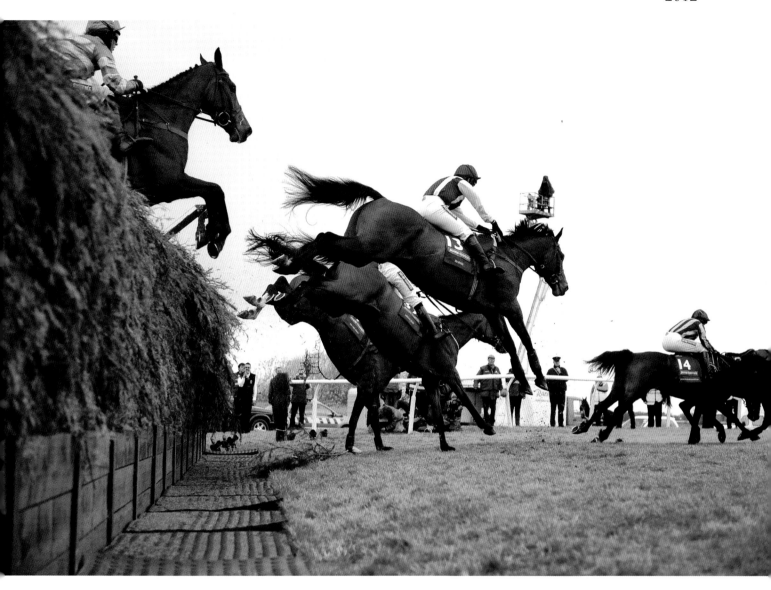

Seabass and Katie Walsh (number 13) sail over Becher's Brook in the Grand National at Aintree. They went on to finish third – the best performance to date by a female rider in the most famous steeplechase in the world.

Opposite: The big wheel keeps on turning as they're off and racing at Listowel for the 154th Harvest Festival.

Trainer Mick Winters is carried shoulder high in the winner's enclosure after *Rebel Fitz*'s win in the Galway Hurdle.

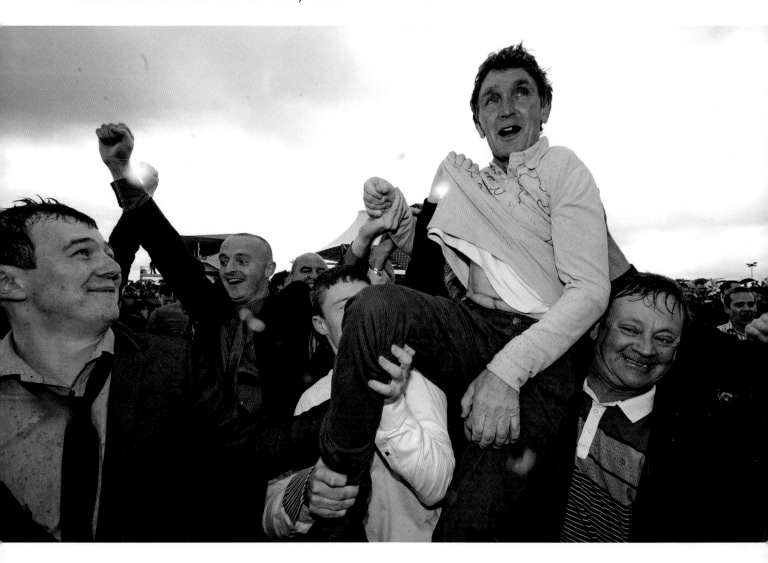

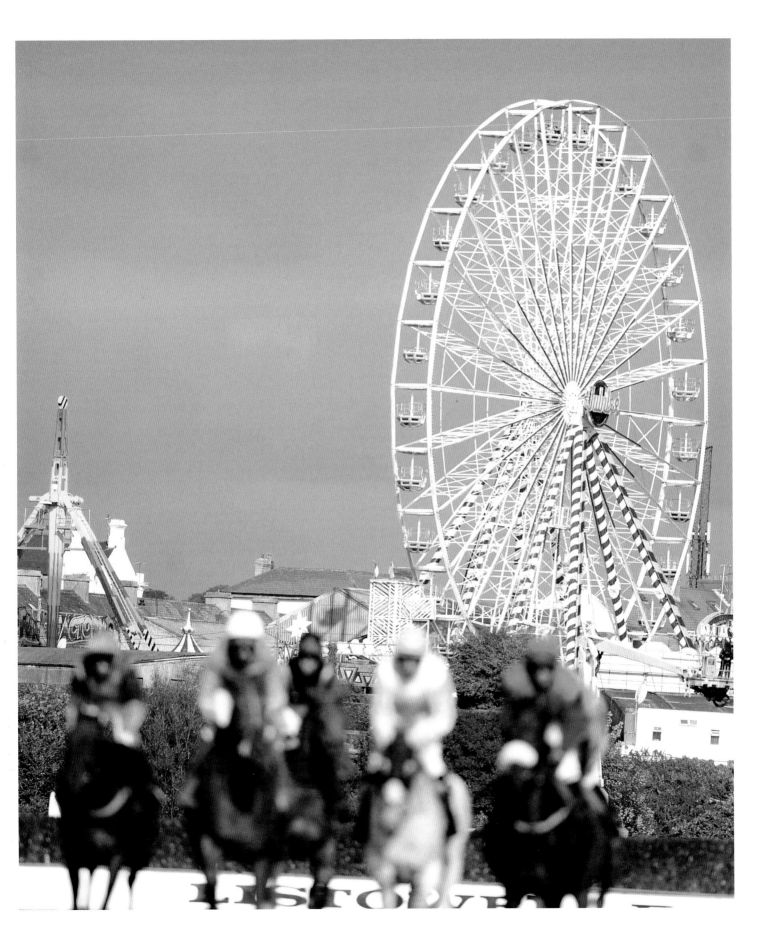

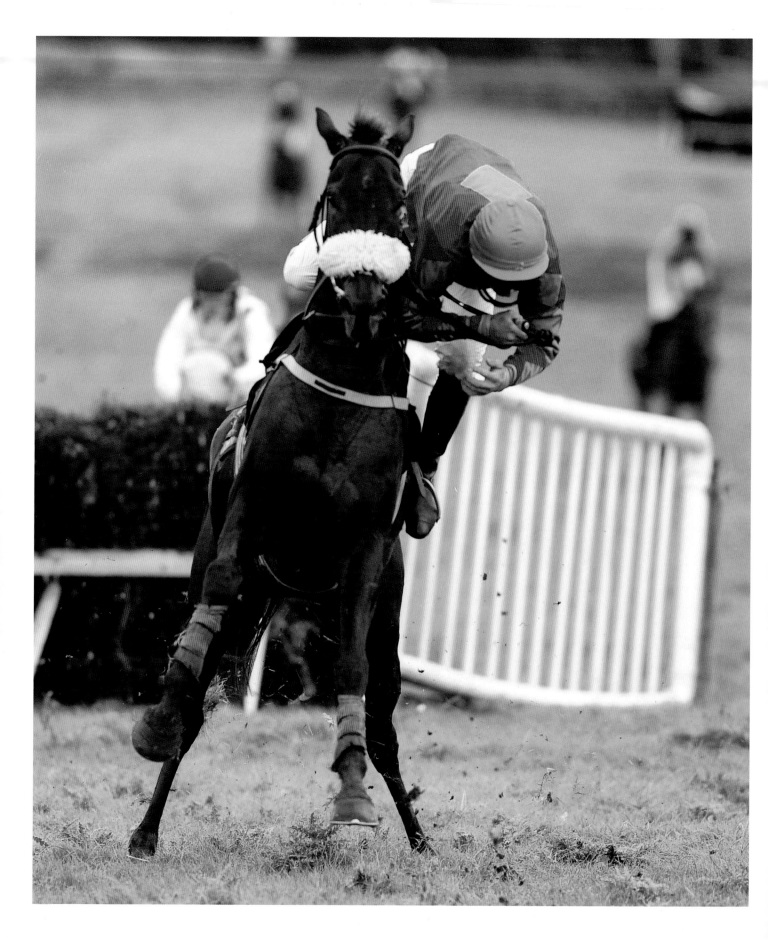

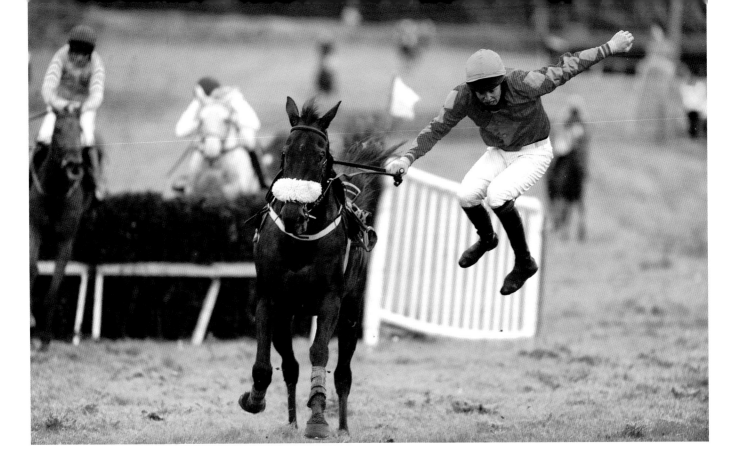

This page and opposite: Despite a gallant effort, there is no way back for Gerry Mangan after *Paddycards* blunders away his chance at the final fence with the race at his mercy at Rathcannon point-to-point, County Limerick.

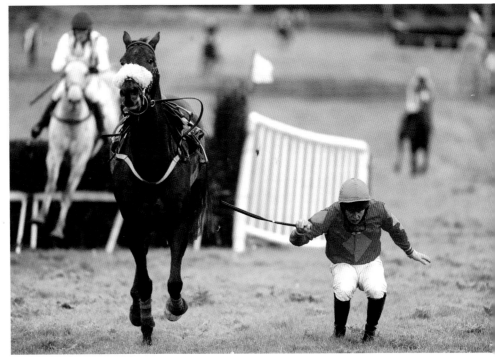

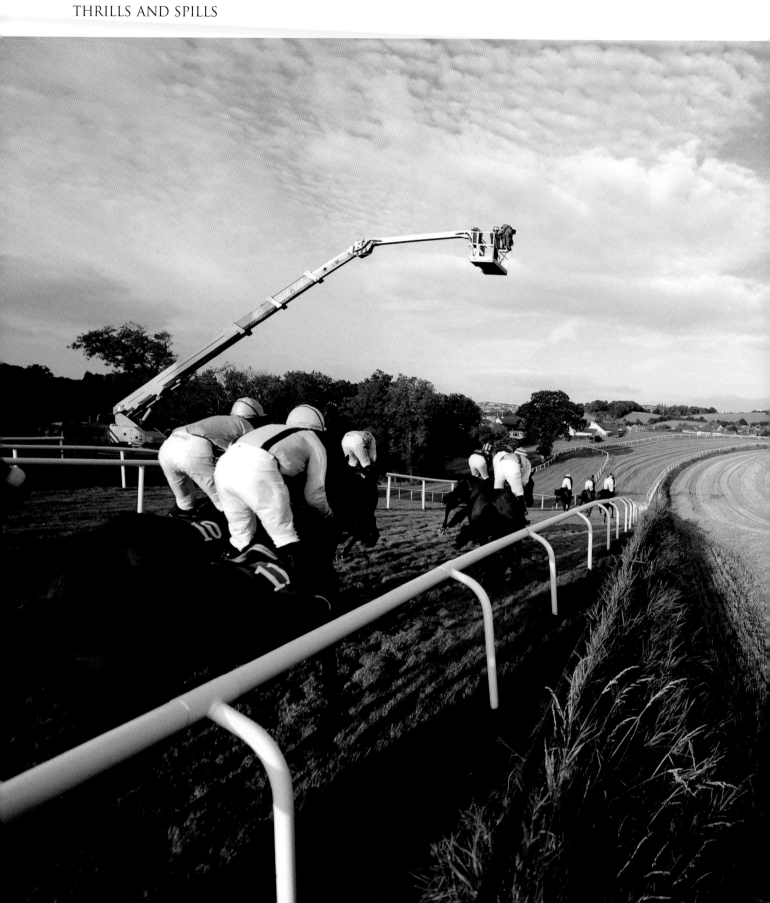

Down the hill as the shadows lengthen at Downpatrick.

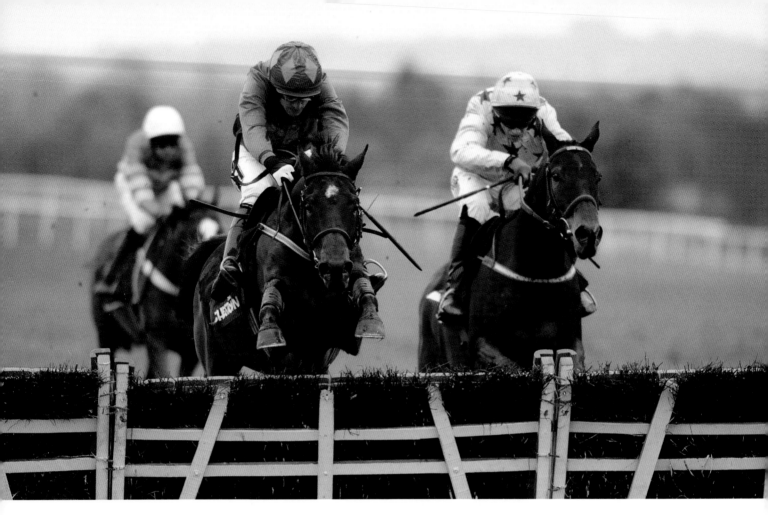

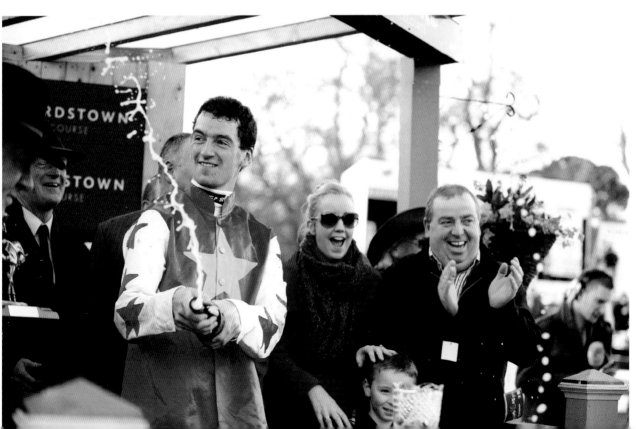

Opposite top: *Hurricane Fly* and Ruby Walsh are low and fast at the final flight on their way to winning the Morgiana Hurdle at Punchestown, ahead of Paul Carberry and *Go Native*, who fell at the last, leaving Mark Walsh and *Captain Cee Bee* to chase the winner home.

Opposite bottom: Patrick Mullins celebrates after winning the Grade 3 ITBA Fillies' Scheme Mares' Hurdle at Leopardstown on 29 December. This victory, on board *Zuzka*, brought the jockey's tally for the year to seventy-three, breaking Billy Parkinson's record for the number of wins an amateur rider accumulated in a calendar year in Ireland. The record had stood for ninety-seven years, and Mullins broke it with two days to spare.

Below: Ruby Walsh drives *Tidal Bay* to victory in the Lexus Chase. Only sixth turning for home, Walsh conjured a run from the eleven-year-old gelding that saw him get up in a thrilling four-way go to the line, beating *First Lieutenant*, *Flemenstar* and *Sir Des Champs* by a head, a half a length and a short head.

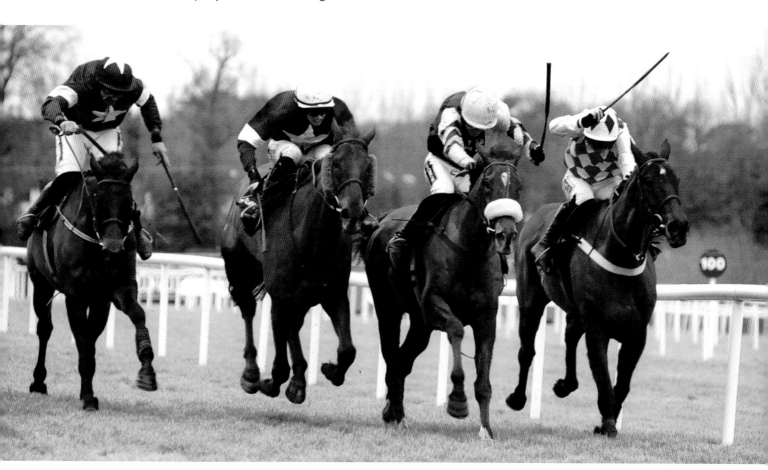

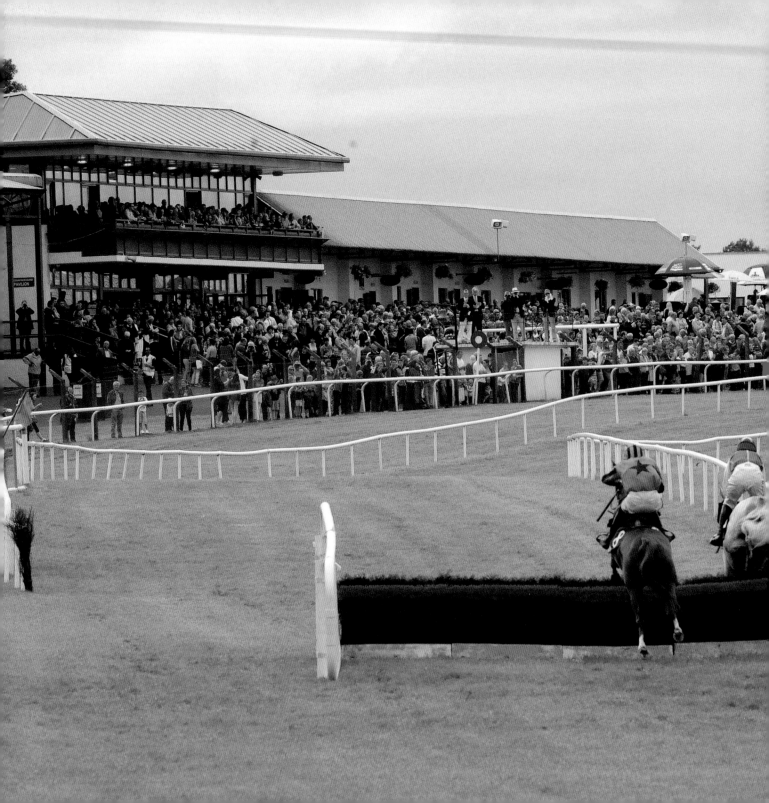

2013

Jumping the last on the first circuit in the Joe Cooney Memorial Handicap Hurdle and facing the crowds at Kilbeggan racecourse, County Westmeath.

Opposite: A foggy January: *Fever Pitch* and David Casey are just about visible in the Foxrock Handicap Chase at Navan.

Jadanli and Andrew Lynch jump the final fence in front before battling on well to win the Thyestes Chase at Gowran Park.

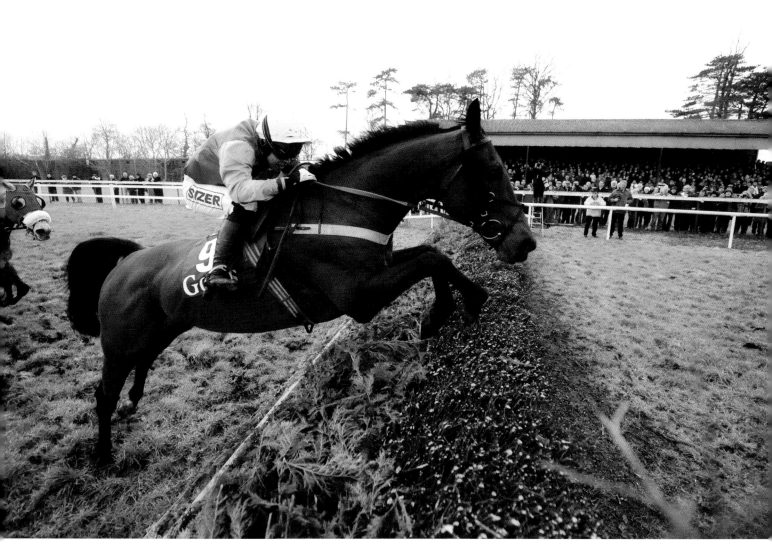

Suspended animation: Danny Fitzsimons sits in mid-air but still has a firm grip
on *Surprise Witness*' reins at Maralin point-to-point in County Armagh.

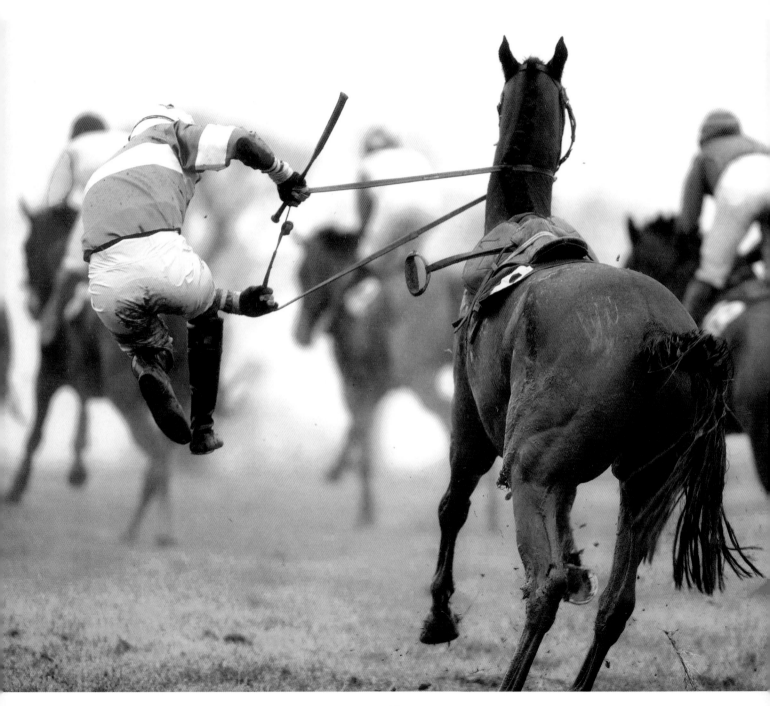

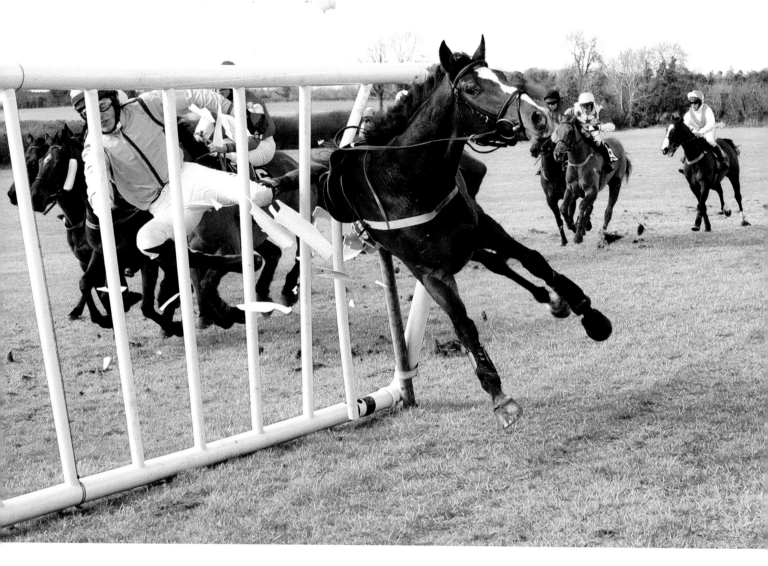

Ben Crawford and *Let Me At It* go their separate ways at The Pigeons
point-to-point in County Westmeath.

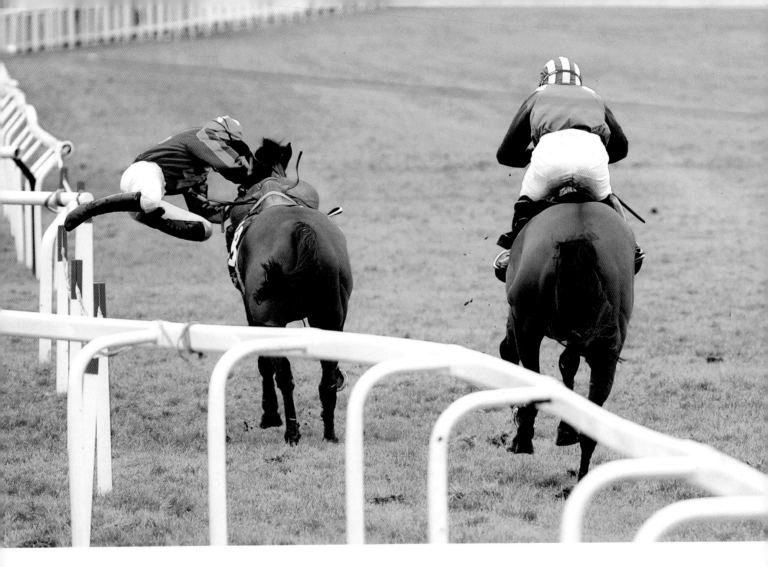

Oscar Delta and Jane Mangan part company on the run-in in the Foxhunter
Chase at Cheltenham with the race at their mercy. It was heartbreaking for
the young rider. She and *Oscar Delta* had jumped all twenty-two fences and
looked set for victory, but the horse jinked at the false rail on the run-in and
unseated his rider, leaving the way clear for *Salsify* and Colman Sweeney to
win the race for the second year running.

Hurricane Fly and Ruby Walsh ping the final flight in the Champion Hurdle on their way to victory. The Willie Mullins-trained gelding became the first horse to win the race in non-consecutive years since *Comedy Of Errors* won it in 1973 and 1975.

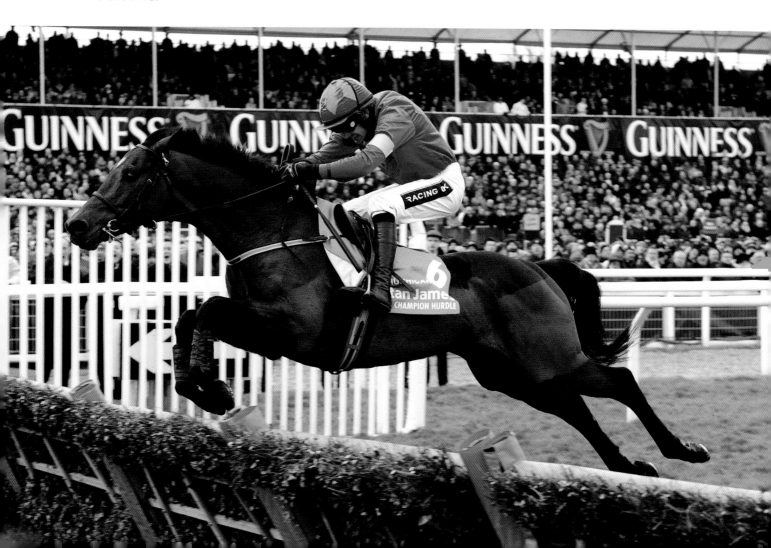

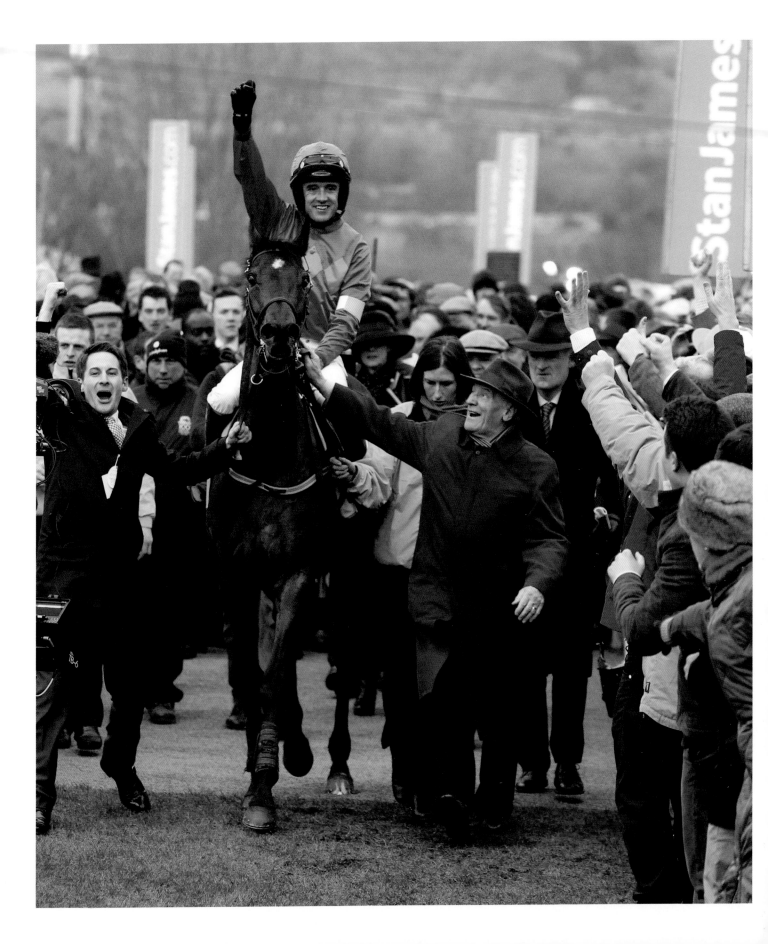

Celebratory punch: Ruby Walsh (left) on *Hurricane Fly* and Bryan Cooper (below) on *Our Conor* both punch the air as they arrive back into Cheltenham's winner's enclosure after winning the Champion Hurdle and the Triumph Hurdle respectively.

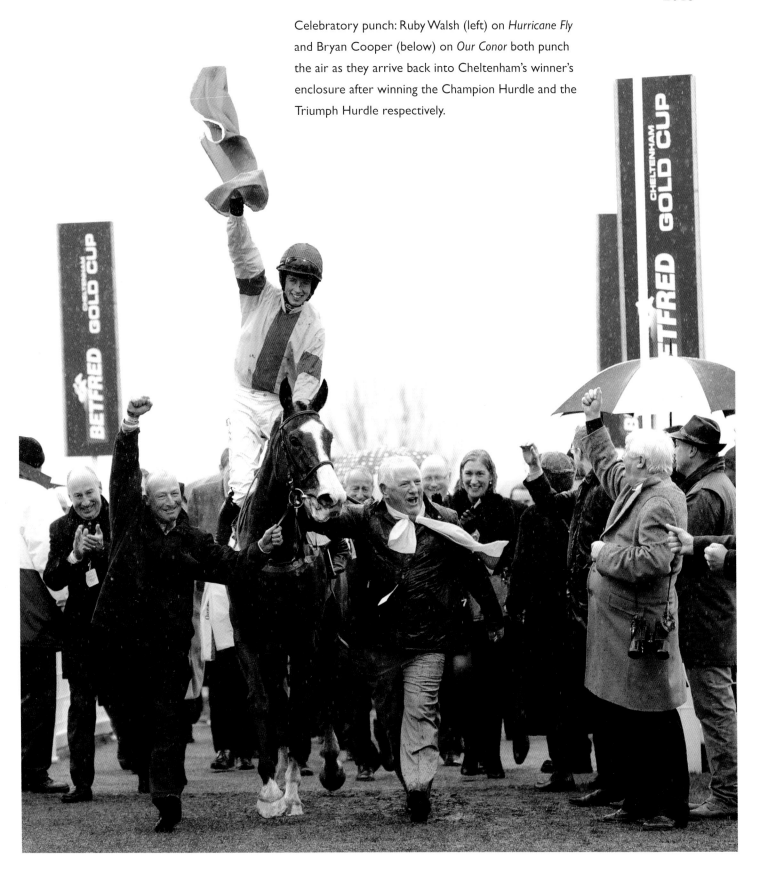

Philip Enright makes a valiant but ultimately unsuccessful effort to remain on board after *Tellherimnothere* makes a bad mistake at Thurles.

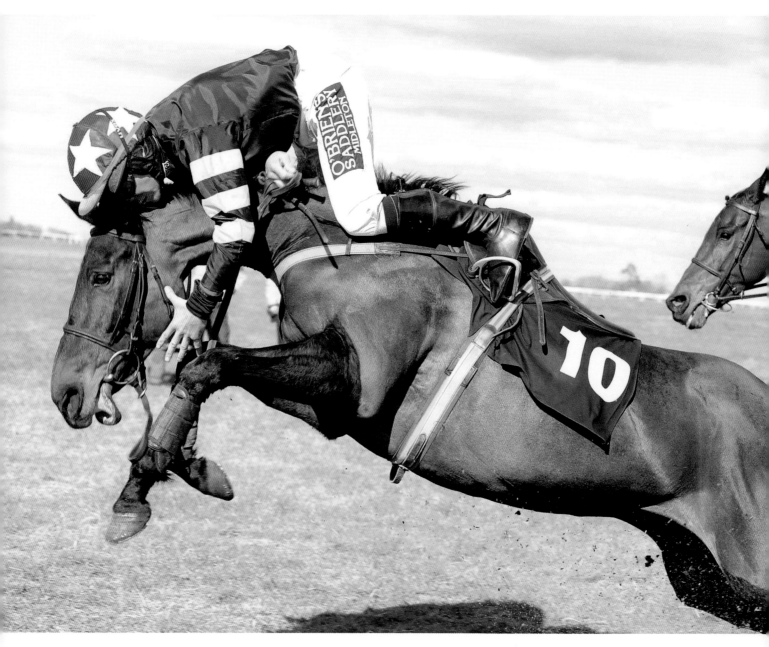

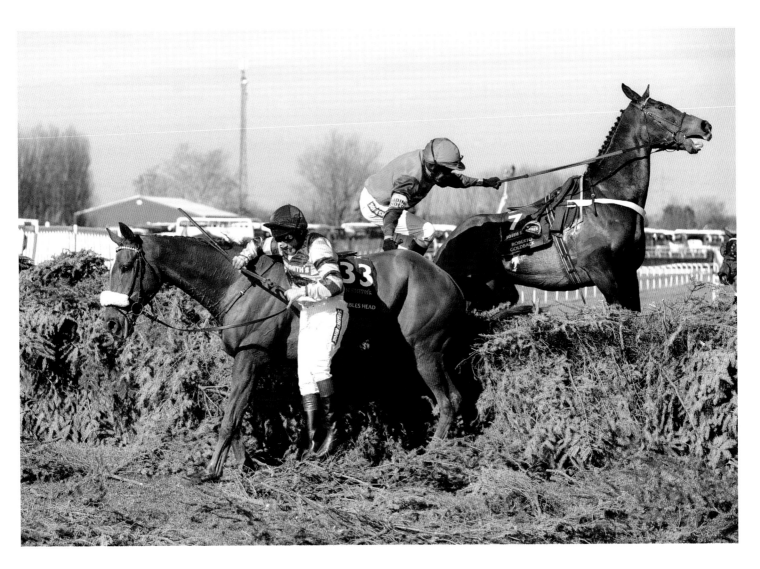

Jamie Moore and *Mumbles Head* are already there, on the landing side of the final fence in the Grand National at Aintree, as *Roberto Goldback* and Barry Geraghty join them.

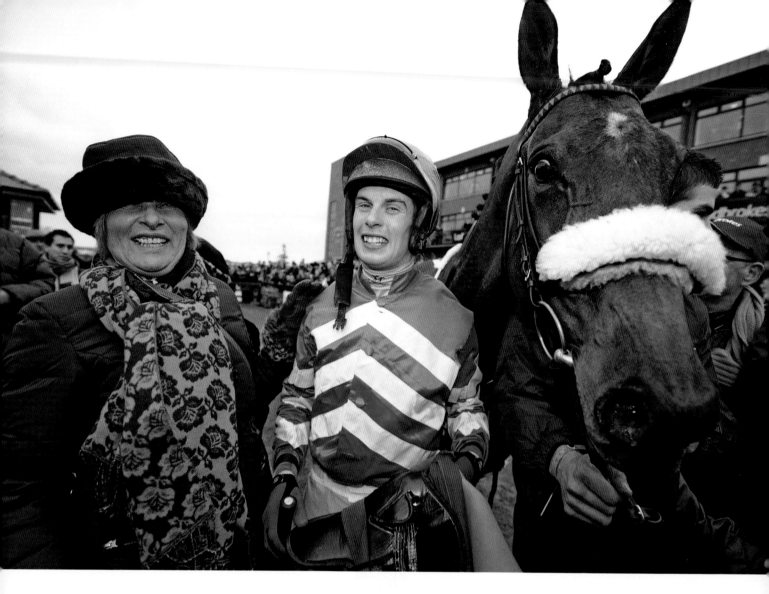

Trainer Dot Love and rider Ben Dalton with *Liberty Counsel* after they have won the Irish Grand National at Fairyhouse.

Close-up: *Mount Benbulben* and Danny Mullins clear the second last fence on their way to an easy victory in the Growise Champion Novice Steeplechase at the Punchestown Festival.

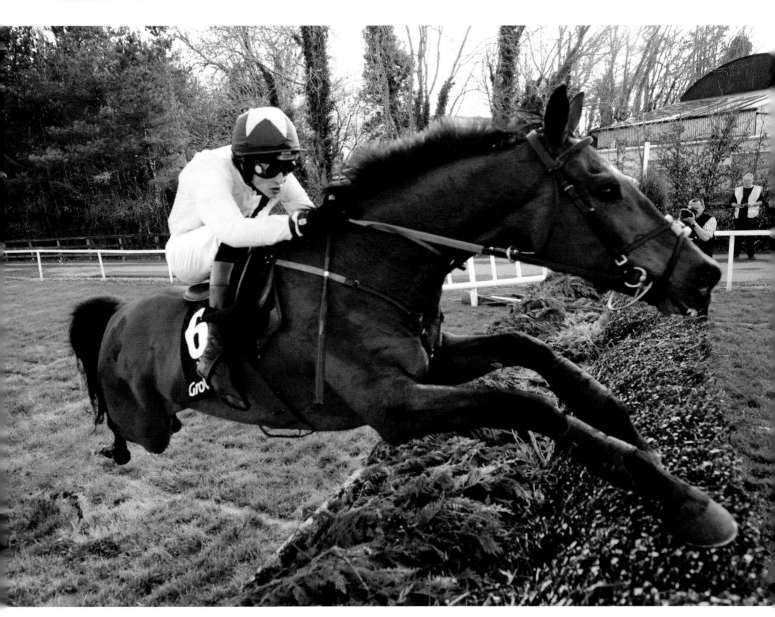

Opposite: It's only a summer shower at Killarney! *Cause Of Causes* enjoys a cooldown.

Below: *Nedzer's Return* and Annie Bowles duck out and run into bales used as course markers, leaving *Nearly A Dream* and Evanna McCutcheon clear to win the Ladies' Open Lightweight Race at Stradbally, County Laois.

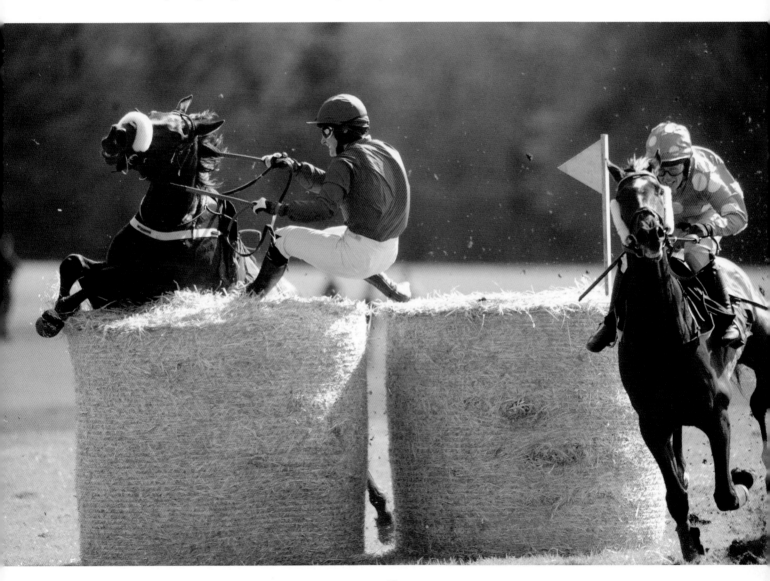

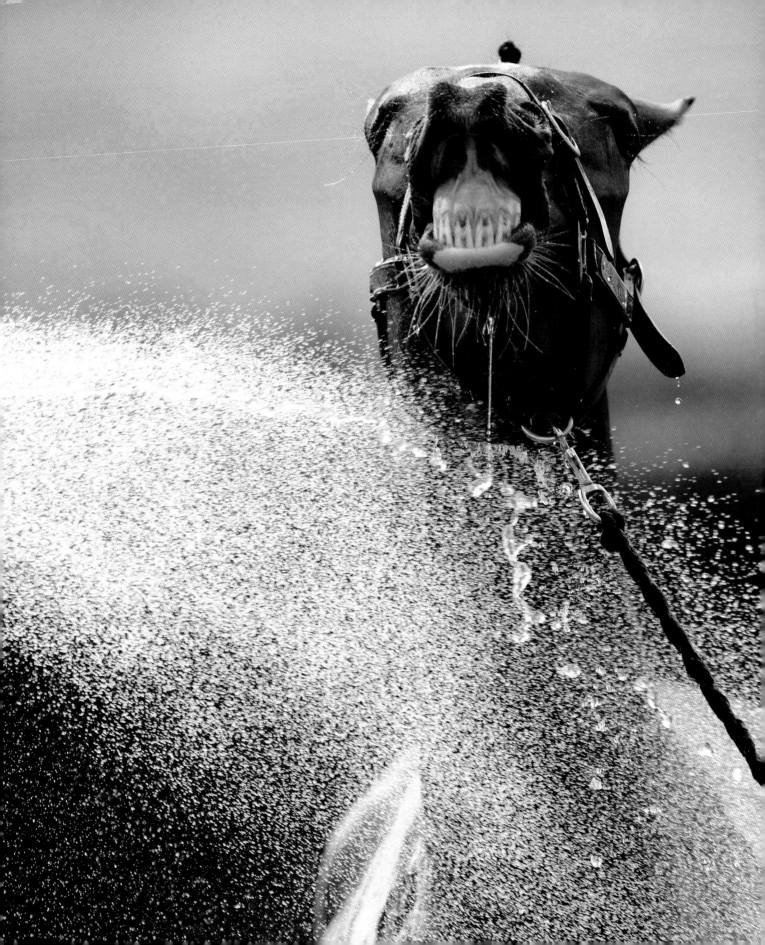

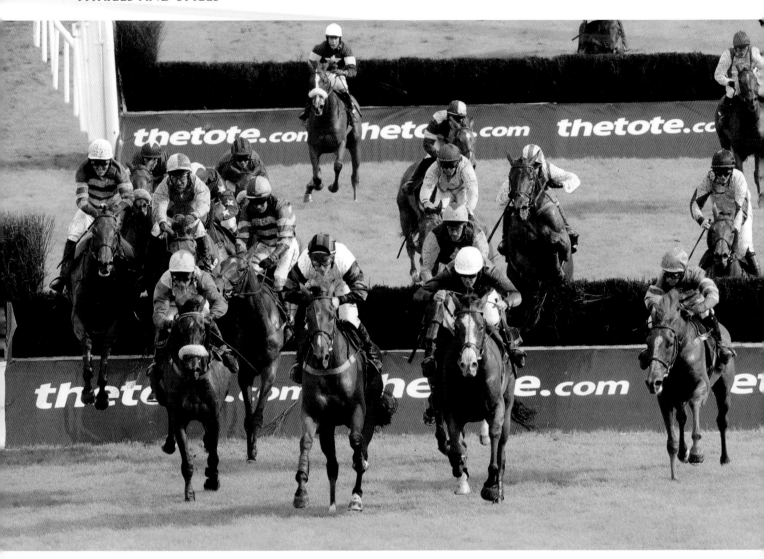

Four in a line as they land over the final fence in the Galway Plate: (left to
right) *Supreme Doc* (eventual 5th), *Fosters Cross* (7th), *Tranquil Sea* (12th)
and *Quantitativeeasing* (2nd). The winner is *Carlingford Lough*, behind on the
inside, AP McCoy in the green and gold JP McManus silks and the white
cap, no better than 7th or 8th jumping the last, and fighting for racing room
with Robbie Power on *Klepht*. It was a power-packed finish, as the strongest
prevailed up the famous Galway hill.

Crystal clear: Trainer Mick Winters and rider Robbie Power are all smiles
after they have teamed up to win the Galway Hurdle with *Missunited*.

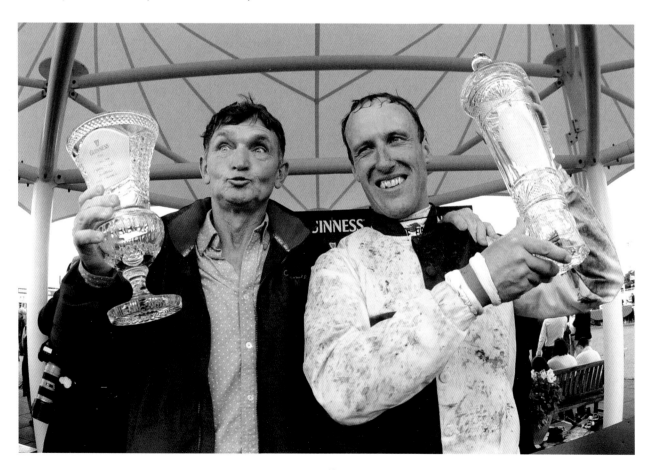

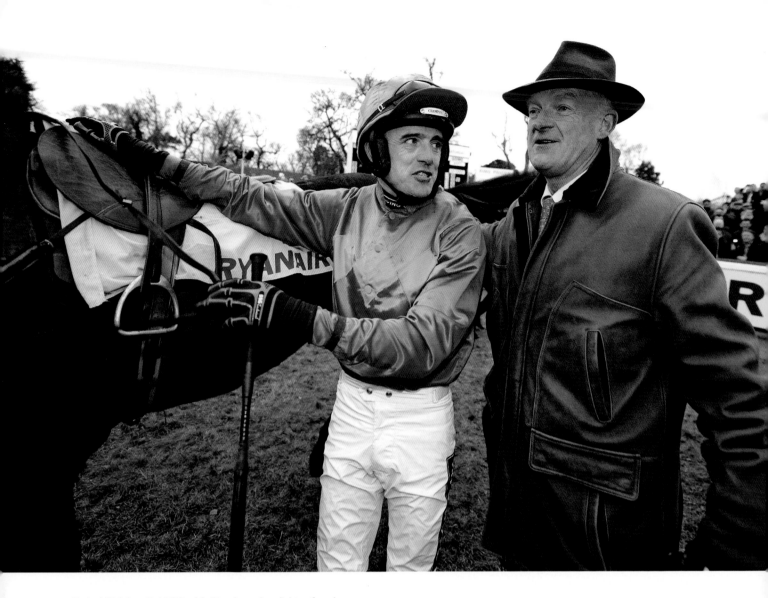

Ruby Walsh tells Willie Mullins how he did it after he and *Hurricane Fly* have just won the Ryanair Hurdle at Leopardstown.

Four falls in the Martinstown Opportunity Handicap Steeplechase at Leopardstown: *De Glebe Star* (number 18) and Stephen Gray (red and white colours) come down at the fourth fence, bringing down *Whats On The Menu* (number 11) and Adam O'Neill (blue and white colours), and hampering *Down Under* (number 7), who unseats Jody McGarvey (green and gold colours). *Love Rory* (number 2) had unseated Shane Butler (not in picture) at an earlier fence. The race was won by *Wrong Turn* and Shane Shortall (also not in picture).

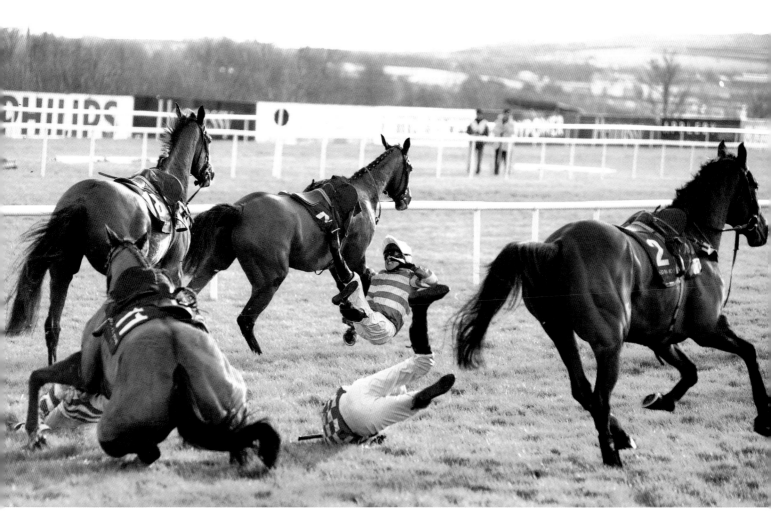

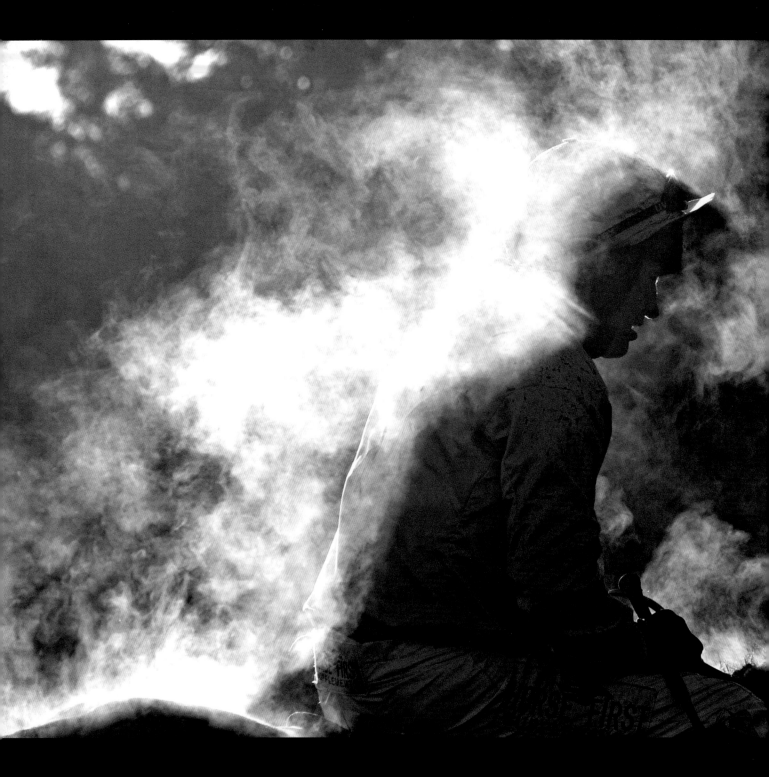

2014

Cooling down as steam rises ... returning to the parade ring at Leopardstown.

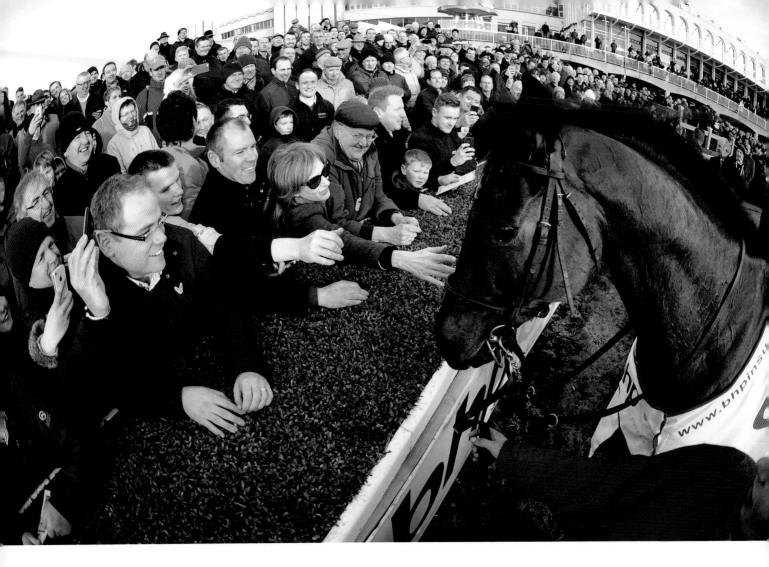

Hurricane Fly laps up the adulation of the racegoers
after he has won the Irish Champion Hurdle again.

Sulu Sea and Katie Walsh part company at the final fence at Punchestown point-to-point.

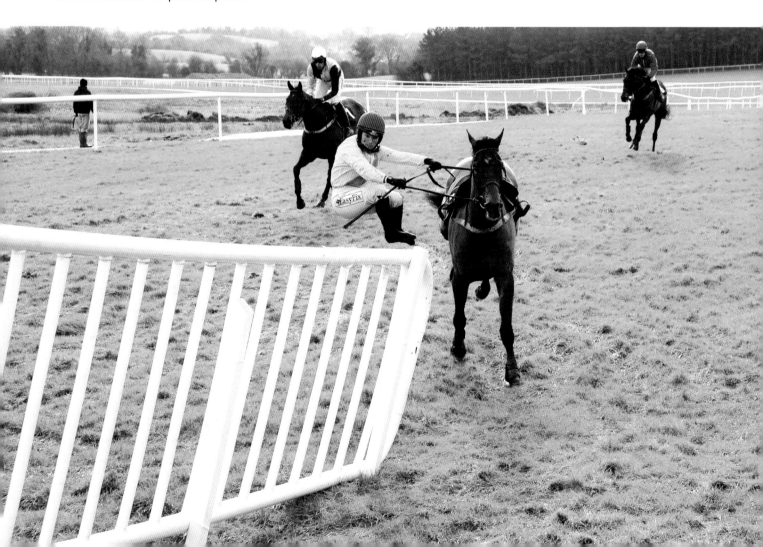

Trainer Willie Mullins with *Quevega*, sticking her tongue out after she has won the Mares' Hurdle at the Cheltenham Festival for the sixth time, thereby becoming the only horse to win a race at the Cheltenham Festival six times, beating the previous record held by *Golden Miller,* who won the Cheltenham Gold Cup five times in the 1930s.

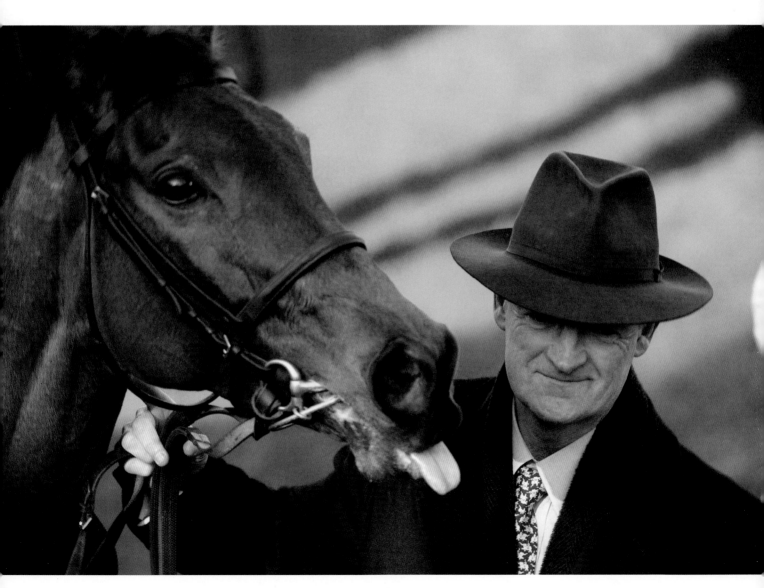

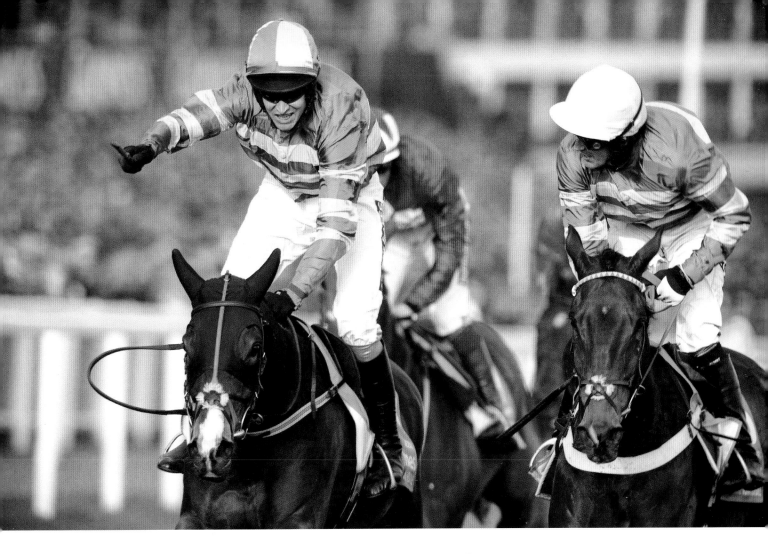

It's a 1-2 for owner JP McManus in the Champion Hurdle at Cheltenham, as *Jezki*
and Barry Geraghty (left) get home by a neck from *My Tent Or Yours* and AP McCoy,
with *The New One* and Sam Twiston-Davies (red colours) back in third.

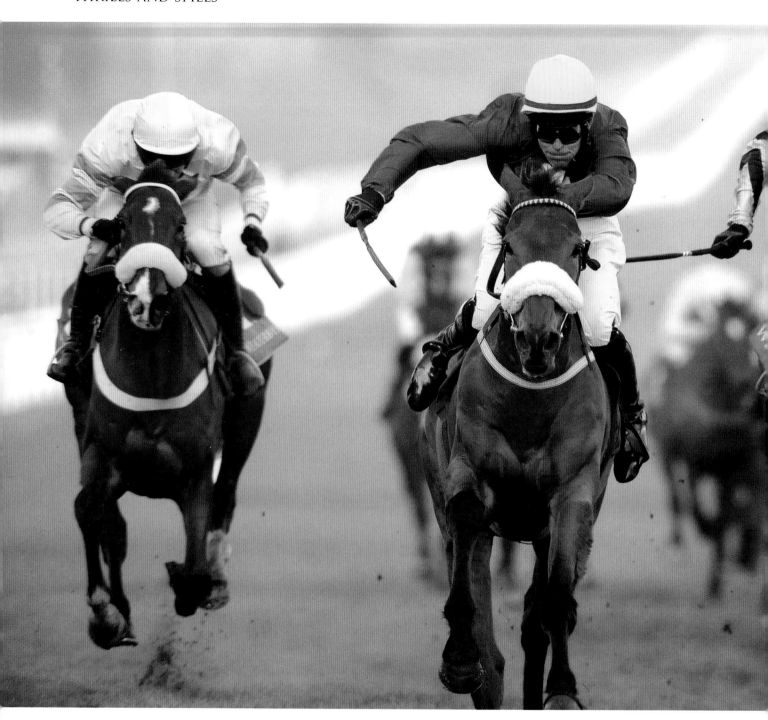

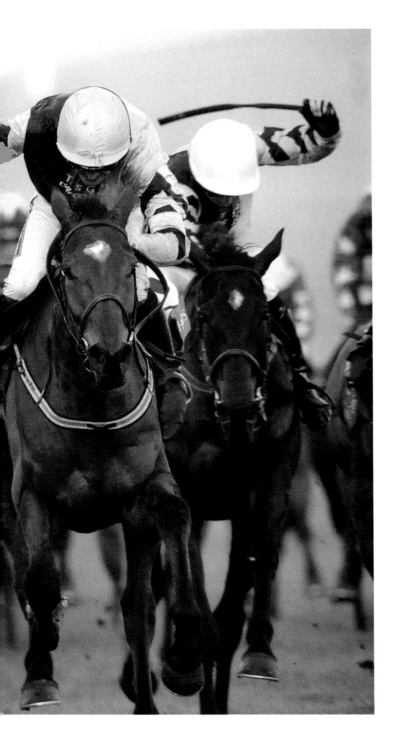

A thrilling finish to the Champion Bumper at Cheltenham, as *Silver Concorde* and Robbie McNamara (yellow cap) prevail from *Shaneshill* and Ruby Walsh (beige cap), with *Joshua Lane* and Barry Geraghty (pink cap) third and *Black Hercules* and Patrick Mullins (white cap) back in fourth. It was amateur jockey Robbie McNamara's first Cheltenham Festival win. The following day, he rode his second, as he booted *Spring Heeled* to victory in the Kim Muir Challenge Cup.

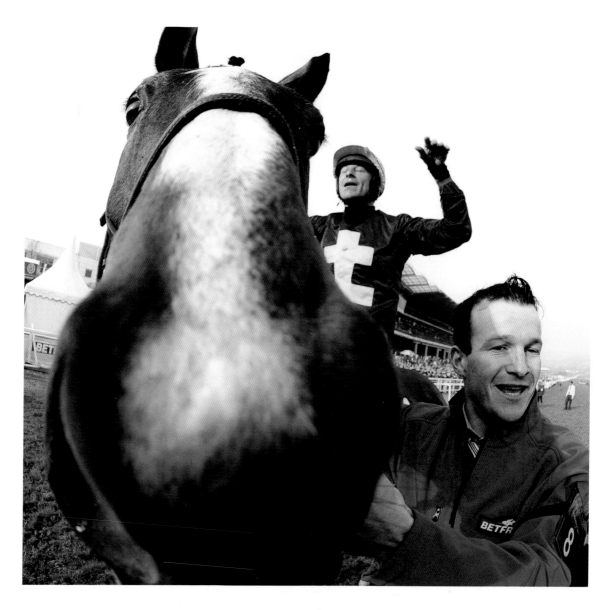

Groom Gary O'Connor with *Lord Windermere* as rider Davy Russell savours
the moment after victory in the Cheltenham Gold Cup.

Shalamzar and Davy Russell go their separate ways at
the second flight in a maiden hurdle at Fairyhouse.

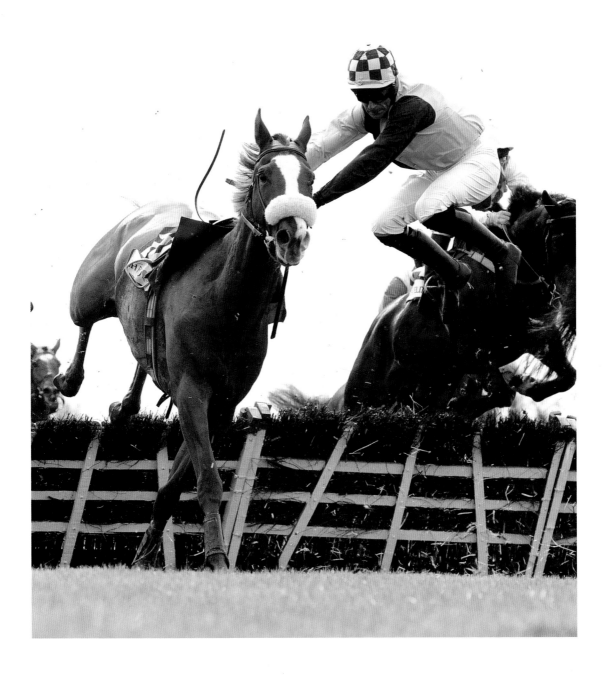

Opposite: The sweet smile of victory all round for Barry Geraghty, *Shutthefrontdoor* and groom Kate Hanson after they have won the Irish Grand National.

Trainer Jonjo O'Neill with *Shutthefrontdoor* and a doffed hat in the winner's enclosure after the Irish Grand National at Fairyhouse.

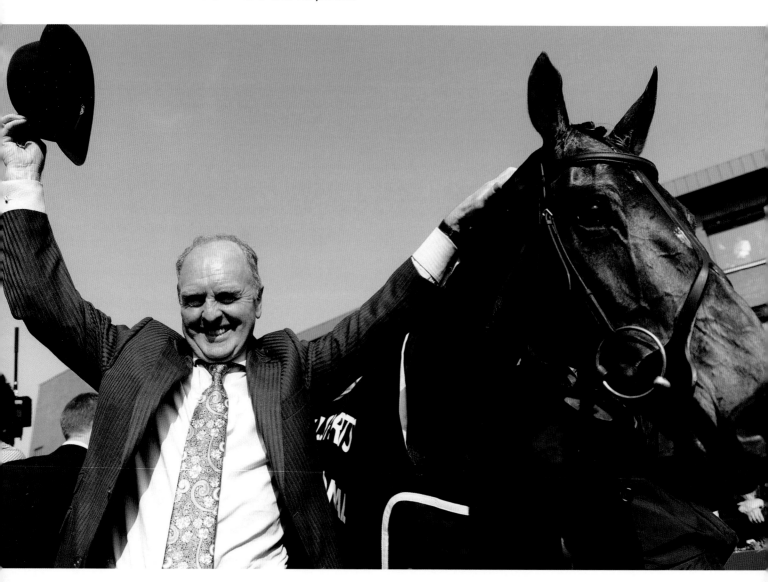

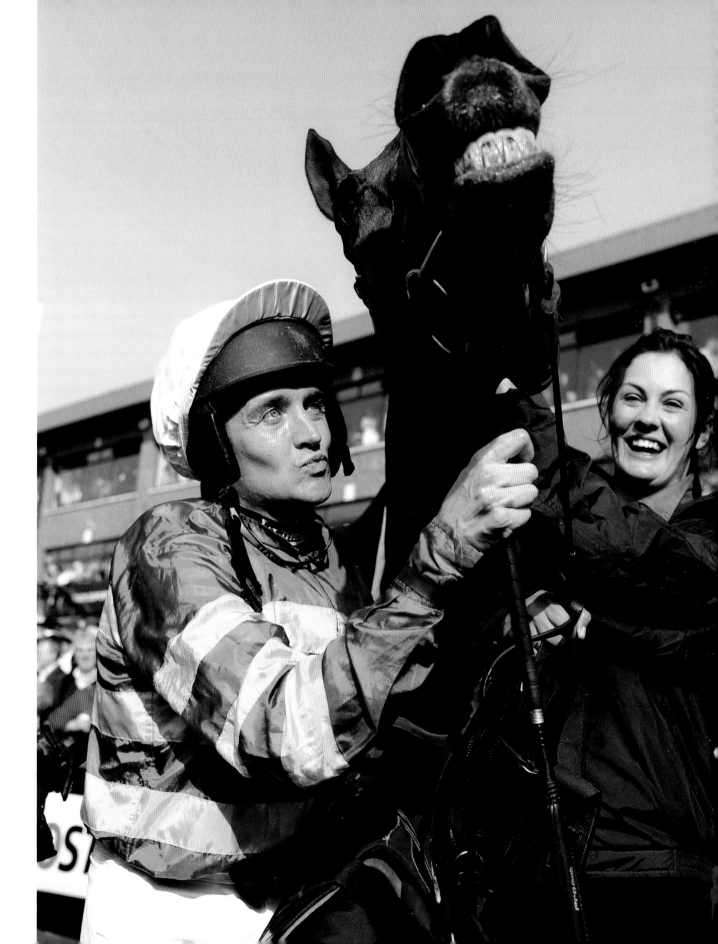

Family celebration: Trainer Jessica Harrington (left) with her daughters Kate (centre) and Emma (right) after *Jezki's* win in the Punchestown Champion Hurdle.

Sizing Europe and Andrew Lynch in full flight at the final fence on their way to victory in the Punchestown Champion Chase.

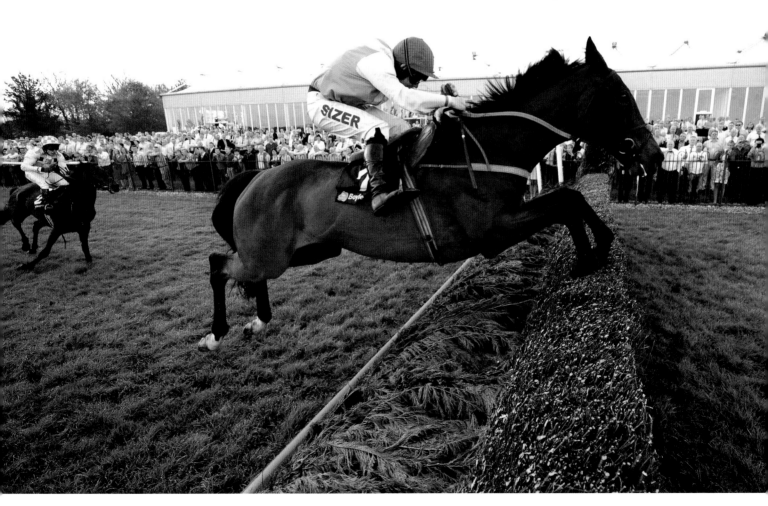

Trainer Noel Meade is all smiles in the winner's enclosure after *Road To Riches* has won the Galway Plate.

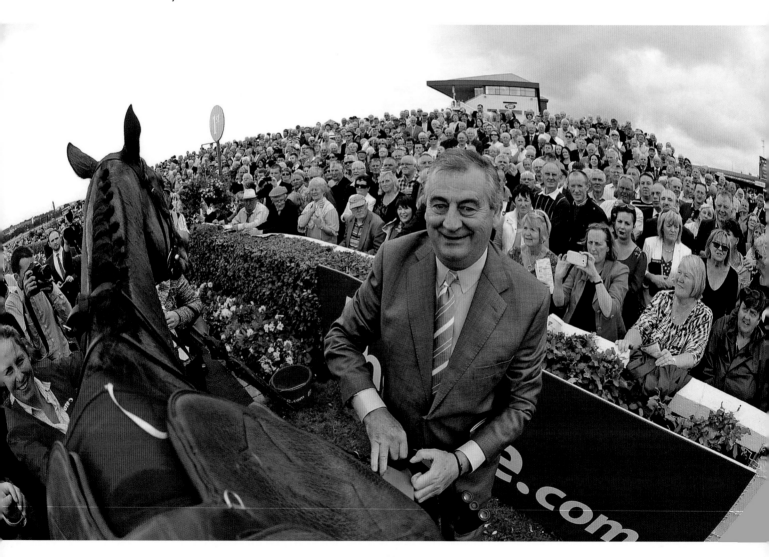

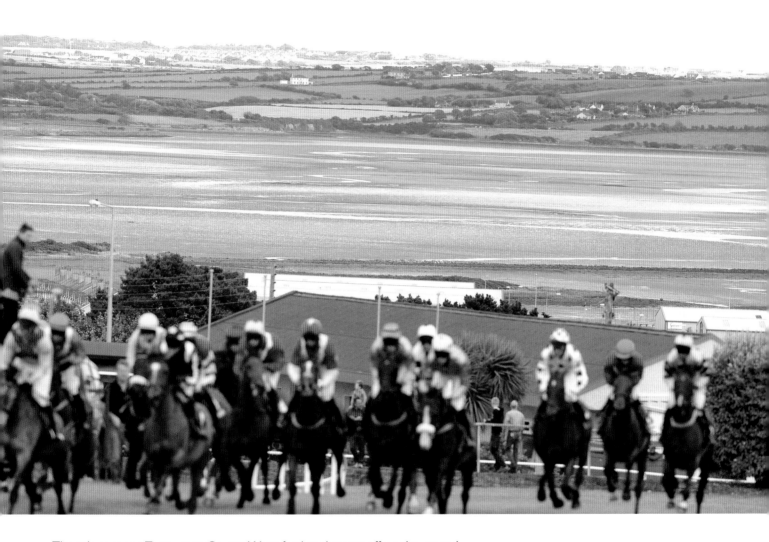

The tide is out at Tramore in County Waterford as they set off on the second day of the August Festival.

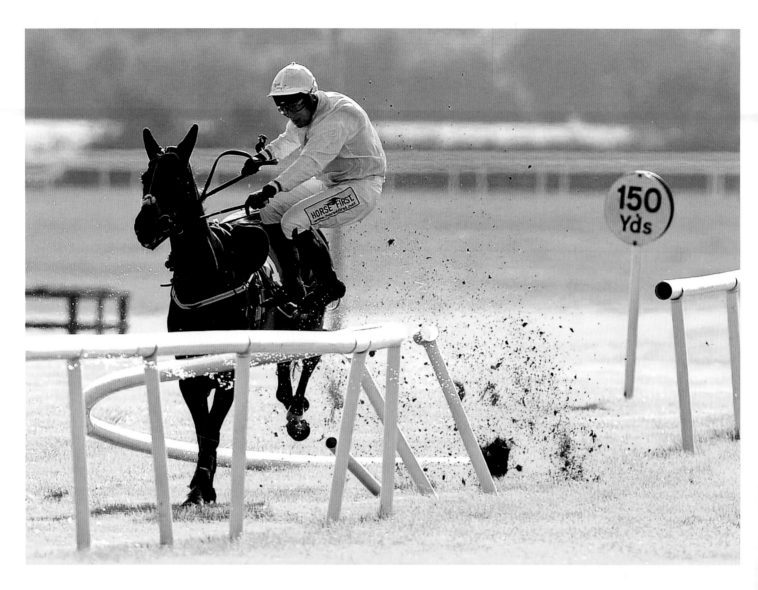

Walk To Freedom and Robbie Power crash out through the rail on the run-in at Fairyhouse while fighting out the finish with *The Herds Garden* and Paul Carberry.

Right: Paul Carberry performs a flying dismount in the winner's enclosure at Down Royal after he and *Road To Riches* have won the Champion Chase.

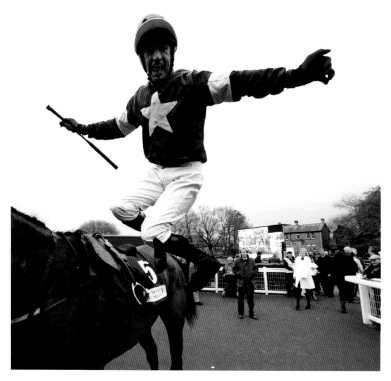

Bird's eye view: Listowel on Kerry National day.

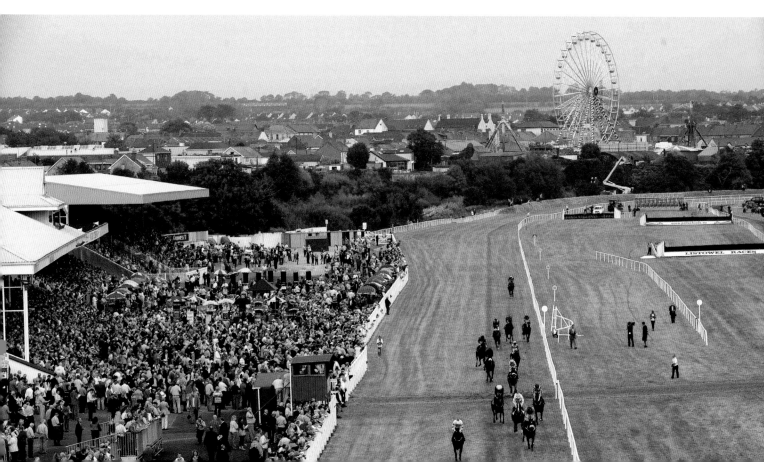

Opposite top: Gordon Elliott-trained *Don Cossack* and Brian O'Connell soar over the final fence at Punchestown en route to victory in the John Durkan Memorial Chase, as *Boston Bob* and Ruby Walsh give chase.

Opposite bottom: Any tips? Frank Feeley and Danny Gray study the card on student raceday at Sligo, as Jemma Shaughnessy (right) takes a call.

Ivy Glen and Mikey Fogarty part company at the final fence in the Molony Cup at Thurles.

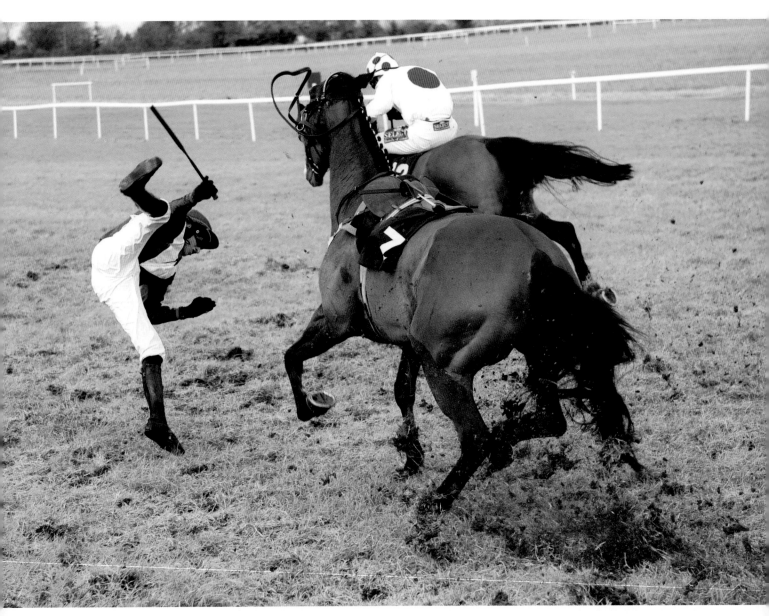

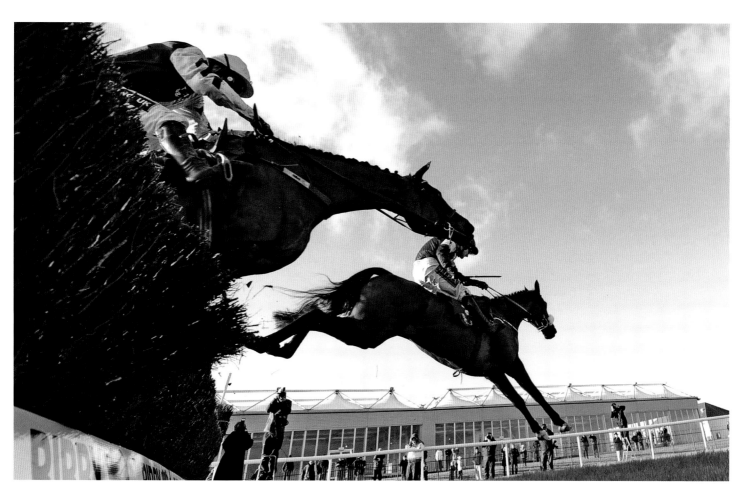

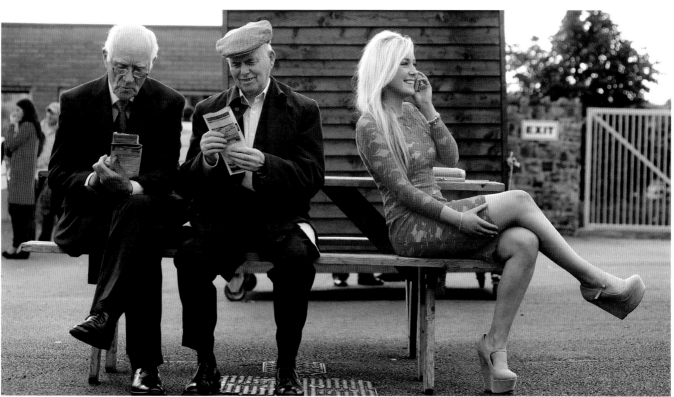

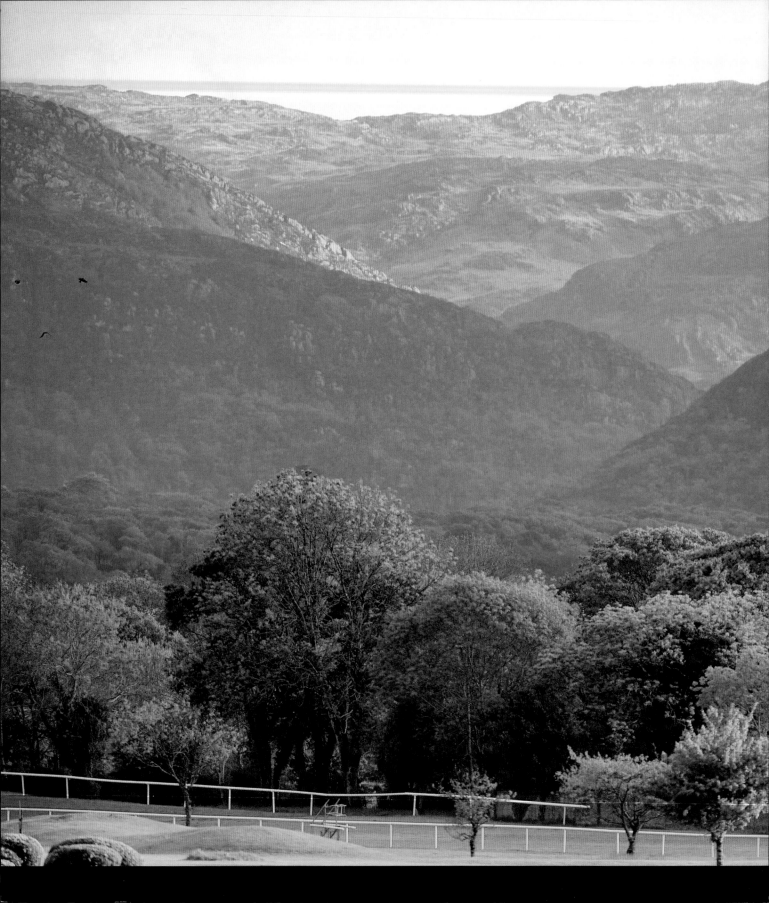

2015

Horses and riders are
dwarfed by the magnificent
McGillycuddy Reeks at
Killarney.

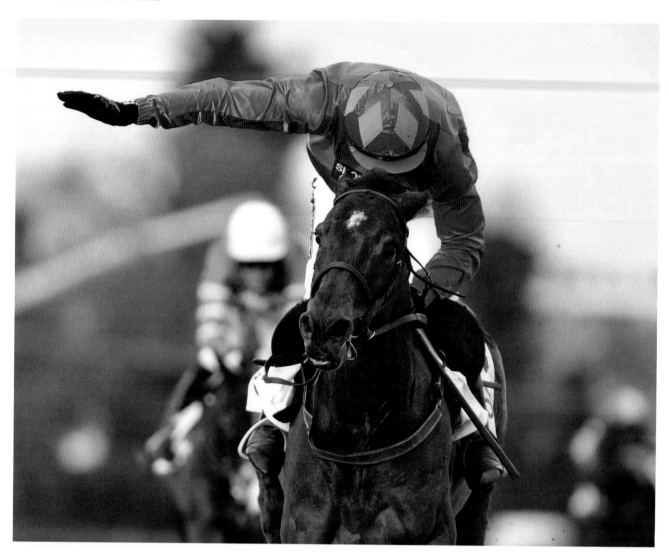

Ruby Walsh gives *Hurricane Fly* a pat on the neck as the pair of them cross the line in the Irish Champion Hurdle. This was the *Montjeu* gelding's fifth win in the race, an eleven-year-old, taking on some horses who were half his age and younger, including one who wasn't even born when he won his first Irish Champion Hurdle. This was the twenty-sixth victory of *Hurricane Fly's* career, his twenty-second Grade I win, and it completed a perfect ten Grade I wins from ten runs at Leopardstown.

Opposite top: *Blodge* and Jonathan Burke (maroon silks with blue chevrons) come down at the first fence at Thurles, bringing *County Champions* and Philip Enright (blue silks, yellow V and chevrons on sleeves) down with them, and causing *The Tinker Molly* to unseat Andrew McNamara (navy silks, red cap).

Opposite bottom: Andrew McNamara retrieves his helmet as all three jockeys emerge relatively unscathed.

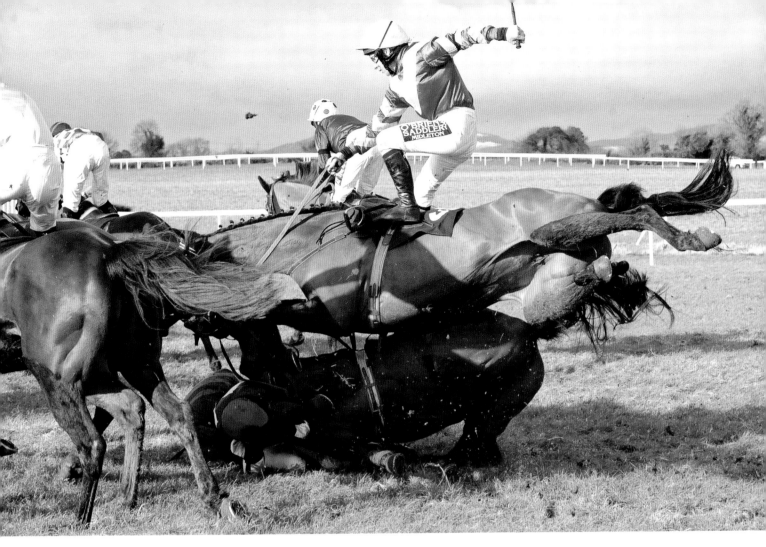
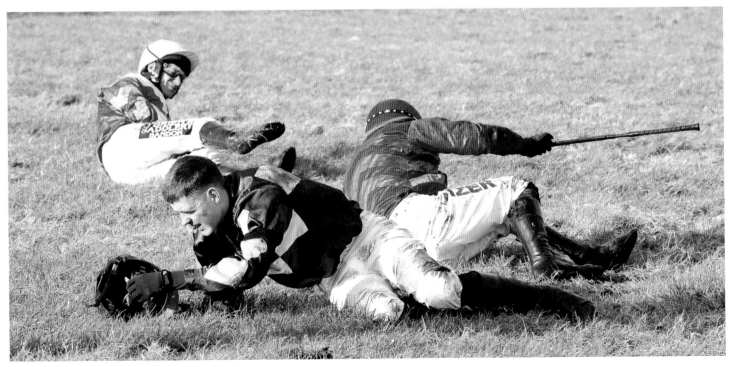

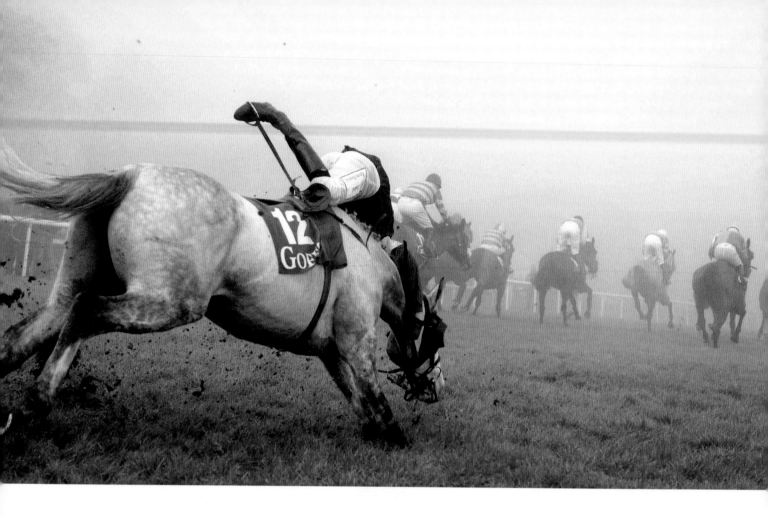

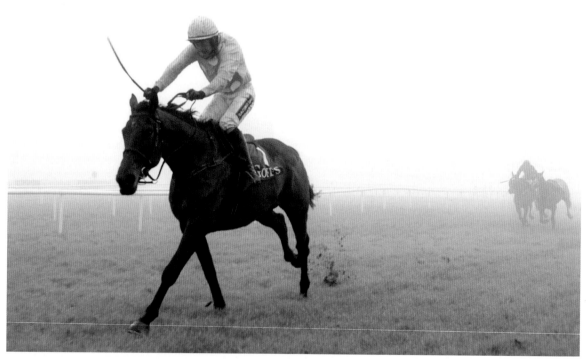

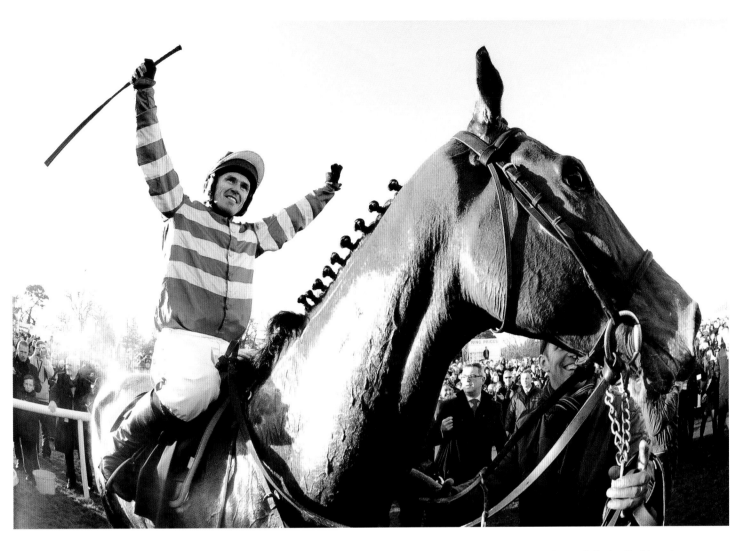

AP McCoy salutes the crowd as he and *Carlingford Lough* arrive back into Leopardstown's winner's enclosure after winning the Irish Gold Cup. The twenty-time champion jockey had just the previous day at Newbury announced his intention to retire from the saddle at the end of the season, so it was his last chance to win the Irish Gold Cup, one of the few big races in National Hunt racing that had thus far eluded him. It was an emotional day, as the crowd gave the champ the reception that he deserved.

Opposite: *Ipsos Du Berlais* unseats Ger Fox at the ninth fence in the Thyestes Chase at Gowran Park before (opposite bottom) *Djakadam* and Ruby Walsh emerge from the fog to post an impressive victory.

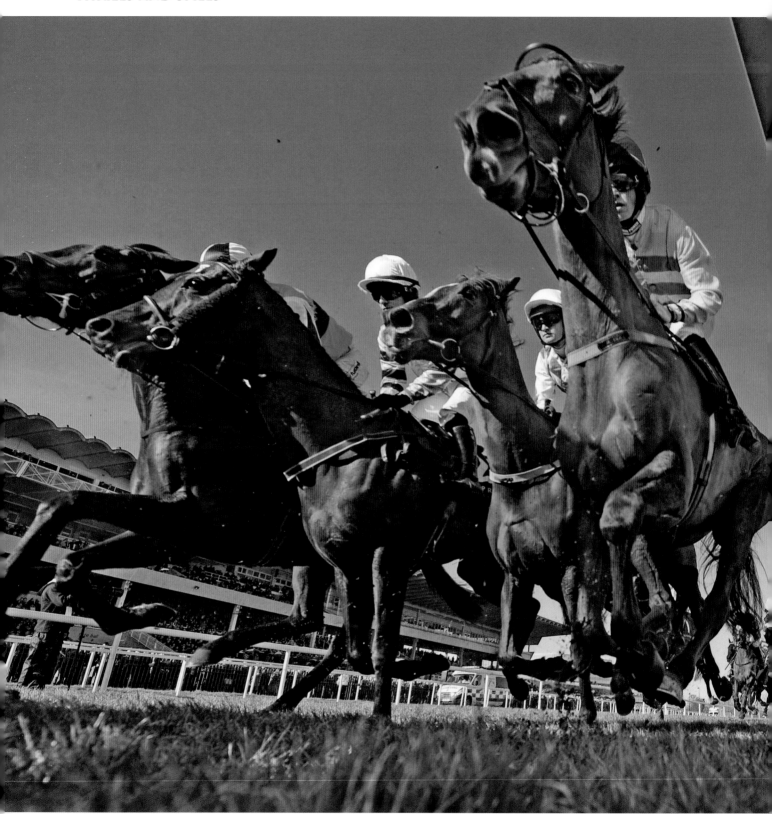

Passing the post with a circuit to go in the Mares' Handicap Hurdle at Leopardstown, from right to left, *Blackandamber Vic* and Jonathan Moore, *Gold Platinum* and Kevin Sexton, *Who's That* and Mark Enright (the ultimate winner) and *I'm All You Need* and Mikey Fogarty.

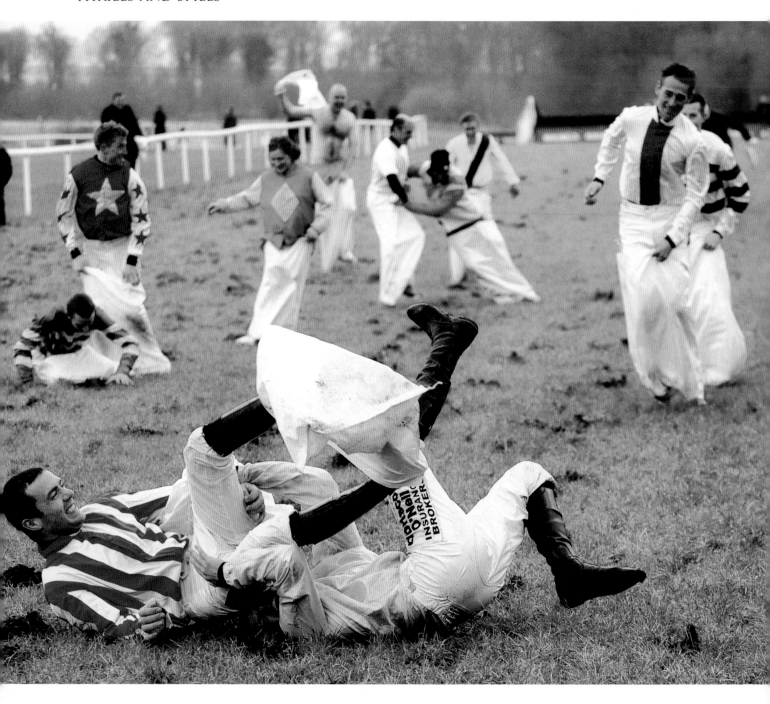

Paul Townend (pink silks) tackles Brian O'Connell (blue and white stripes) after they have crossed the winning line in the Injured Jockeys' Fund Sack Race at Gowran Park, with the field strung out behind them. The stewards held a post-race inquiry into possible interference inside the final furlong, but no action was taken.

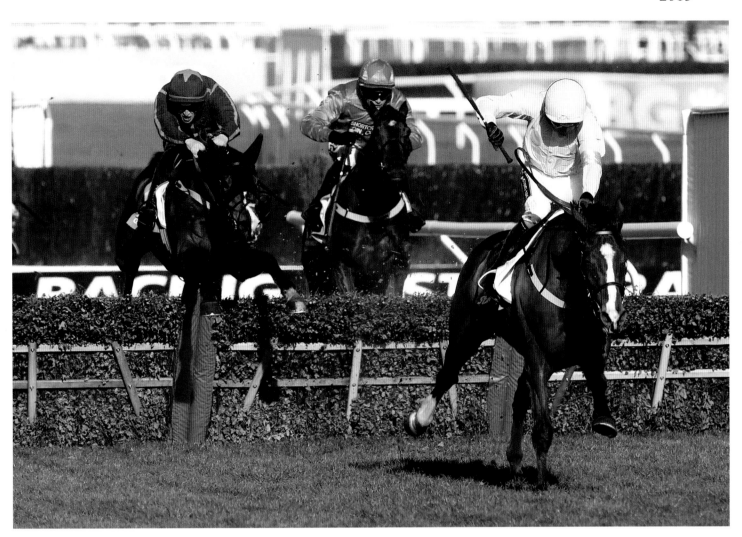

Faugheen and Ruby Walsh land over the final flight on their way to victory in the Champion Hurdle at Cheltenham. His stable companions *Arctic Fire* (left) with Danny Mullins and *Hurricane Fly* (centre) with Paul Townend chased him home, thereby completing a 1-2-3 in the Champion Hurdle for champion trainer Willie Mullins.

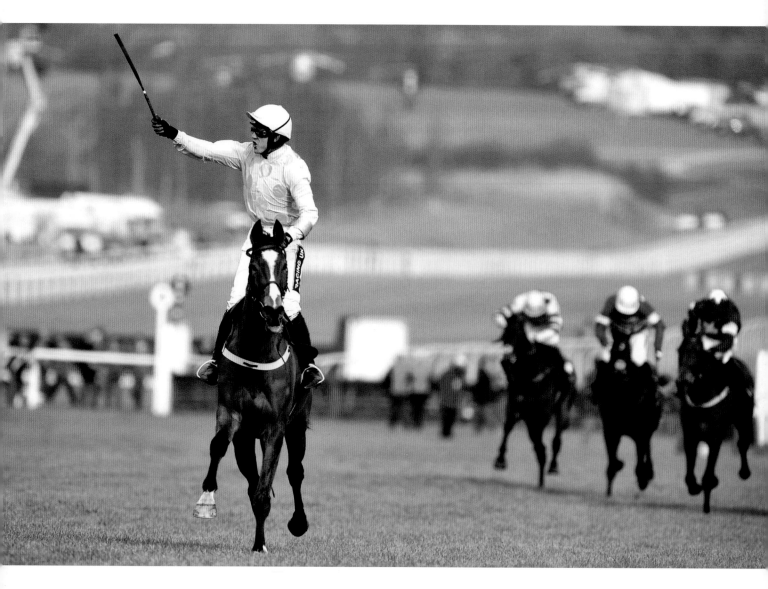

Ruby Walsh salutes the crowd and *Vautour* pricks his ears as the pair of them come home fifteen lengths clear of their rivals in the JLT Novice Chase at Cheltenham for trainer Willie Mullins.

Opposite: *Annie Power* and Ruby Walsh crash through the final flight and come down, with the Mares' Hurdle at Cheltenham at their mercy, leaving *Glens Melody* and Paul Townend (yellow silks, black chevrons) to claim victory.

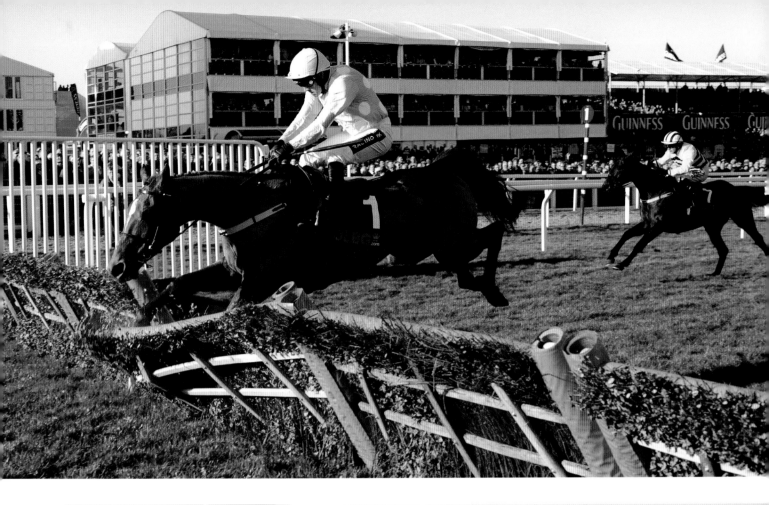

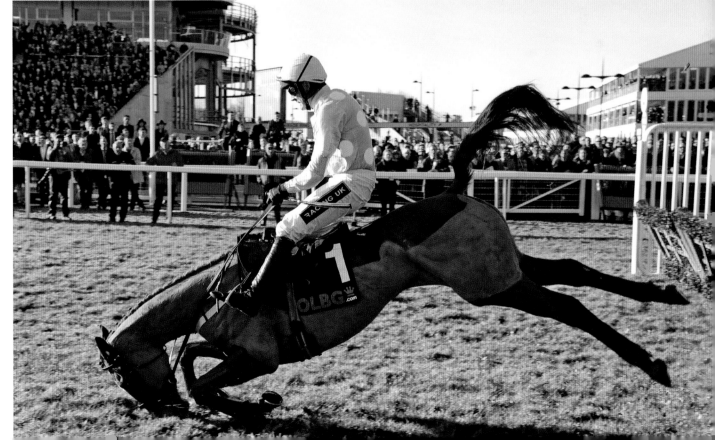

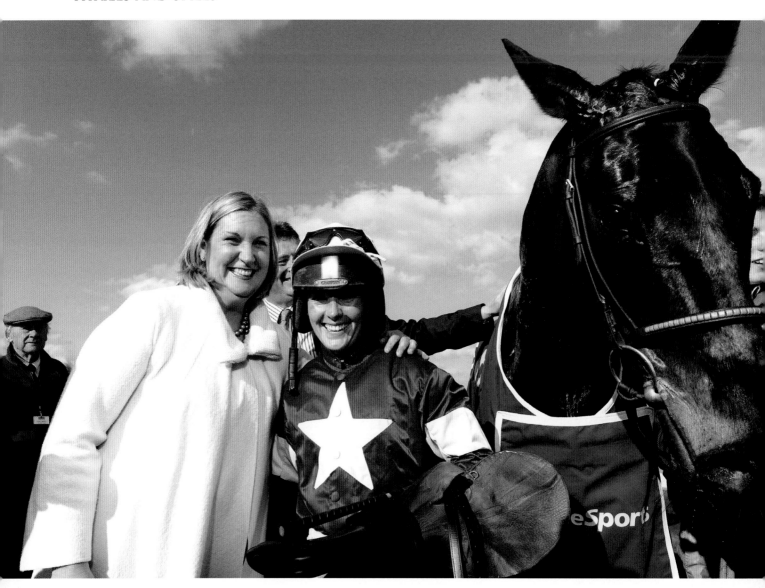

Thunder And Roses with trainer Sandra Hughes
and jockey Katie Walsh after they have won
the Irish Grand National.

Opposite: Delight on Nina Carberry's face
after she has guided *On The Fringe* over the
Aintree fences and on to victory in the Fox
Hunters' Chase.

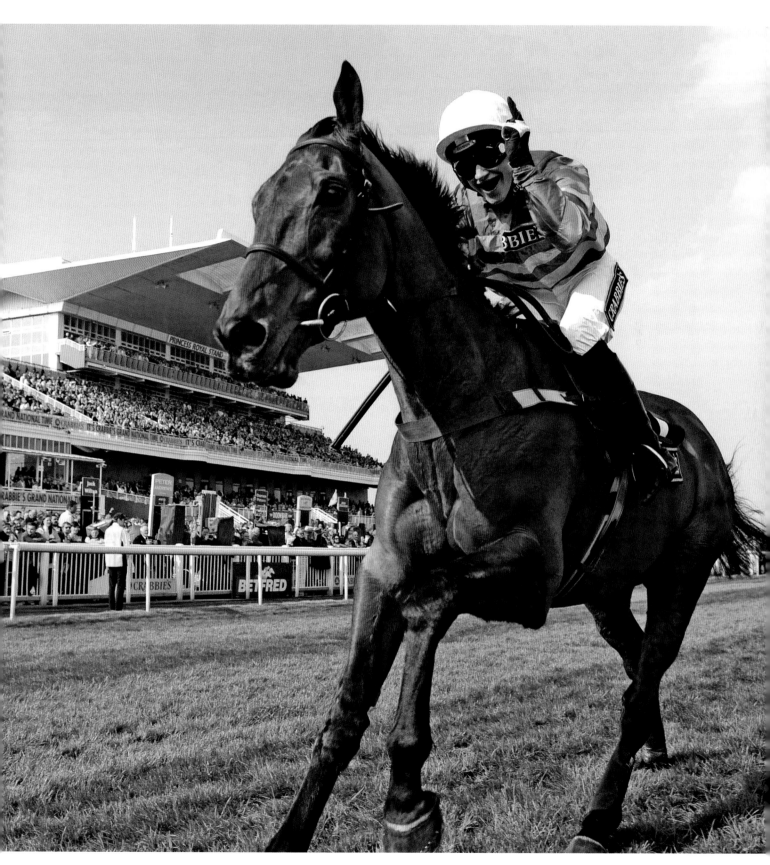

Gordon Elliott plants a kiss on Paul Carberry's cheek after the pair of them have teamed up with *Don Cossack* to land the Punchestown Gold Cup.

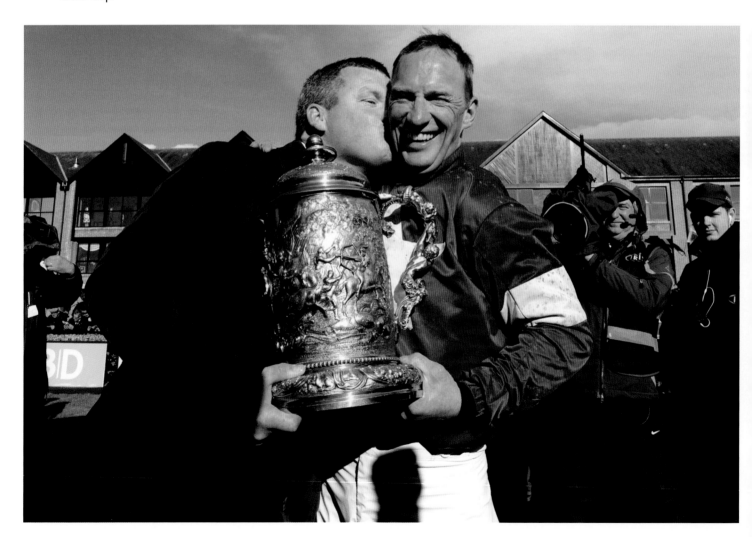

100

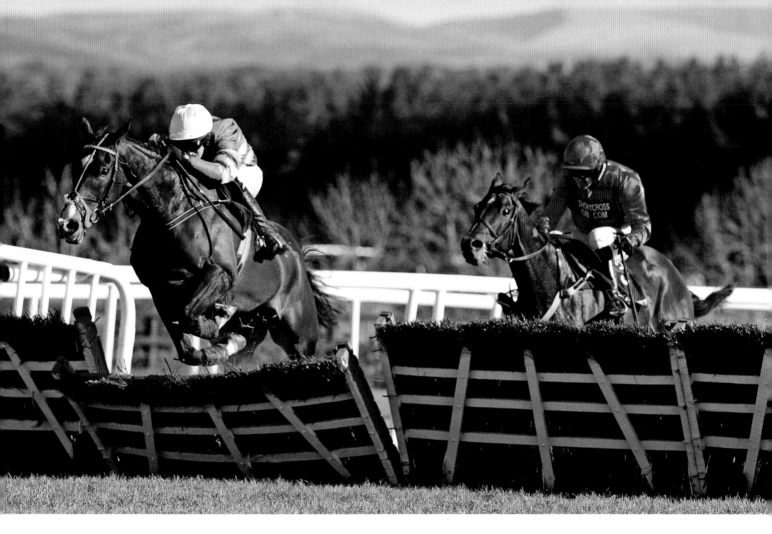

Jezki and Mark Walsh jump the final flight just in front of *Hurricane Fly* and Ruby Walsh before going on to win the World Series Hurdle at Punchestown, at the end of a thrilling encounter between the two former Champion Hurdlers, both of them racing over three miles for the first time.

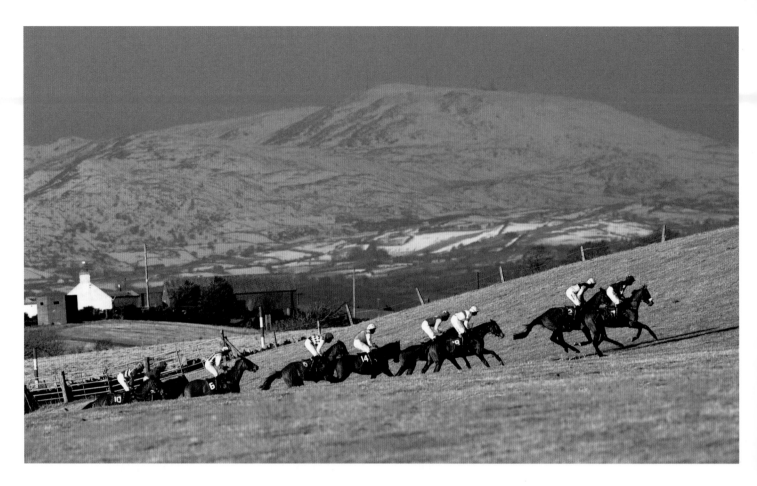

Climbing the hill at Tyrella point-to-point in County Down.

Opposite: Horsemen line up
beneath the castle at Galway.

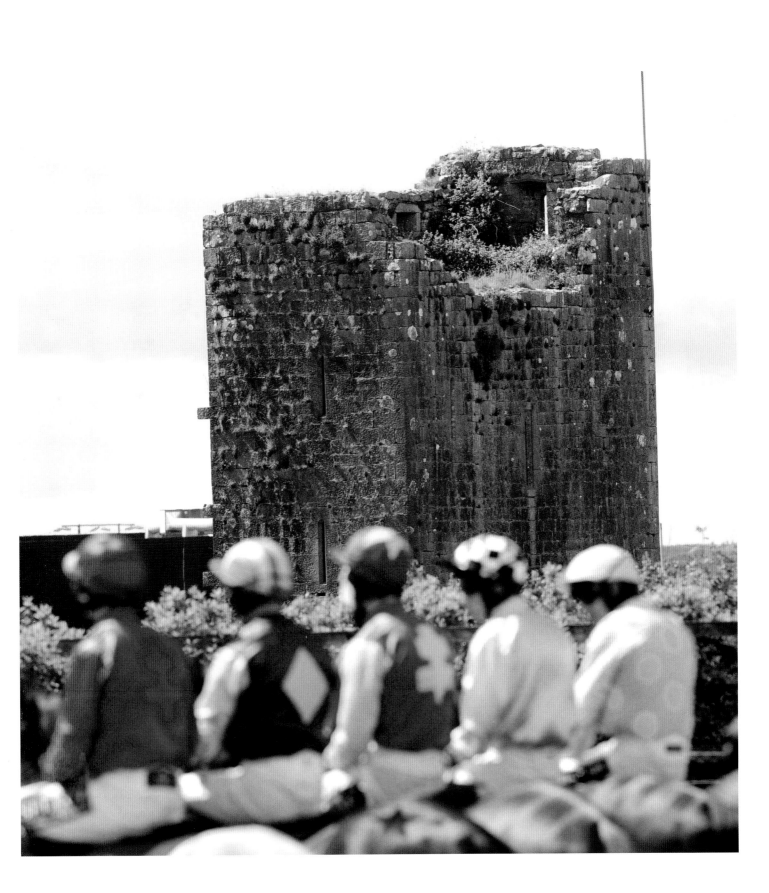

Thomas Edison and Barry Geraghty come down at the final flight in the Galway Hurdle, leaving fellow Tony Martin-trained runner *Quick Jack* and Denis O'Regan (yellow sleeves, white cap) to coast to victory.

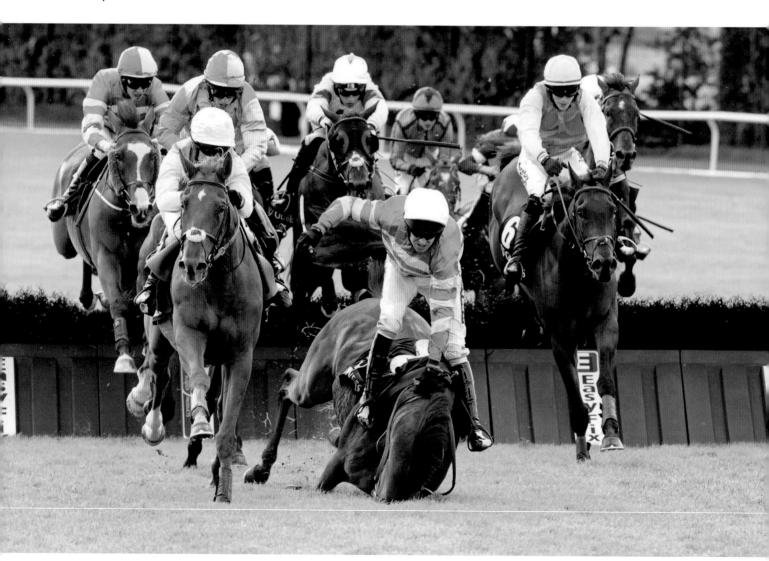

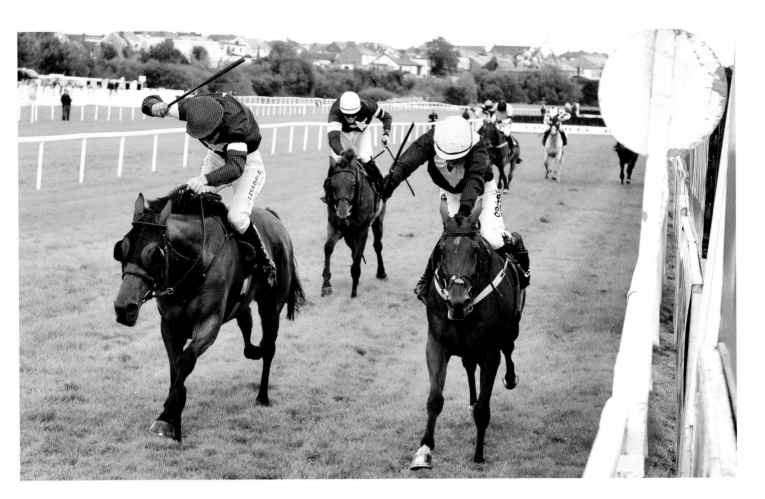

Rogue Angel and Ger Fox (left) just get up to beat *Urano* and Paul Townend by a short head in the Kerry National at Listowel.

Right: James and Eddie Jones, sons of owner Sean Jones, and wearing their dad's silks, walk the track at Galway.

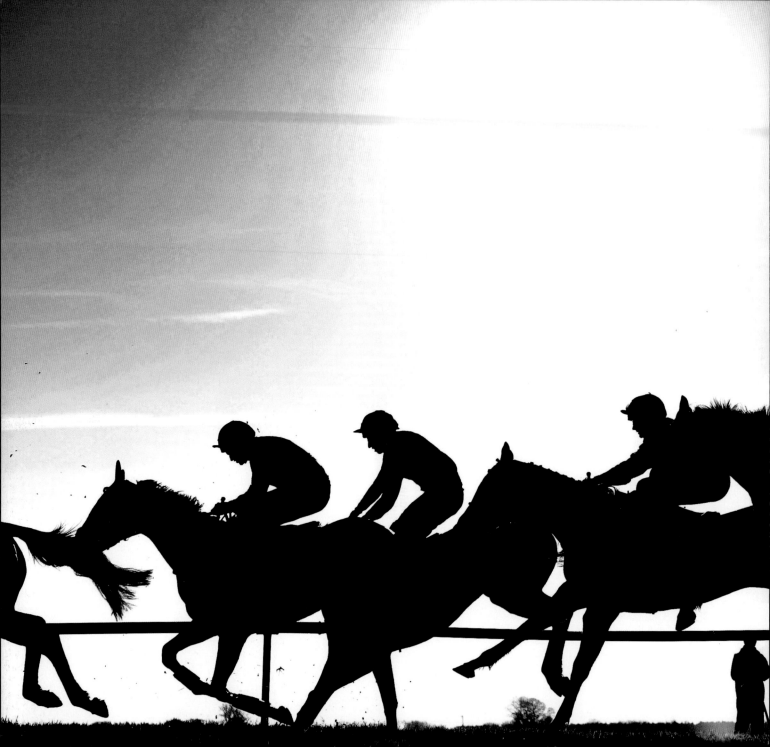

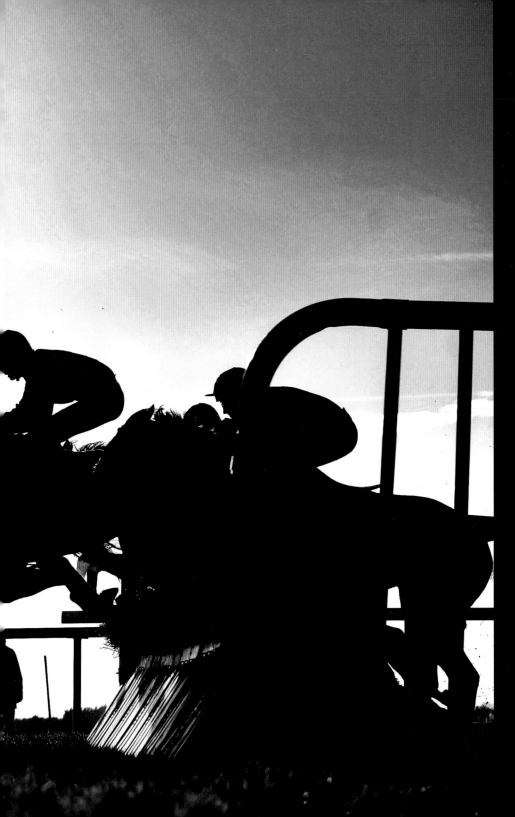

2016

Silhouettes in flight at
Fairyhouse.

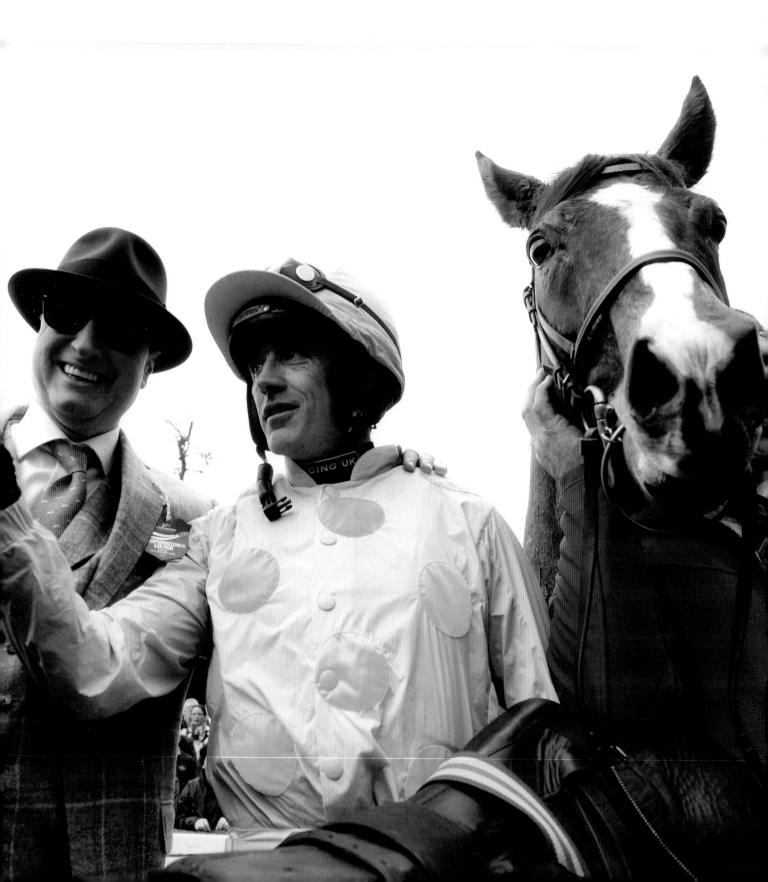

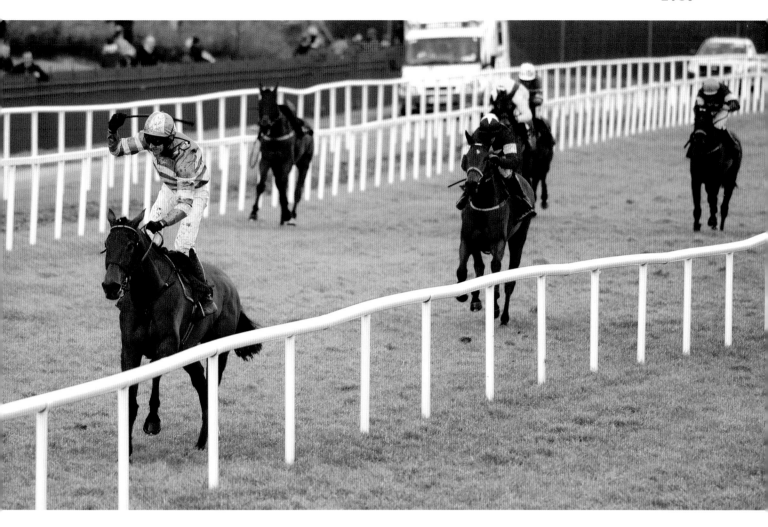

Mark Walsh punches the air after he has guided
Carlingford Lough to victory in a second Irish
Gold Cup.

Opposite: Owner Rich Ricci with rider Ruby
Walsh and *Faugheen* in the winner's enclosure at
Leopardstown after the Irish Champion Hurdle.

Same time, same place, different outcome: Twelve months after their fall in the Mares' Hurdle at Cheltenham, *Annie Power* and Ruby Walsh fly the final flight this time on their way to a famous victory in the Champion Hurdle.

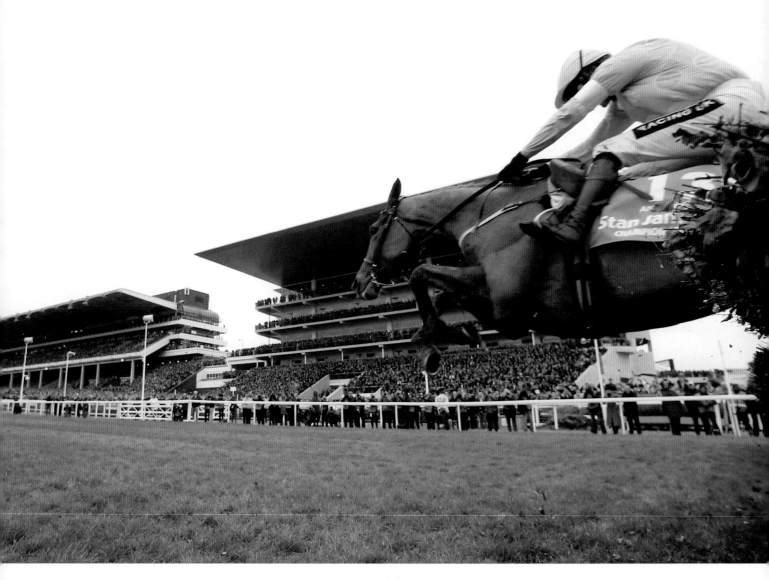

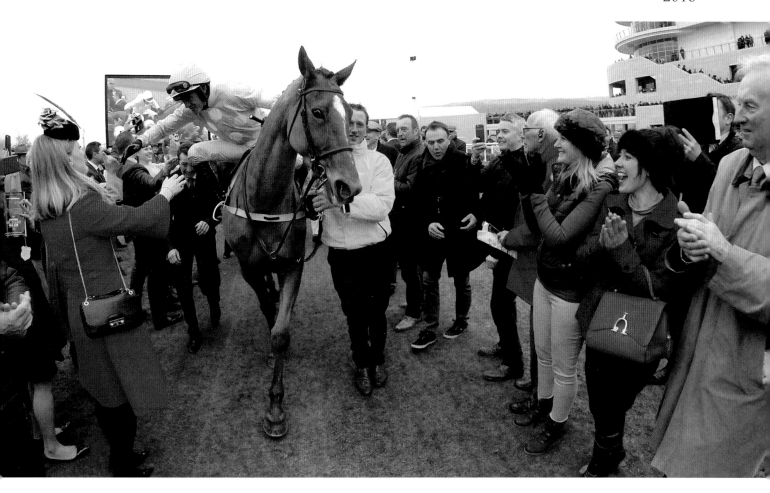

Ruby Walsh about to embrace his wife Gillian
(red coat) as he and *Annie Power* return to
Cheltenham's winner's enclosure.

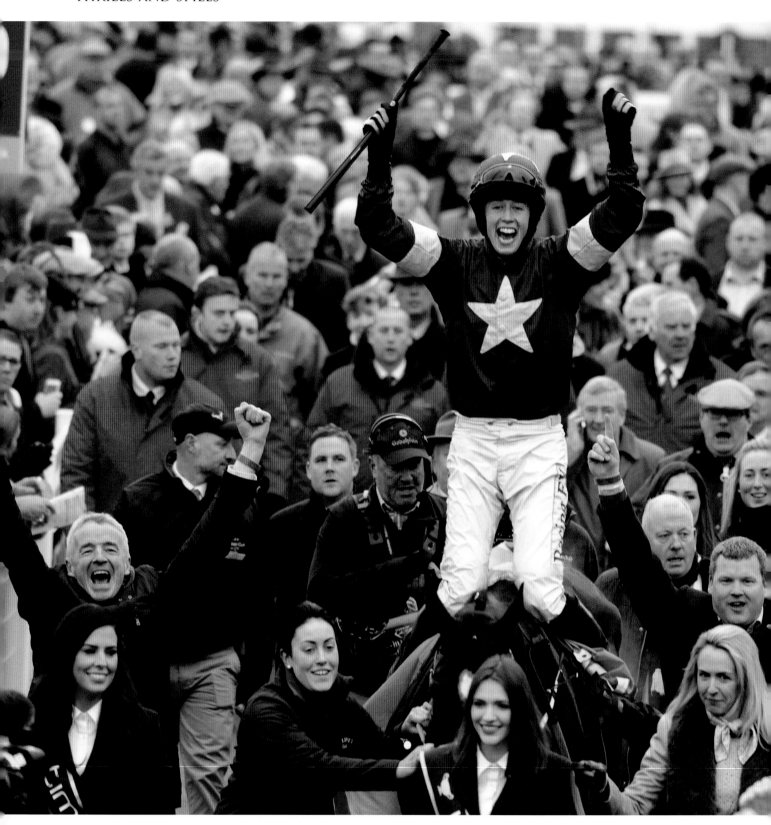

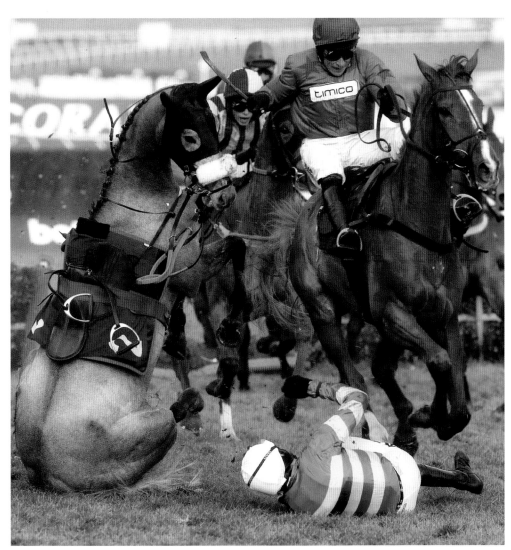

Campeador and Barry Geraghty take a tumble at the final flight when challenging for the lead in the Fred Winter Hurdle, as *Kasakh Noir* and Harry Skelton take evasive action.

Opposite: Bryan Cooper stands tall as he and *Don Cossack* return to the winner's enclosure after winning the Cheltenham Gold Cup for owner Michael O'Leary (left, arms raised) and trainer Gordon Elliott (right, arms raised).

THRILLS AND SPILLS

Rogue Angel and Ger Fox (left) battle on bravely to get home by a short head from *Bless The Wings* and Ruby Walsh (centre) in the Irish Grand National, with *Ballyadam Approach* and David Splaine finishing third. This victory was the first leg of a remarkable Grand National double for owners Gigginstown House and trainer Mouse Morris.

Opposite: Mouse Morris and son Jamie embrace after *Rule The World's* emotional victory in the Aintree Grand National. It was less than a year since Mouse's son and Jamie's brother Christopher (Tiffer) had passed away.

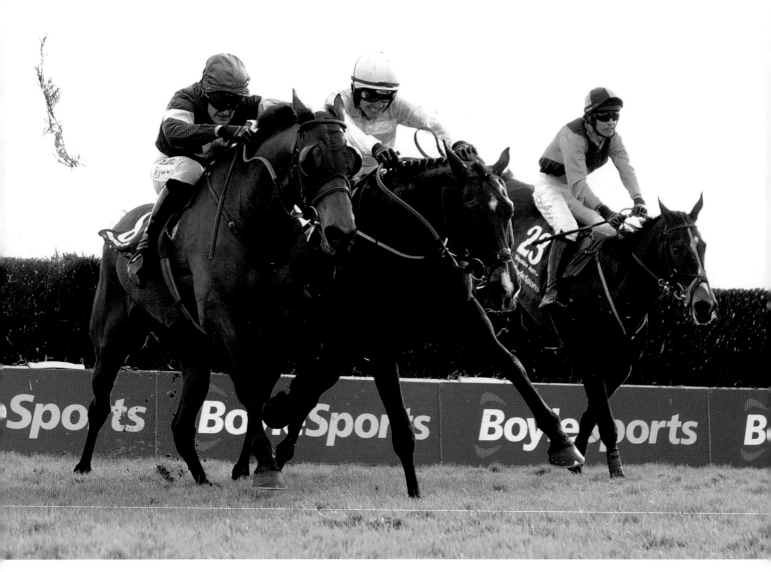

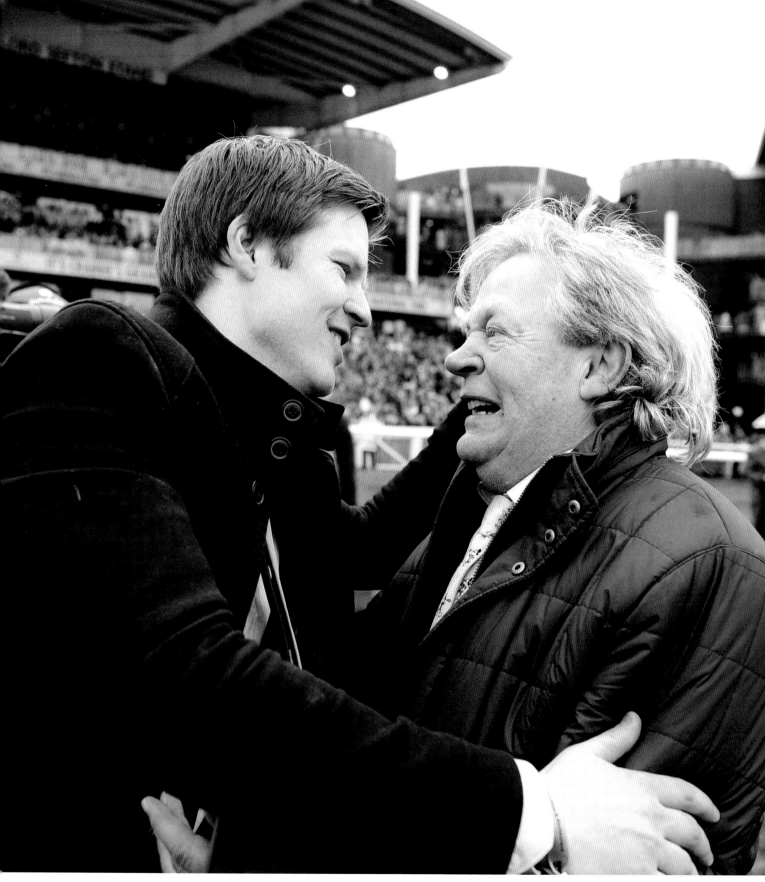

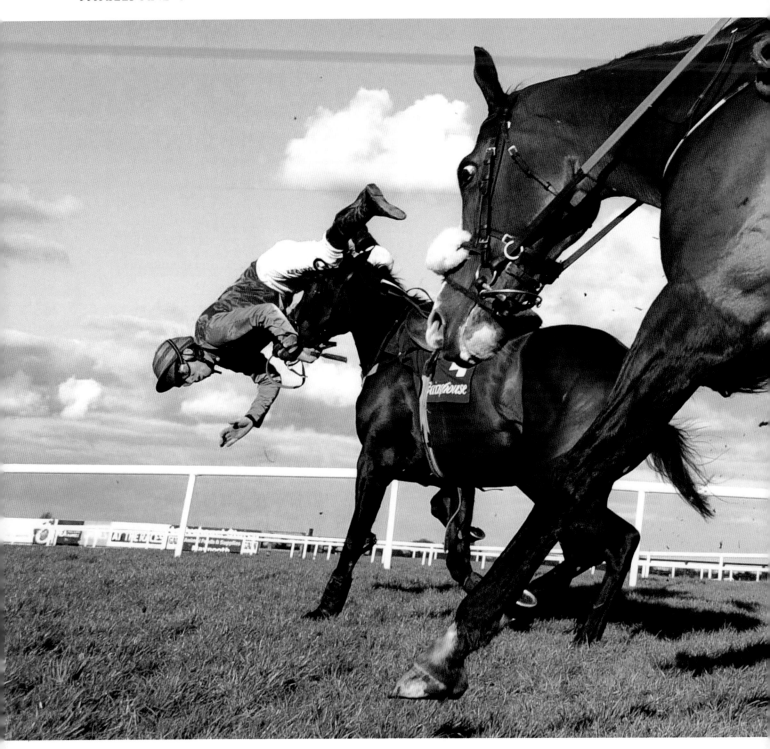

Opposite: *Missyspet* gets in tight to the final fence in the Mares' Beginners' Chase and unseats Andrew Lynch, leaving *Kara Loca* (far side, almost completely obscured) and Jonathan Burke clear to record an easy victory.

Michael and Anita O'Leary steal a kiss as David Mullins looks on and *Rule The World* looks away after their victory in the Aintree Grand National.

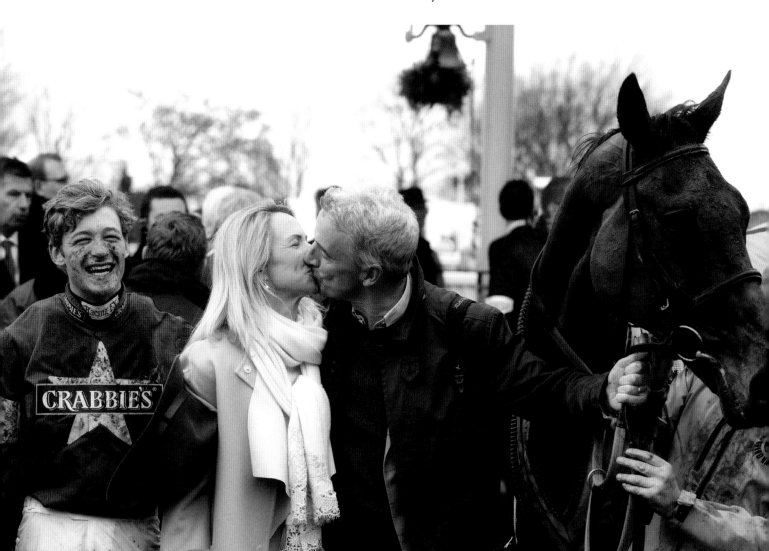

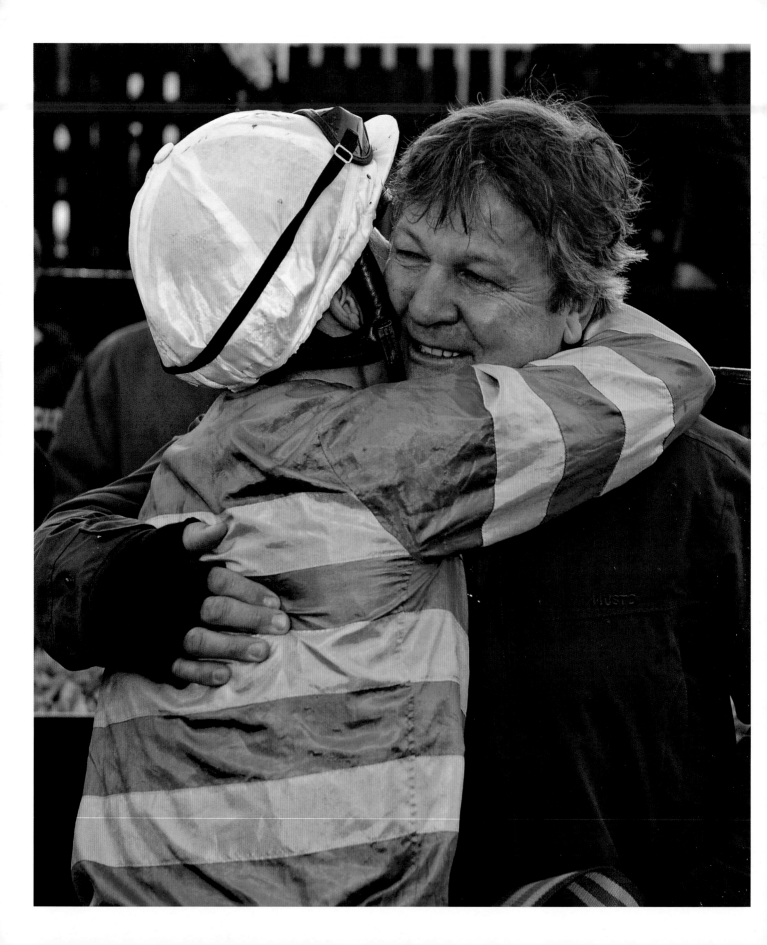

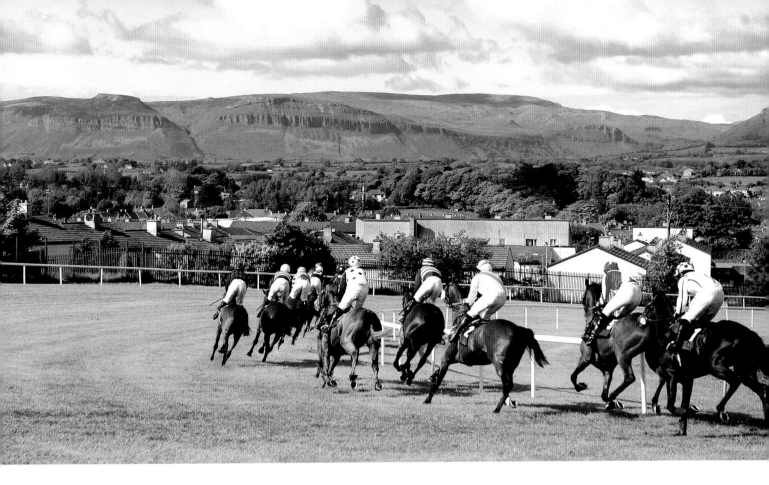

'Horseman, pass by!' WB Yeats
Runners sweep around the bend at Sligo under Ben Bulben.

Opposite: Trainer Enda Bolger and jockey Nina Carberry embrace after *On The Fringe's* victory in the Champion Hunters Chase at Punchestown, thereby completing the Cheltenham/Aintree/Punchestown hunters' chase treble for the second year running.

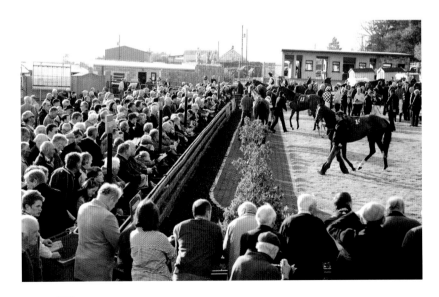

Packed deep around the parade ring at Roscommon.

Down the back straight, surrounded by gorse at Down Royal.

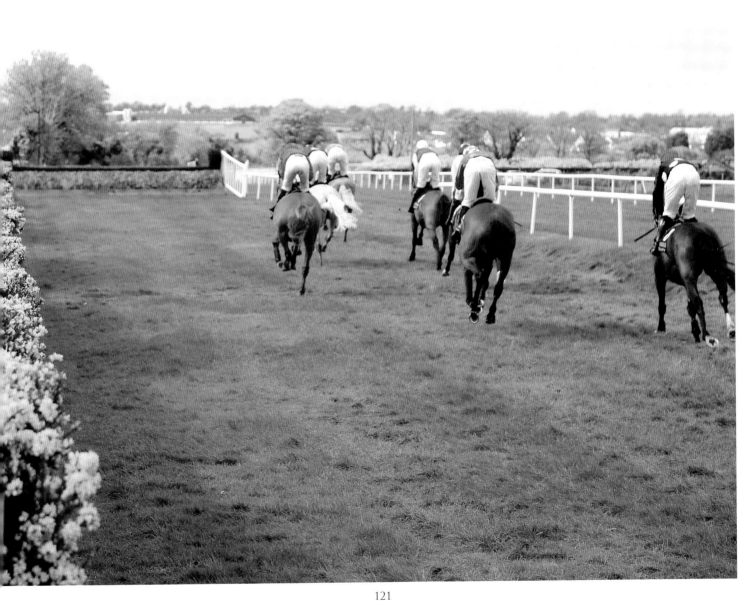

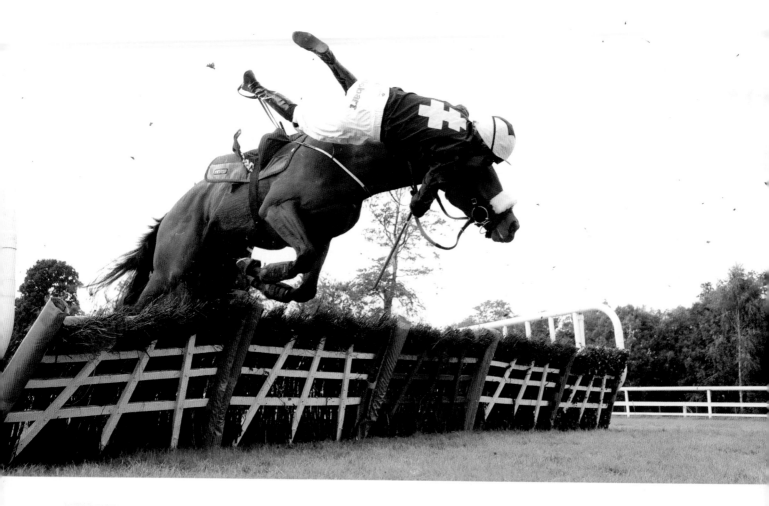
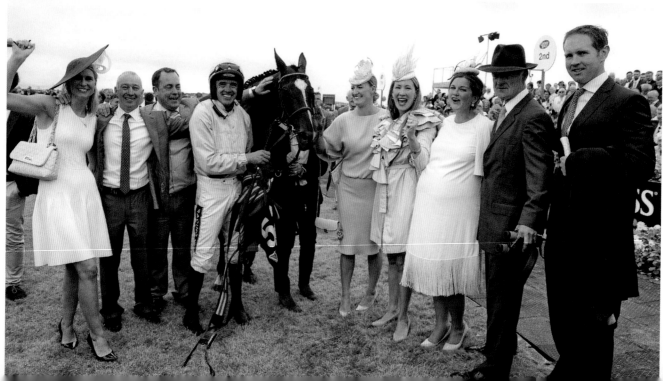

Opposite top: *Zanjabeel* and Mikey Fogarty part company spectacularly at the third flight in a three-year-olds' hurdle at Gowran Park. Neither horse nor rider held a grudge though, as they teamed up again eleven days later and won a maiden hurdle at Punchestown at 20/1.

Opposite bottom: Members of the Act D Wagg Syndicate celebrate in the winner's enclosure with trainer Willie Mullins and jockey Ruby Walsh after their horse, *Clondaw Warrior*, has won the Galway Hurdle. From left to right: Áine Casey, David Casey, Michael Gannon, Ruby Walsh, Gillian Walsh, Tamso Doyle, Aisling Gannon, Willie Mullins and David Cox.

Below: *Tiger Roll* and Donagh Meyler come clear to spring a 20/1 shock in the Munster National at Limerick, leaving Stellar Notion and David Mullins (light blue silks) and *Kylecrue* and Danny Mullins (white cap) in their wake.

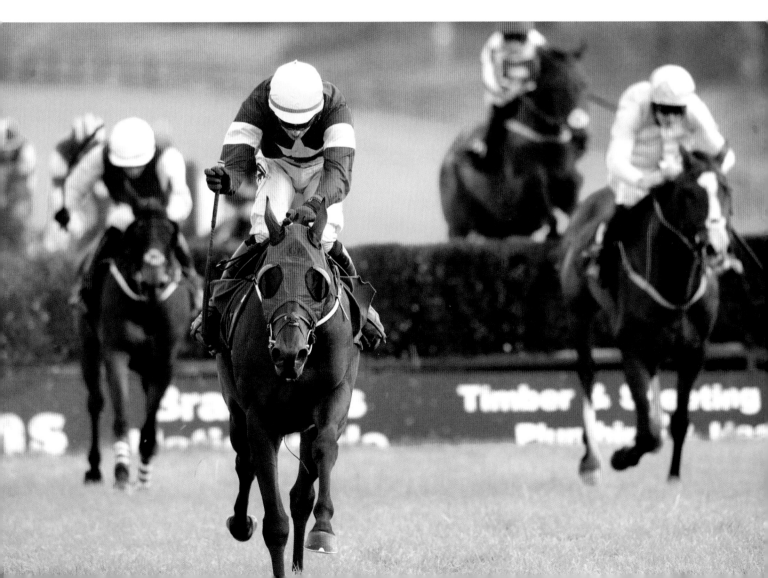

Below: Gordon Elliott (far left) with his team at Navan after Jamie Codd (maroon and white silks) has guided *Three Swallowsnick* to victory in the final race of the day, the mares' bumper, a sixth win for Team Elliott on the day.

Opposite top: Davy Russell, Mary Nugent and *Noble Endeavor* are all smiles after they have won the Paddy Power Chase at Leopardstown.

Opposite bottom: Michael O'Leary and Jack Kennedy take a moment in Leopardstown's winner's enclosure after the rider has recorded the first Grade 1 win of his career on the owner's horse *Outlander* in the Lexus Chase.

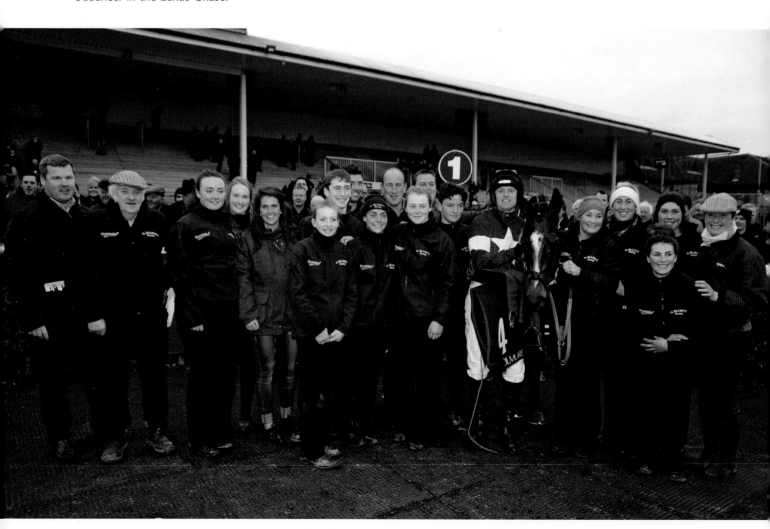

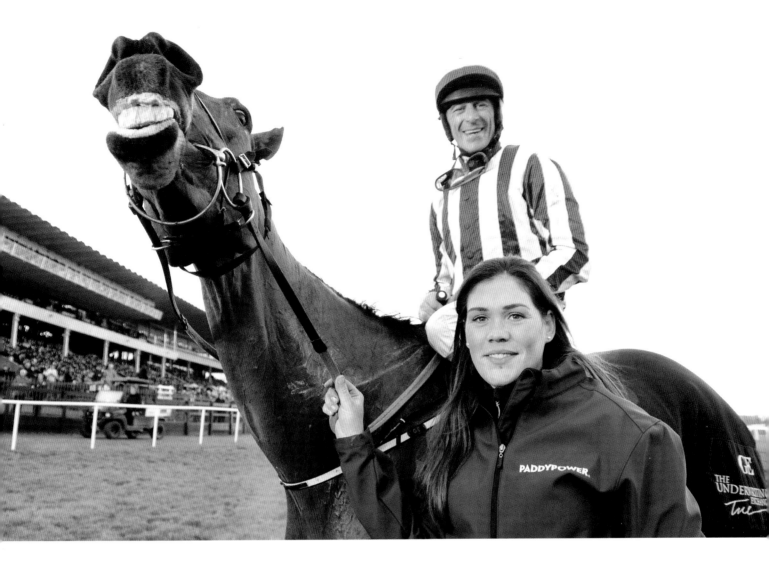

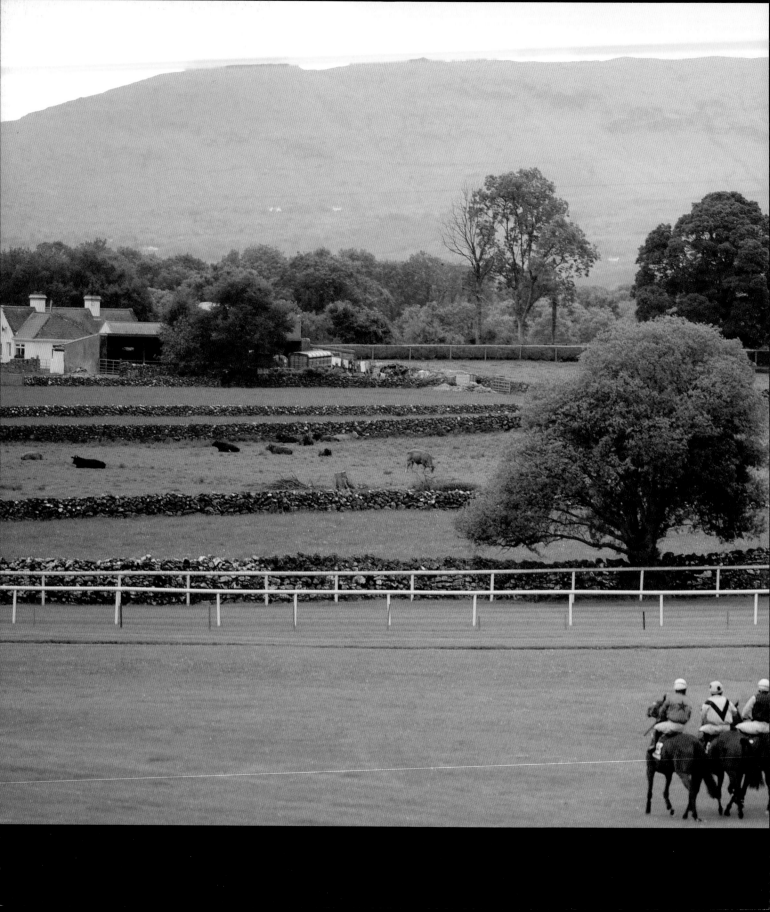

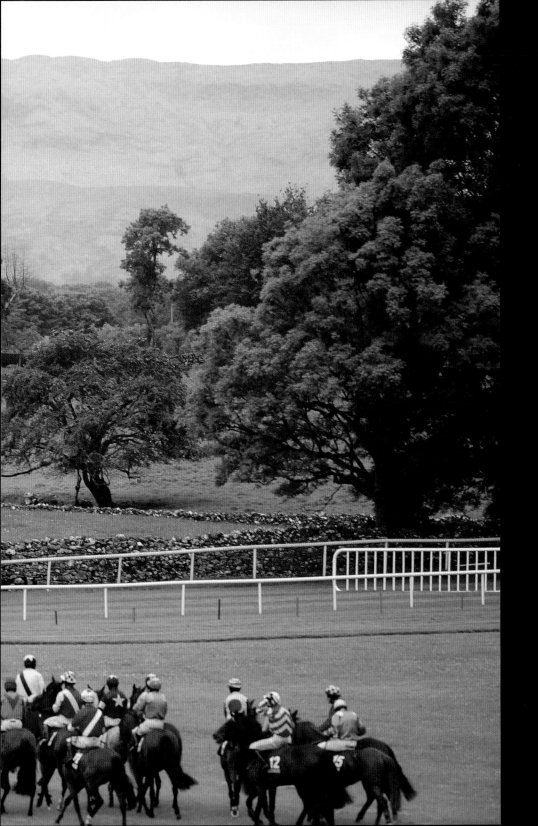

2017

Getting ready to race at Ballinrobe, County Mayo.

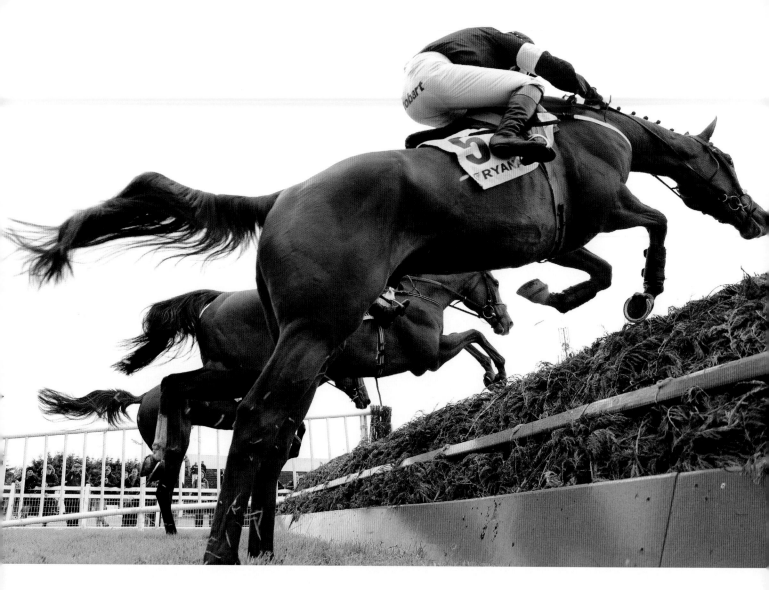

Three in a line jumping the final fence on the first circuit in the Ryanair Gold Cup at Fairyhouse: *Yorkhill* and Ruby Walsh (far side), *Attribution* and David Mullins (centre) and *Road To Respect* and Bryan Cooper (nearest camera), who ultimately prevailed, getting the better of *Yorkhill* in a thrilling finish.

Robbie Power (red cap) accepts the congratulations from the
Gigginstown House Stud riders, David Mullins (maroon cap, *Don
Poli*), Jack Kennedy (white cap, *Empire Of Dirt*) and Sean Flanagan
(blue cap, *Road To Riches*) after he and the Jessica Harrington-trained
Sizing John have won the Irish Gold Cup at Leopardstown.

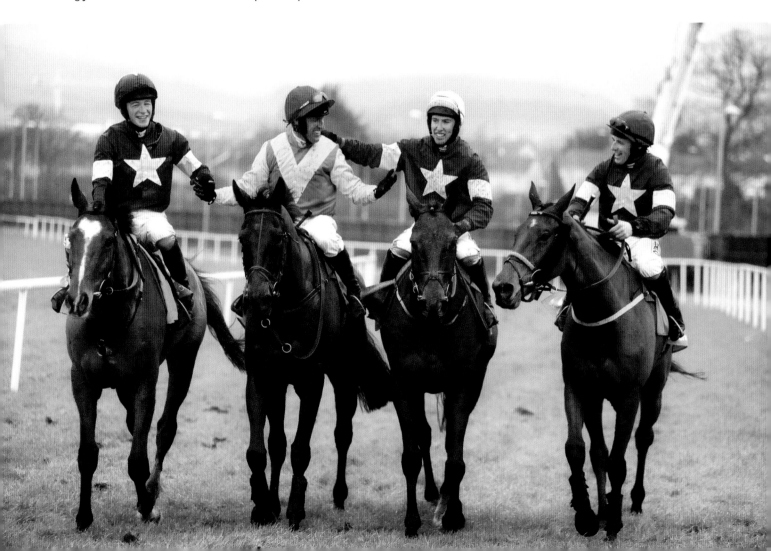

The *Un De Sceaux* team in the Cheltenham winner's enclosure after
the Willie Mullins-trained gelding and Ruby Walsh have landed the
Ryanair Chase, bedecked in the blue and orange colours of owner
Edward O'Connell's silks.

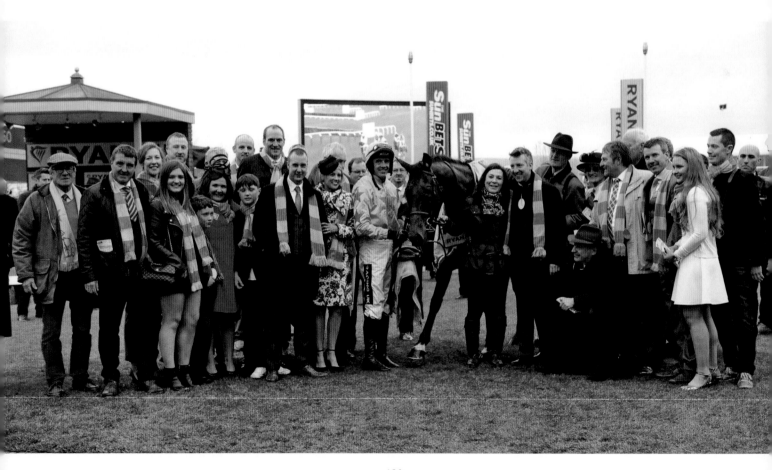

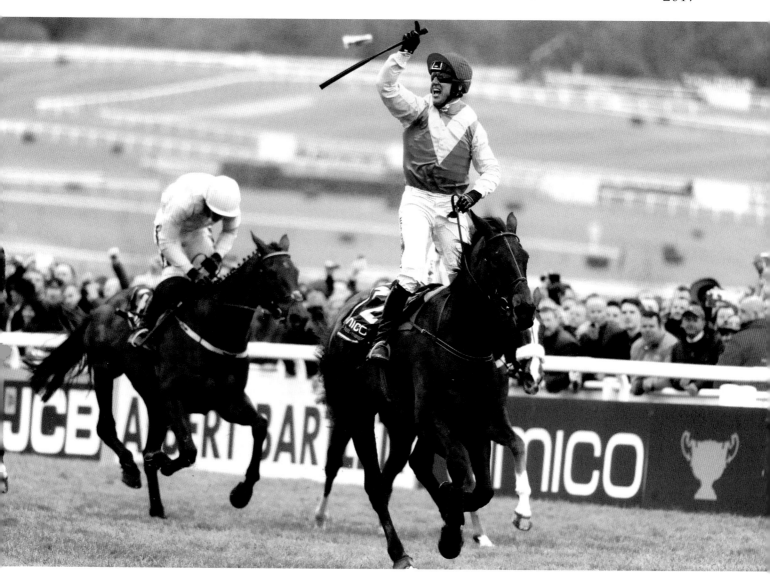

That indescribable feeling: *Sizing John* and Robbie Power win the
Cheltenham Gold Cup.

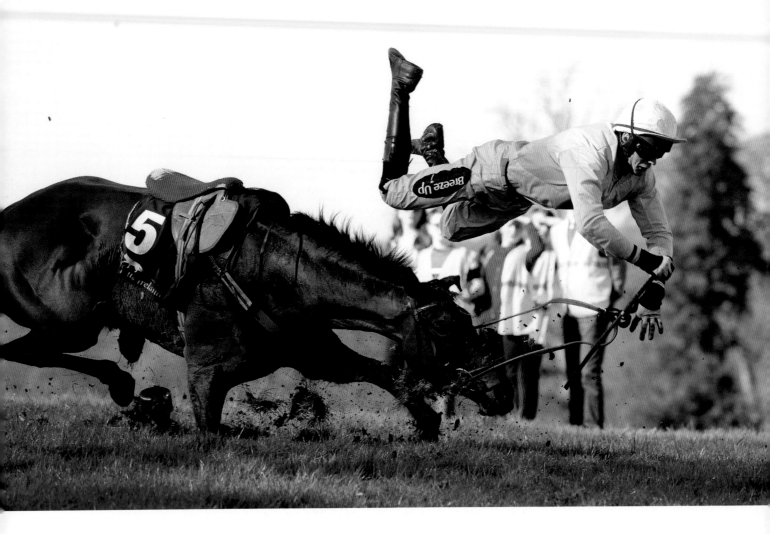

Kayem sends Harley Dunne forward at the final fence when ten
lengths clear at Durrow point-to-point.

Sizing John and Robbie Power soar on their way to victory in the
Punchestown Gold Cup, the Jessica Harrington-trained gelding
following up his Irish Gold Cup and Cheltenham Gold Cup
victories and completing a famous Gold Cup treble.

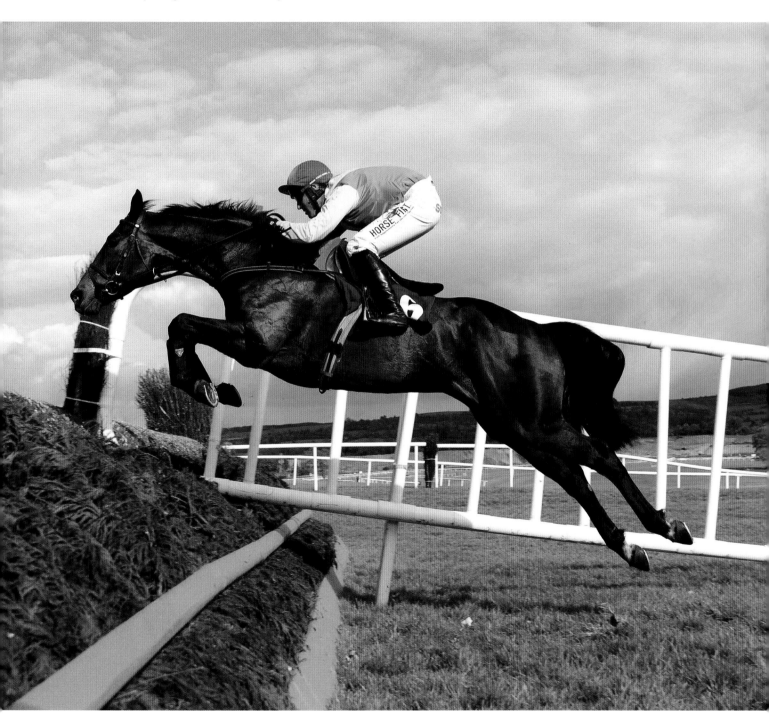

David Mullins makes a valiant attempt to retain his partnership with *Baily Cloud* after the final
fence in the Ryanair Novice Chase at Punchestown.

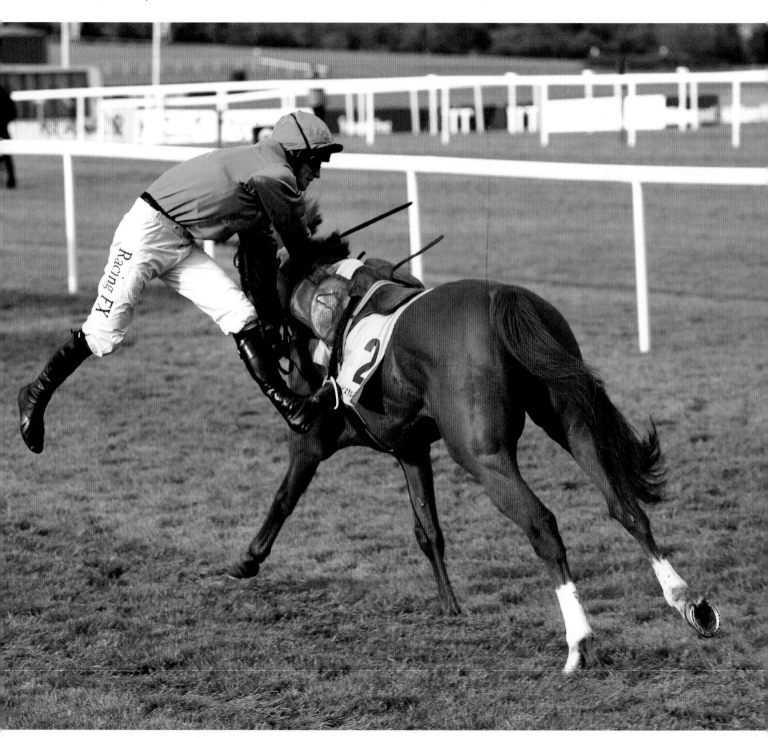

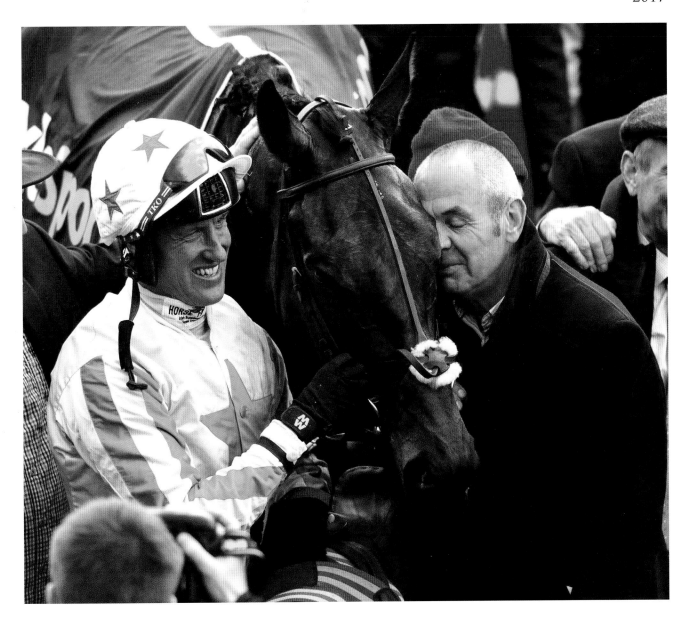

Owner Billy Cooper shows his affection for *Our Duke* in the
winner's enclosure with rider Robbie Power after they have won
the Irish Grand National.

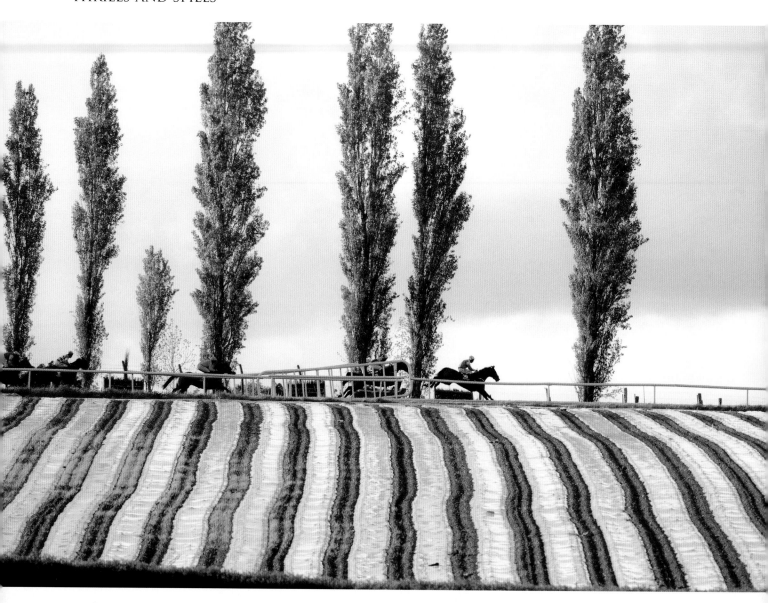

A tree-lined route at Clonmel racecourse in County Tipperary.

Champion jockey Ruby Walsh congratulates Rachael Blackmore on being crowned champion conditional jockey.

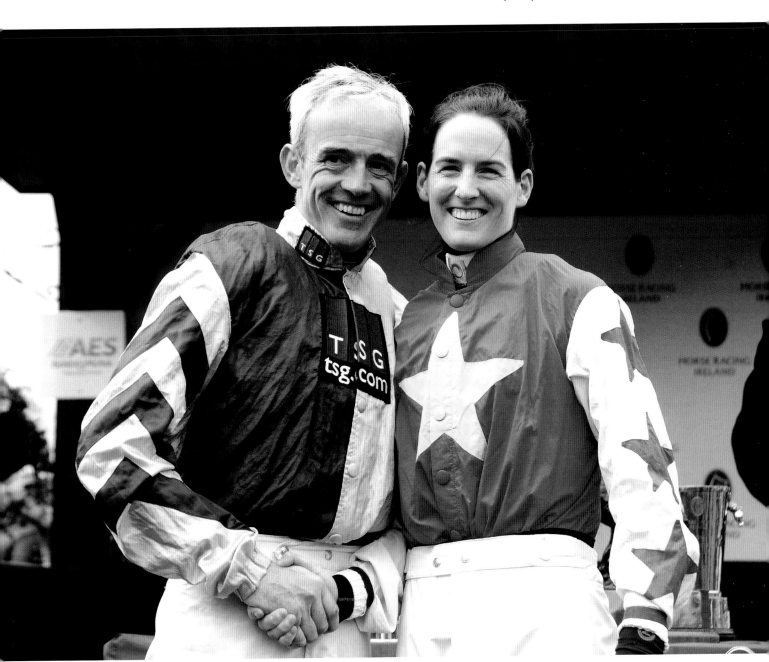

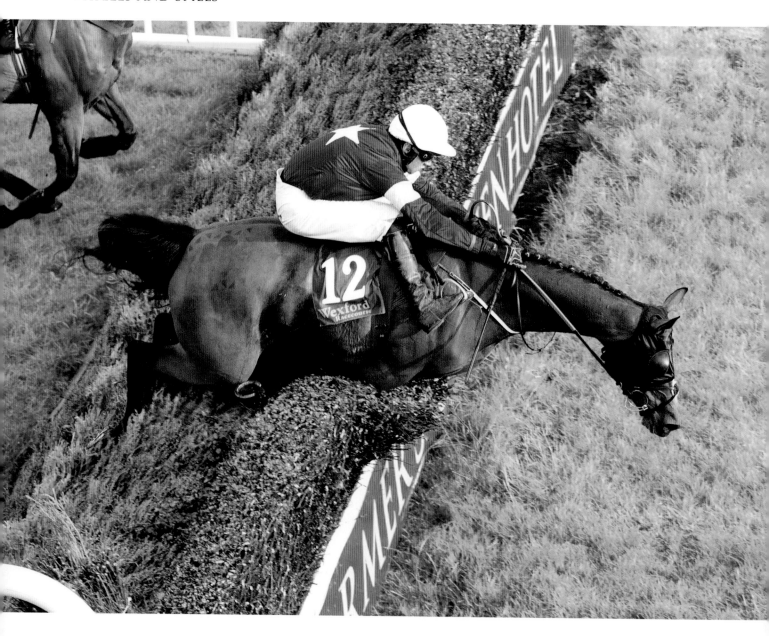

Opposite: *Theatre Wine* and Conor Brassil get in tight and come down in a beginners' chase at Wexford.

Champagne Harmony and Robbie Dunne (yellow sleeves) part company at the second last fence in the Galway Blazers Chase at Galway. *Riviera Sun* and Barry Geraghty (white cap, fourth from left) went on to win the race.

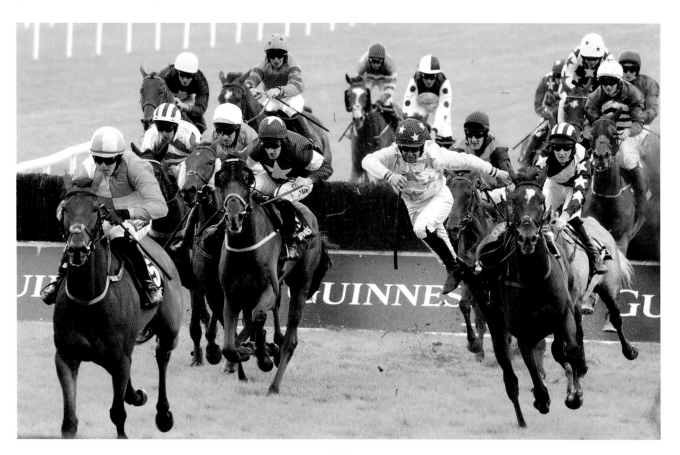

A pat on the back: Owner JP McManus' wife Noreen congratulates jockey Barry Geraghty after he has ridden *Tigris River* to victory in the Galway Hurdle.

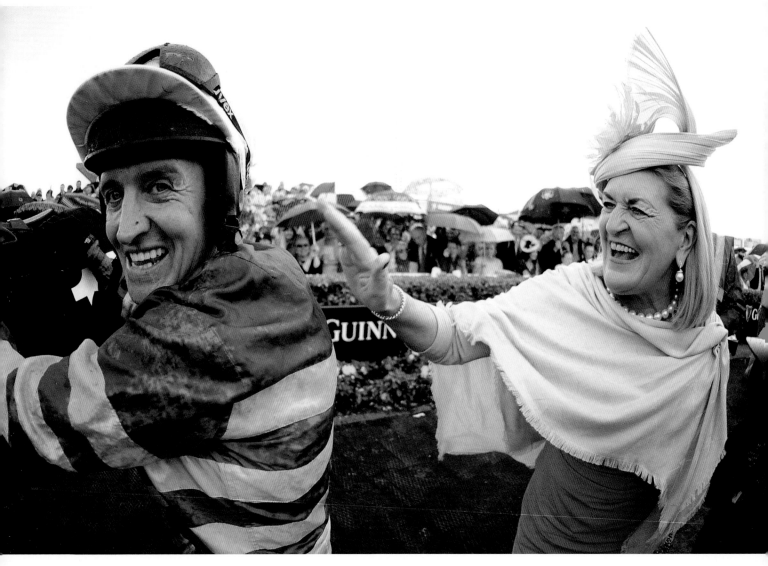

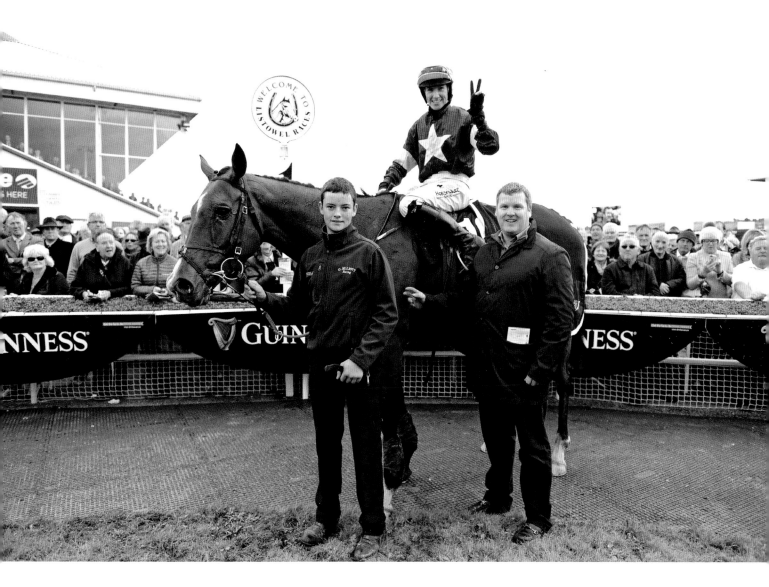

Potters Point with groom Sean Healy, trainer Gordon Elliott and jockey Lisa O'Neill in the winner's enclosure after the Kerry National. It was the second time in a row that trainer and rider had teamed up with owners Gigginstown House Stud to land the Listowel feature.

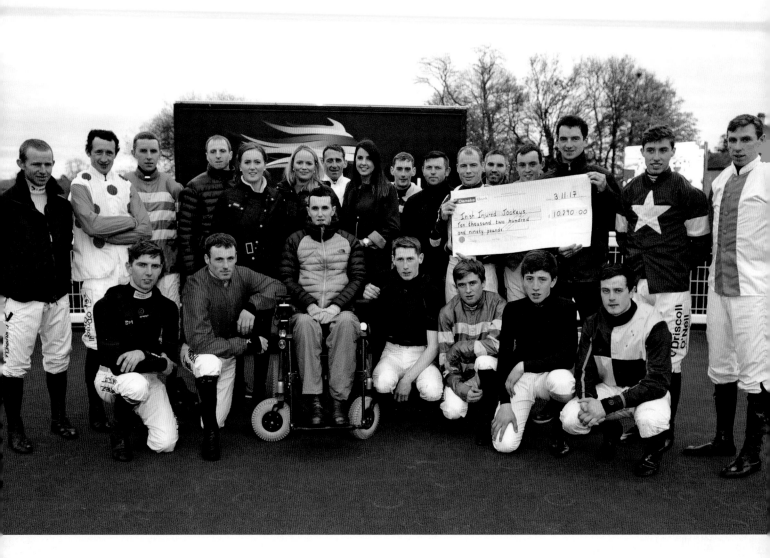

Jonjo Bright makes a presentation of €10,289 to
Irish Injured Jockeys at Down Royal. Jonjo Bright was
paralysed in a fall at Tyrella point-to-point in 2013
when he was nineteen.

Members of the Niccolai Schuster Horse Racing Club celebrate after their horse, *Ellie Mac*, has sprung a 50/1 shock in the maiden hurdle on St Stephen's Day at Leopardstown. It was an emotional victory, coming, as it did, just two years after Niccolai Schuster was one of six Irish students killed in the Berkeley balcony tragedy. 'This is the greatest day of our lives since the tragedy,' said Niccolai's father John. 'My son was a great racing fan.'

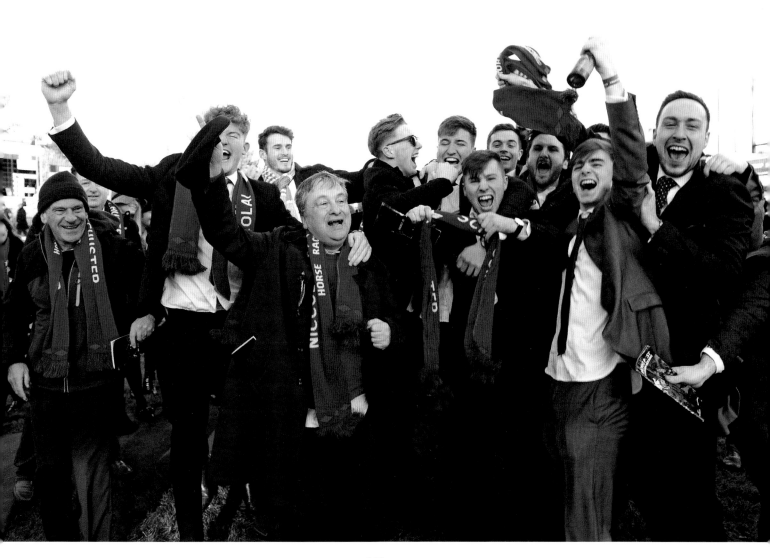

Robbie Colgan tries valiantly to remain on board as *Some Drama* jumps to his right at the final fence in the Porterstown Chase at Fairyhouse. *Presenting Percy* and Davy Russell (not in picture) won the race, with *Forever Gold* and Chris Timmons (yellow cap with green hoops) finishing second, and *He Rock's* and Denis O'Regan (maroon cap with white stars) in third.

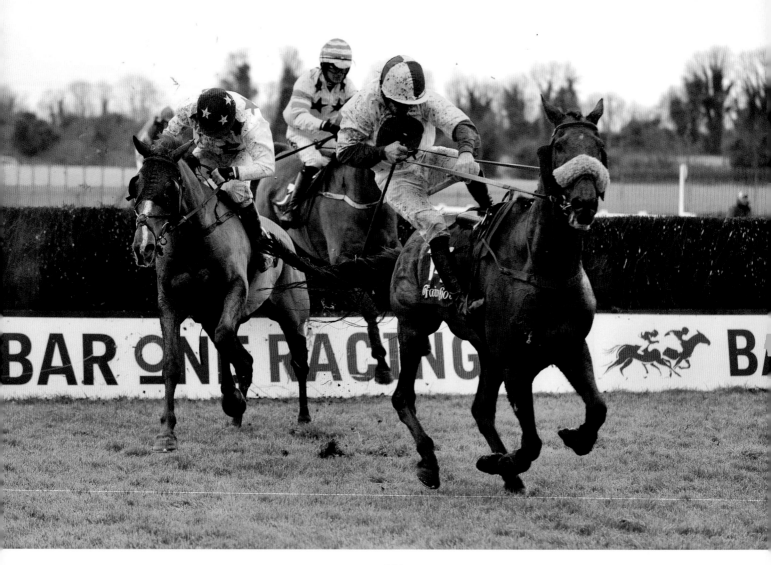

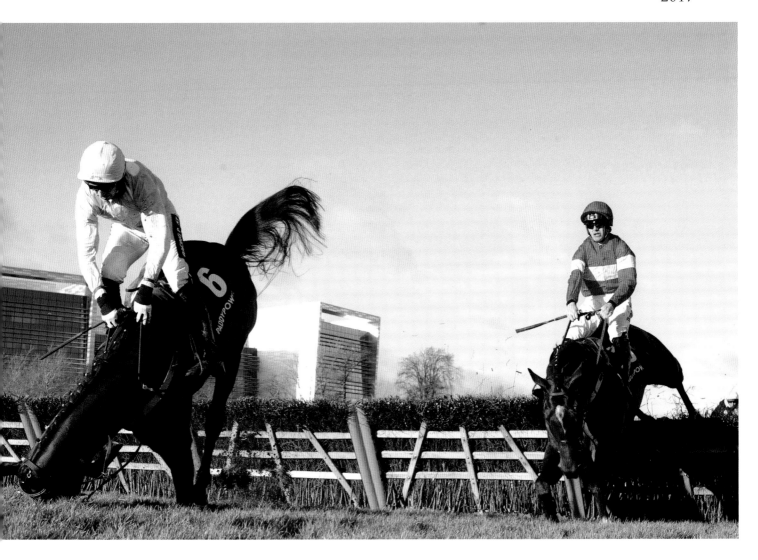

Sharjah (number six) and Patrick Mullins come down at the final flight in the Future Champions Novice Hurdle at Leopardstown when they appeared to have the race in the bag. Stable companion *Real Steel* and Paul Townend (red cap) also came down, which left the way clear for another Willie Mullins-trained horse, *Whiskey Sour*, with David Mullins on board (yellow cap, just in picture) to prevail.

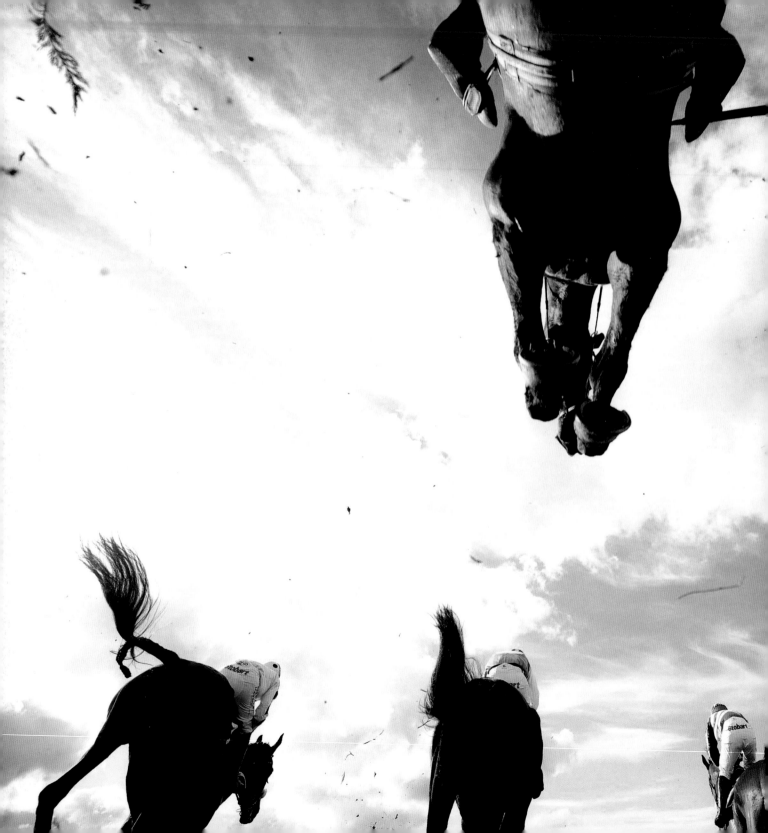

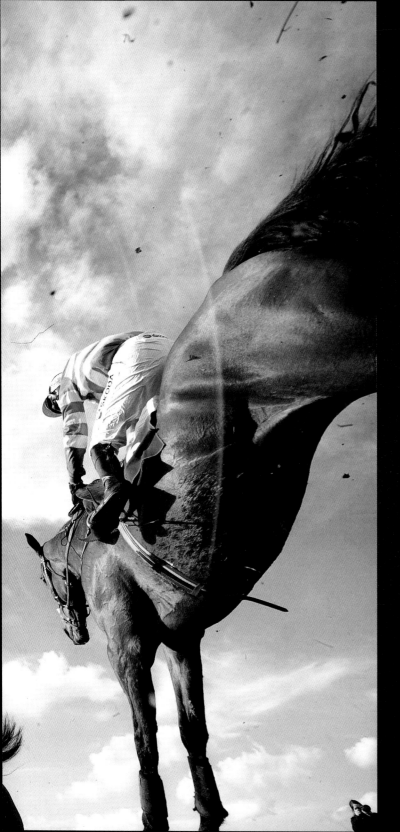

2018

Jumping action from the
Thurles Vintners' Handicap
Chase.

Derek O'Connor (red cap) delivers *Edwulf* with a perfectly-timed challenge to get up and beat *Outlander* and Jack Kennedy, by a head, in the Irish Gold Cup at Leopardstown. It was a fantastic training performance by Joseph O'Brien to get *Edwulf* back to his peak, and a top-class ride by amateur jockey Derek O'Connor, which was voted ride of the year.

Opposite: Paul Townend loses his reins at the final fence at Fairyhouse, but keeps his balance and his partnership with *Kemboy* intact before coasting to victory in his beginners' chase.

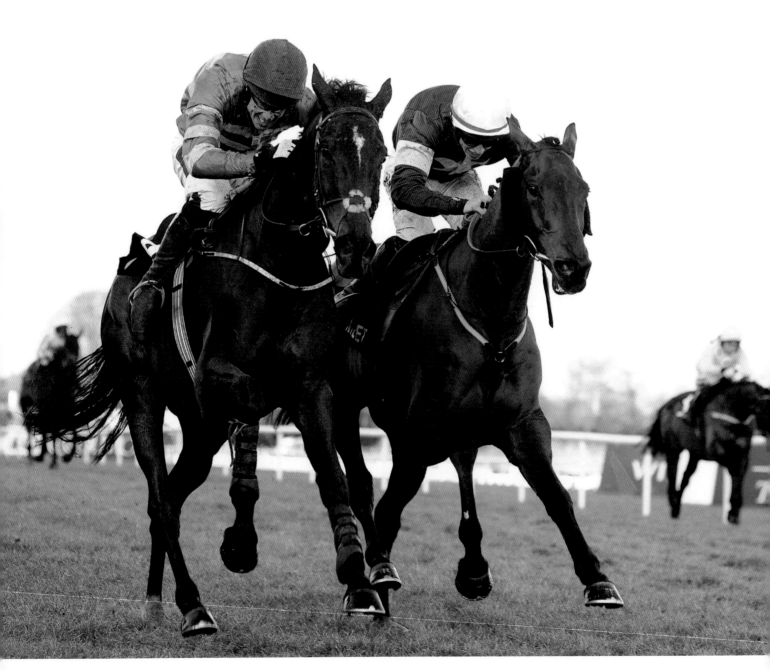

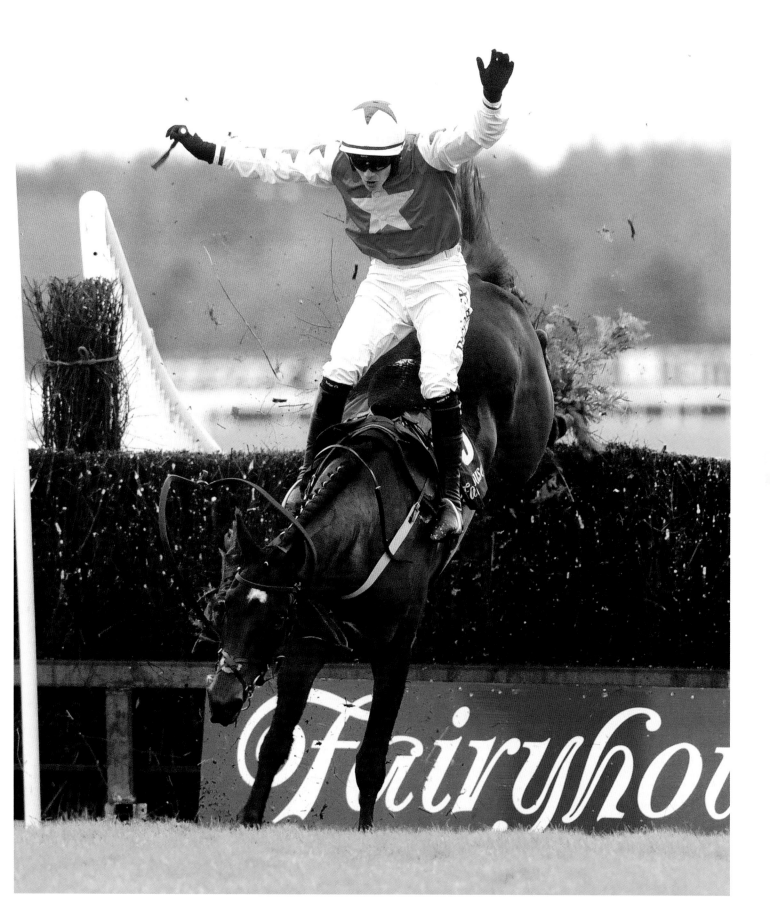

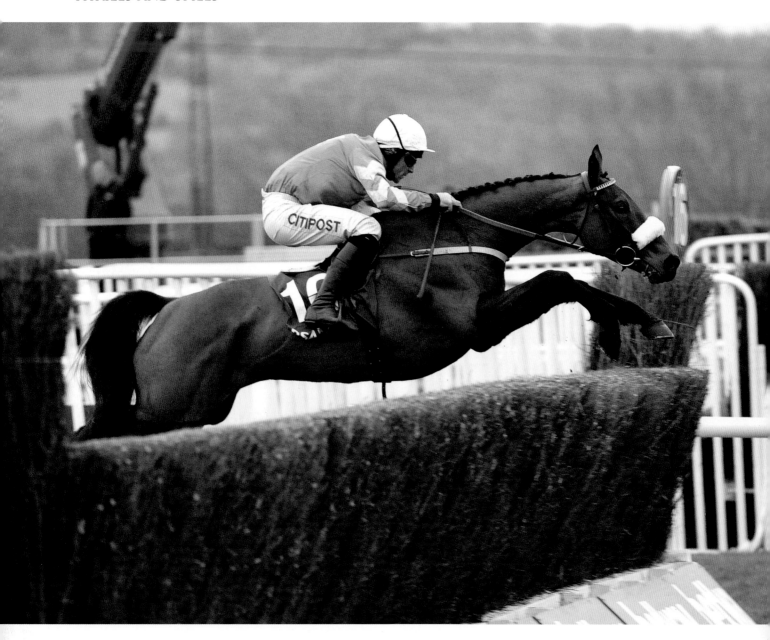

Presenting Percy and Davy Russell in full flight on their
way to victory in the RSA Insurance Novices' Chase at
Cheltenham.

Footpad and Ruby Walsh come home in splendid isolation
in the Arkle Challenge Trophy at Cheltenham.

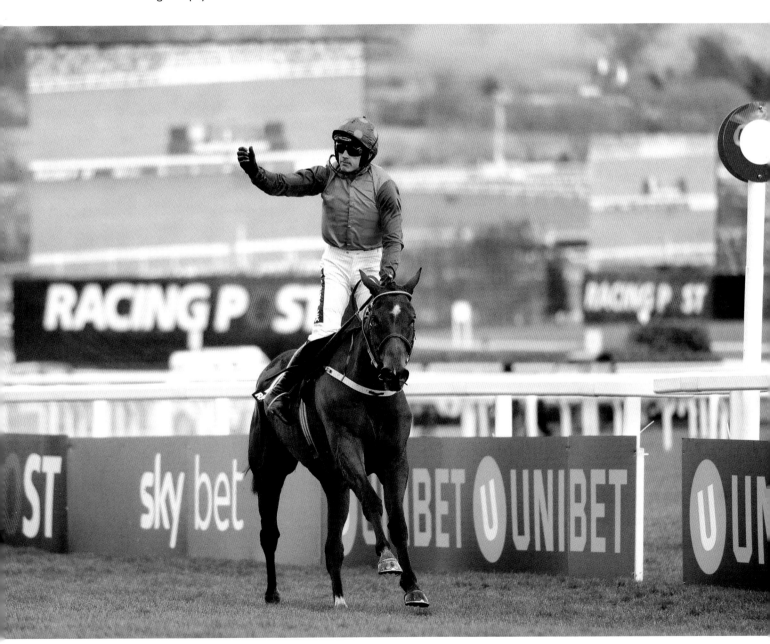

Robbie Power is helpless when he and *Finian's Oscar* are
forced the wrong side of the wing at the final fence in the
Growise Champion Novice Chase at Punchestown, as
Al Boum Photo and Paul Townend crash through the rail,
leaving the way clear for *The Storyteller* and Davy Russell
(just coming into view) to claim a fortuitous victory.

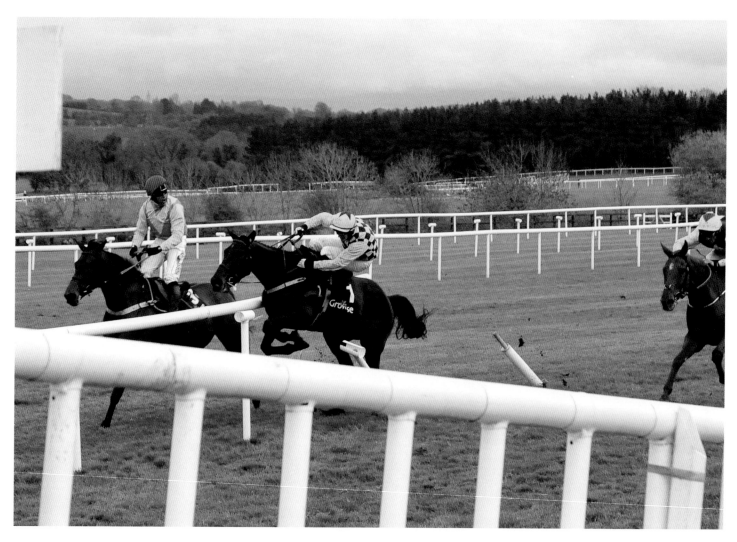

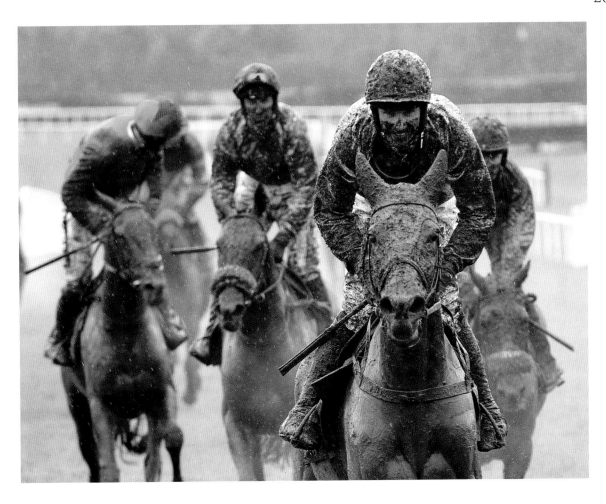

A mud-covered Paul Townend (mud colours, eyes visible) pulls up a mud-covered *Bargy Lady* before the second last flight at the Fairyhouse Steel Handicap Hurdle in April, as Robbie Power on *Moonshine Bay* (mud colours, third from left), Mark Browne on *Hollow Tree* (mud colours, right), Denis O'Regan on *Carrig Cathal* (mud colours, left) and Mark Walsh on *Kilfenora* (mud colours, second from left) follow suit.

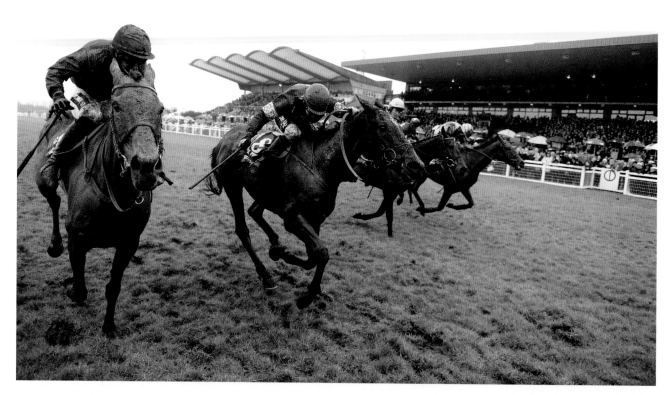

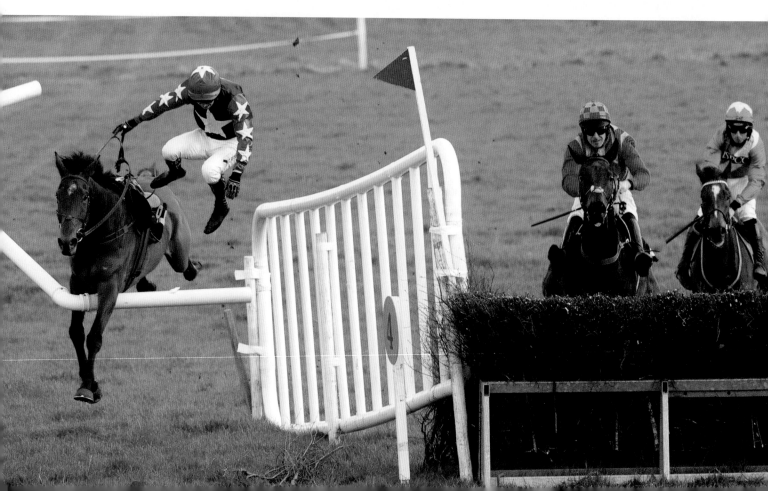

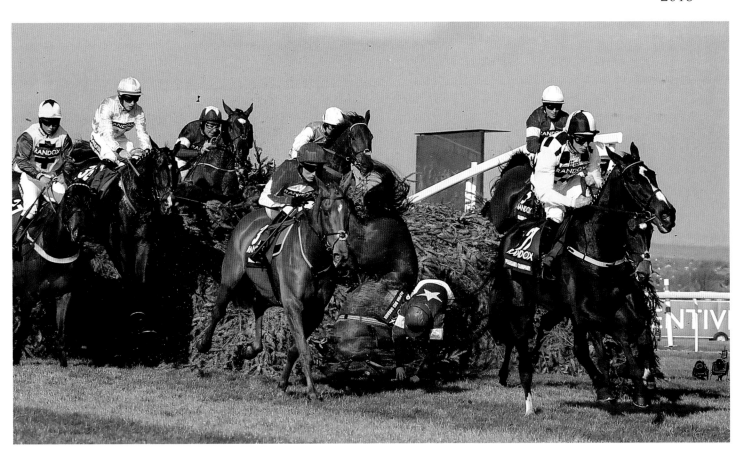

Opposite top: *General Principle* and JJ Slevin (red cap, number 8) get up in the final strides of a thrilling Irish Grand National at Fairyhouse, to just deny *Isleofhopendreams* and Danny Mullins (nearest camera, black cap with red star), with *Forever Gold* and Adam Short (green and yellow cap, four from camera) third, *Bellshill* and David Mullins (beige cap, three from camera) fourth, subsequently demoted to fifth, and *Folsom Blue* (far side, maroon cap with white star) fifth, subsequently promoted to fourth. After three miles and five furlongs, less than two lengths separated the first five home, and four of them traded at odds-on in-running.

Opposite bottom: *Hi Murphy* runs out at the final fence at Largy point-to-point and unseats Noel McParlan, while *Hill Of Keash* and Barry O'Neill (red colours) come down, leaving *Uluroo* and Jamie Codd (green colours) to run out an easy winner.

Above: Rachael Blackmore (blue cap) takes a crashing fall from *Alpha Des Obeaux* at The Chair in the Grand National. The eventual winner, *Tiger Roll,* Davy Russell wearing the maroon cap with the white star, is jumping the fence just behind, and does well to avoid the faller without losing much momentum.

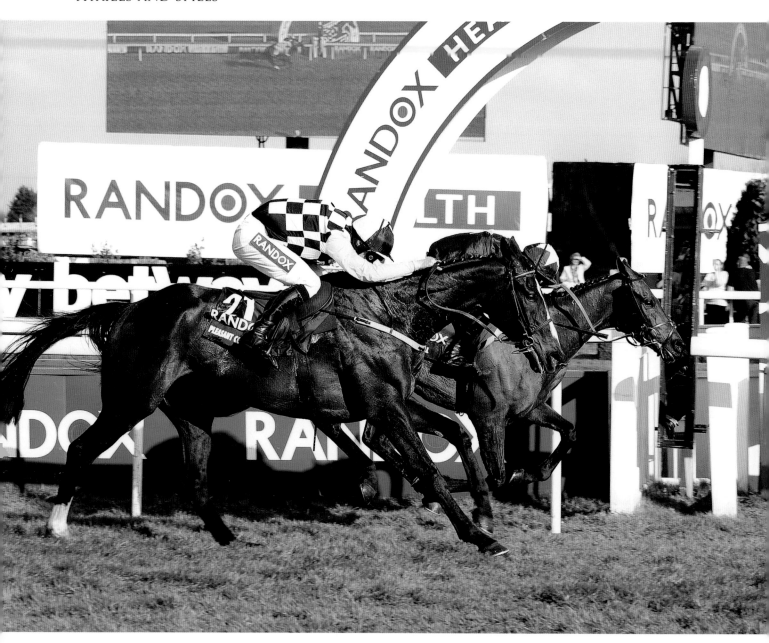

Tiger Roll and Davy Russell just get home in the Grand
National by a fast-diminishing head from *Pleasant Company*
and David Mullins.

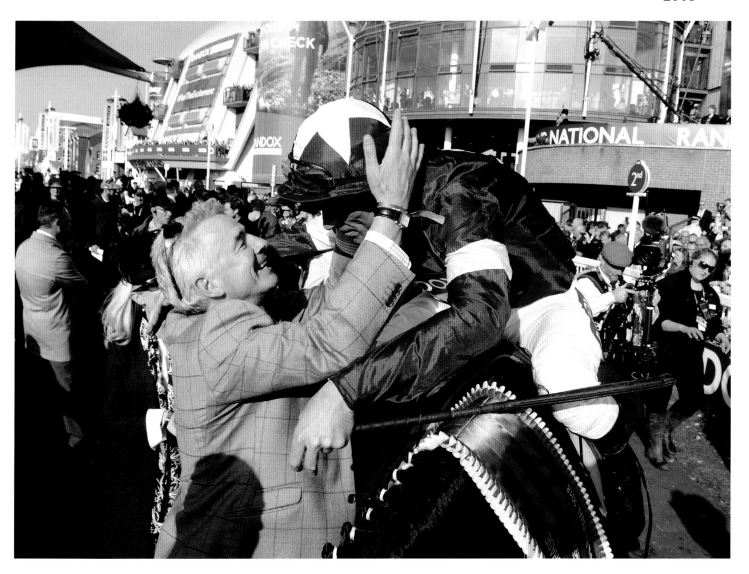

Owner Michael O'Leary and rider Davy Russell embrace
as soon as the rider and *Tiger Roll* arrive back into Aintree's
winner's enclosure.

Un De Sceaux and Patrick Mullins lead all the way and put up a scintillating performance to land the Punchestown Champion Chase, leaving in their wake *Douvan* and Paul Townend (pink colours), *A Toi Phil* and Jack Kennedy (maroon cap, white star) and *Ordinary World* and Davy Russell (maroon and white stripes).

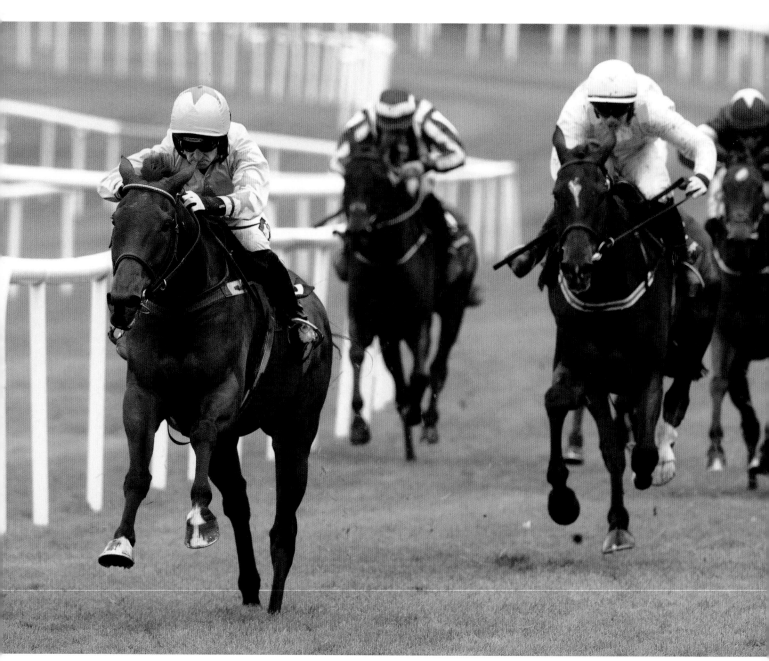

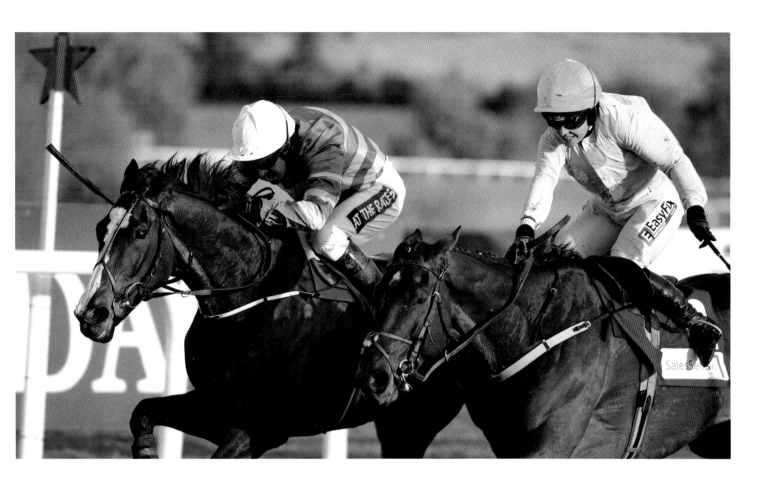

Katie Walsh (nearest camera, green cap) drives *Antey* to victory in the SalesSense International Novice Hurdle at Punchestown, getting up to beat *Shady Operator* and Barry Geraghty by a short head. We didn't know it at the time, but it was Katie Walsh's last ever ride in public, as she dismounted in the winner's enclosure and promptly announced her retirement from the saddle, 'I wanted to go out on a winner.'

Katie Walsh takes a moment with her dad, Ted.

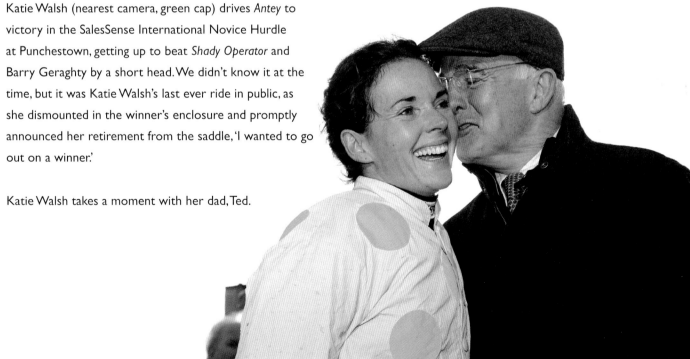

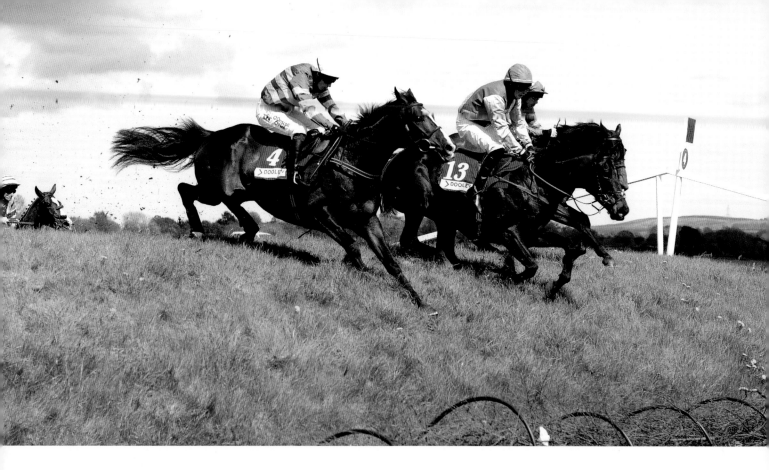

Josies Orders (number 4) and Nina Carberry zip across *Ruby's Double* in the Dooley Insurances Cross Country Chase at Punchestown, alongside *Vital Island* (number 13) and Sean O'Keefe, and *Blue Templar* and Derek O'Connor (far side), on their way to victory in the Cross Country Chase. Like Katie Walsh the day before, Nina announced her retirement from the saddle after she dismounted in the winner's enclosure. Two of the best Irish female riders ever chose to bow out at the same meeting, on their own terms, within a day of each other.

Nina Carberry with husband Ted Walsh and their daughter
Rosie in the winner's enclosure after Nina's announcement.

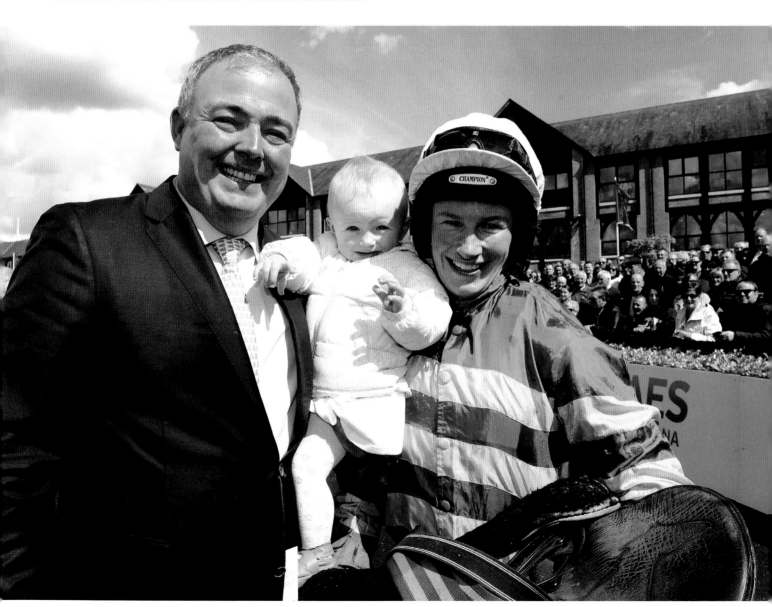

Cheering them on at Down Royal on May
bank holiday Monday.

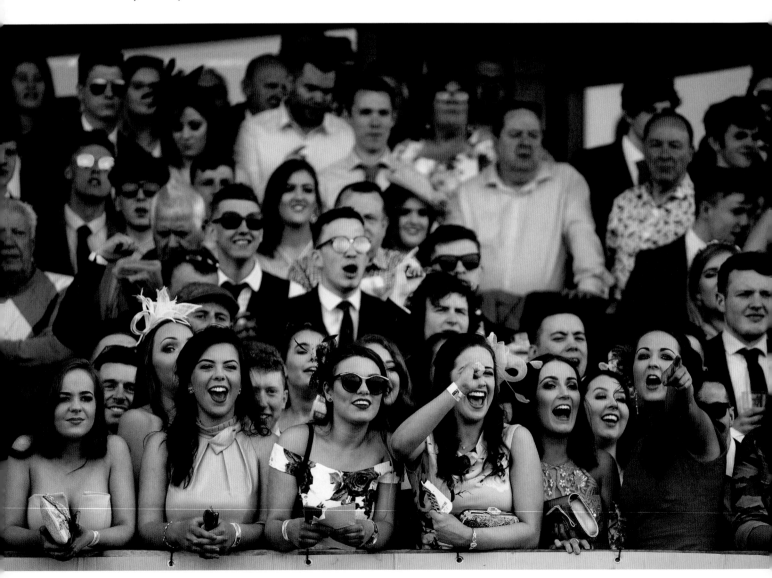

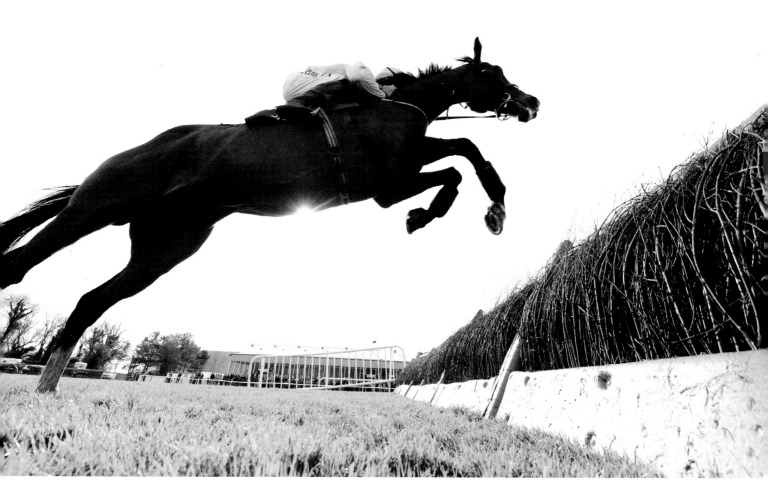

Shining brightly: *Faugheen* and David Mullins in
full flow at Punchestown.

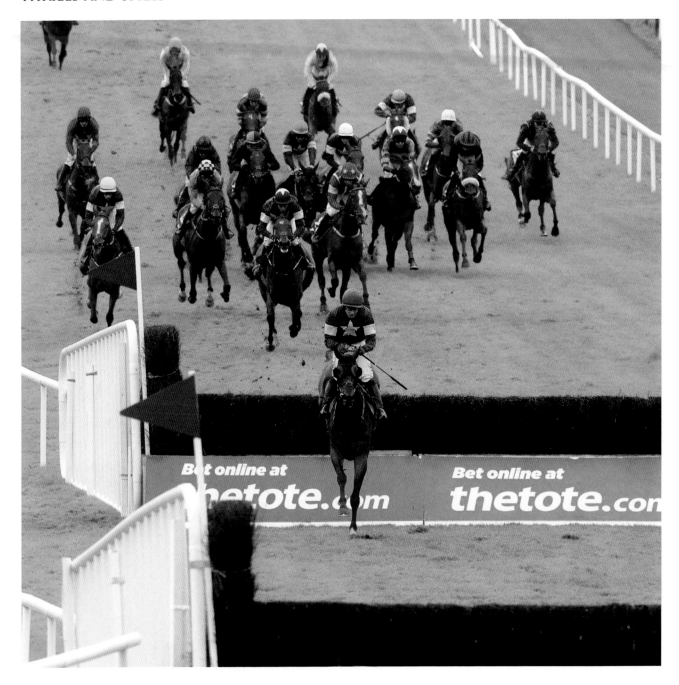

Clarcam and Mark Enright have made all and are still clear of their
field at the second last fence in the Galway Plate.

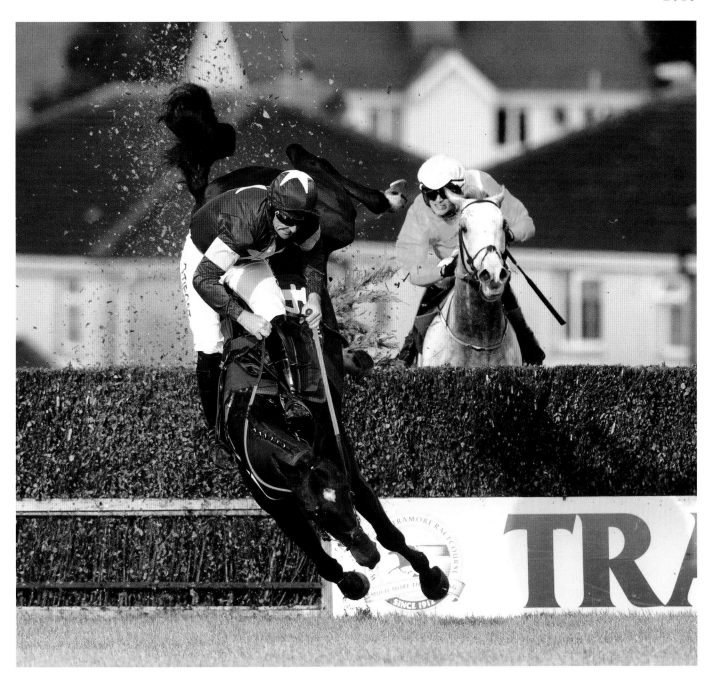

Monatomic and Davy Russell take a crashing fall at the final fence at Tramore when looking set for victory, leaving *Teqany* and Danny Mullins clear.

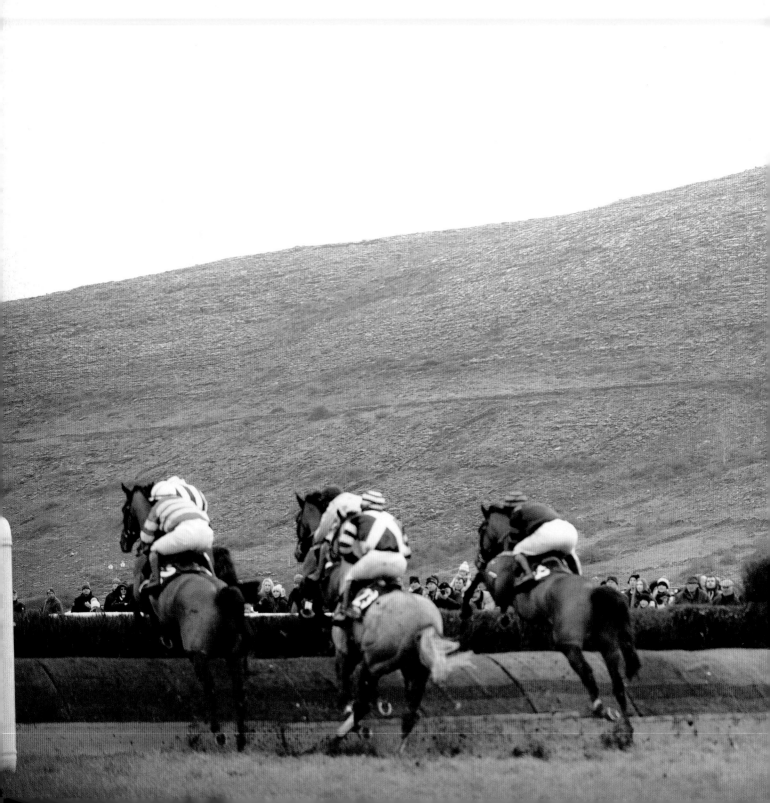

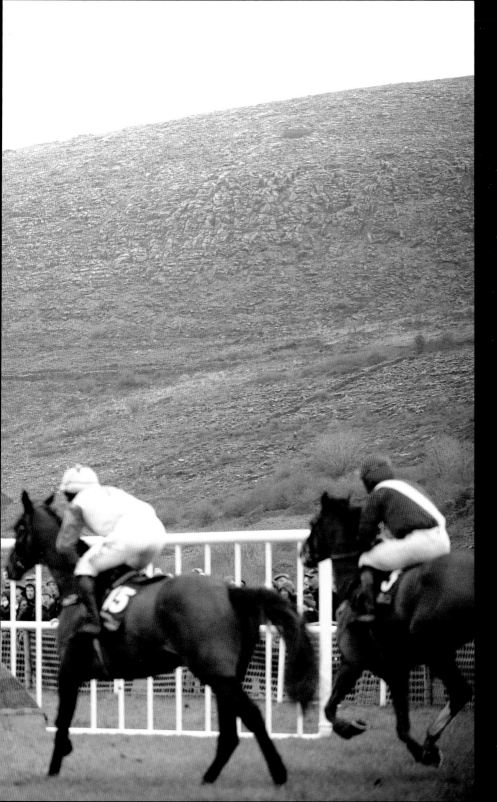

2019

High-rise at the picturesque Bellharbour, County Clare, deep in the karst landscape of the Burren.

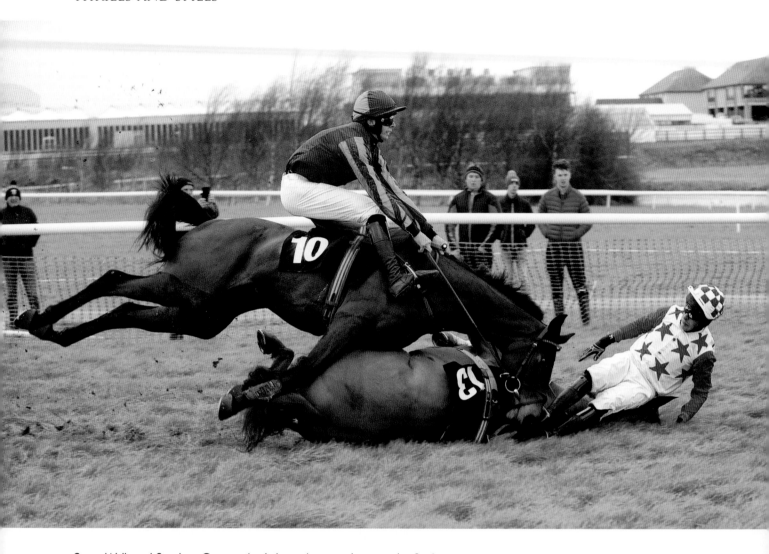

Orpen Wells and Stephen Connor (red sleeves) come down at the final fence when looking likely to win at Punchestown point-to-point, bringing *Fiddler Of Dooney* (number 10) and Timmy Love down with him, leaving the way clear for *Ted* and Rob James (not in picture) to prevail.

Facing the hill up the home straight at Farmaclaffey, County Armagh – one
of the oldest point-to-point courses in the country, dating back to 1895.

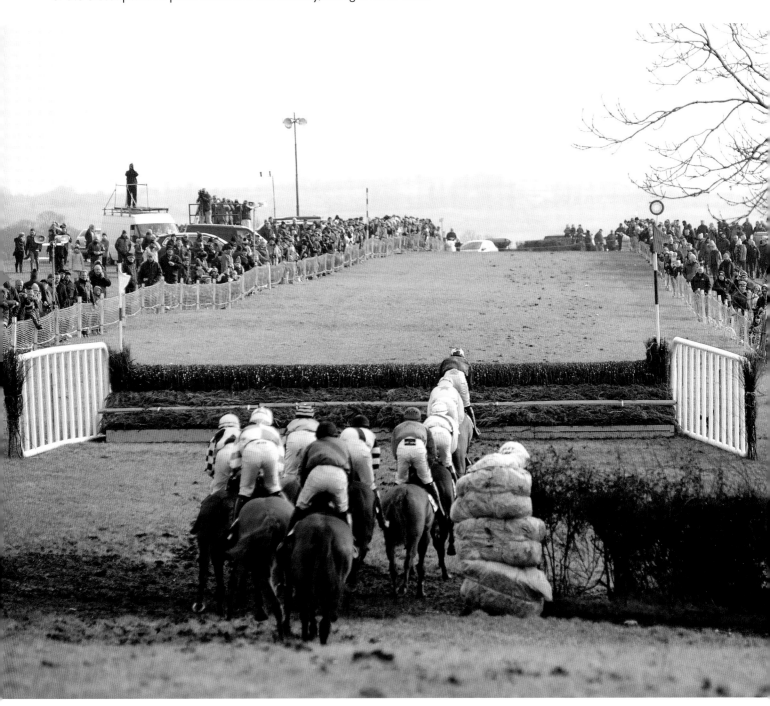

THRILLS AND SPILLS

Megan Donovan and the Denis Hogan-trained *Above Lixnaw* in the parade ring in the March snow before the bumper at Leopardstown.

Opposite top: *Espoir D'Allen* and Mark Walsh come clear of their rivals to win the Champion Hurdle at Cheltenham by fifteen lengths, with the riderless *Buveur D'Air* (left) their nearest pursuer.

Opposite bottom: Mission accomplished: Trainer Gavin Cromwell with his first Champion Hurdle winner, *Espoir D'Allen,* with groom Nicola Walsh.

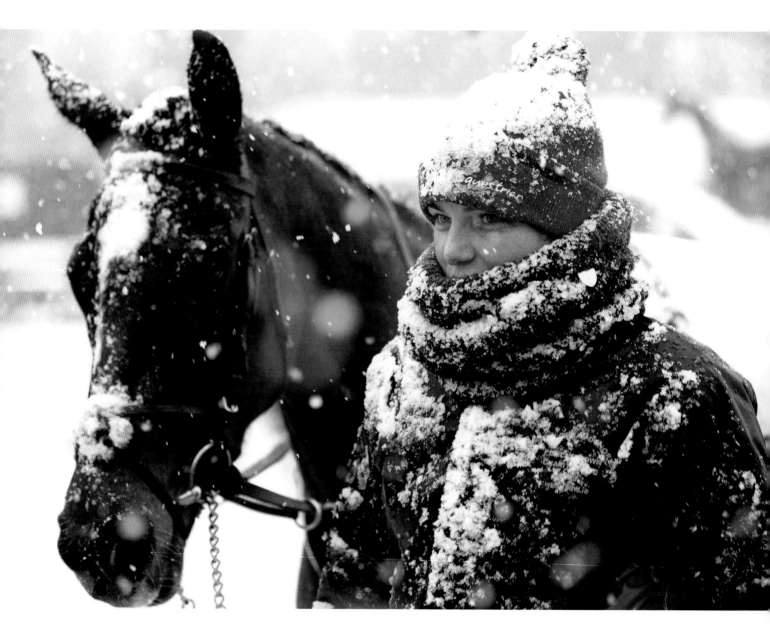

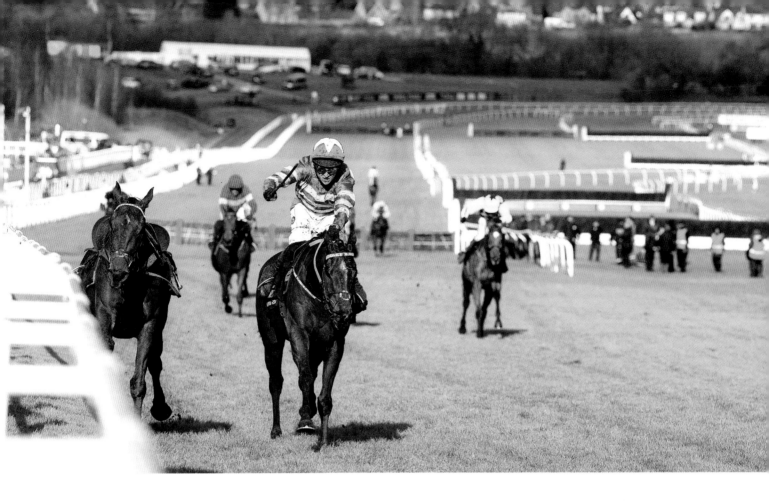

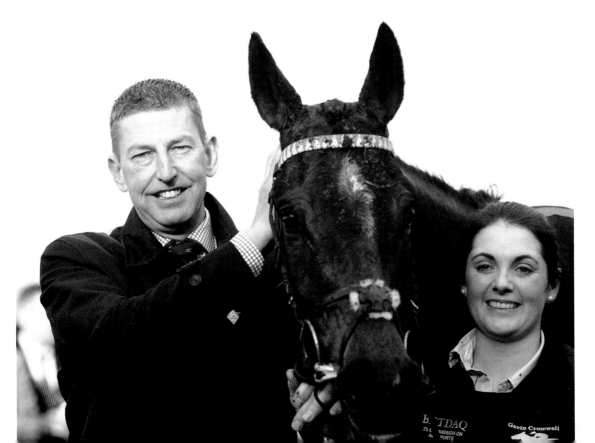

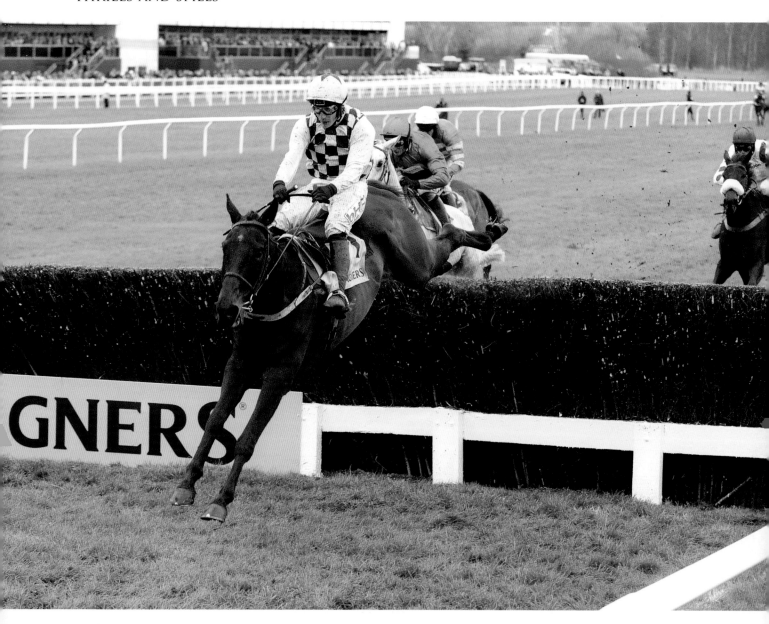

Al Boum Photo and Paul Townend clear the final fence on their way to
victory in the Cheltenham Gold Cup, chased home by *Bristol De Mai*
(grey horse) and Daryl Jacob (3rd), *Anibale Fly* and Barry Geraghty (white
cap, 2nd) and *Clan Des Obeaux* and Harry Cobden (blue cap, 5th).

Jockey Ruby Walsh congratulates Willie Mullins on winning the Gold Cup.
The jockey won the Gold Cup twice on *Kauto Star*, but the trainer had
never won the race. Willie Mullins had sent out the Gold Cup runner-up
six times, so his first win in steeplechasing's blue riband was overdue, and
it was welcomed accordingly.

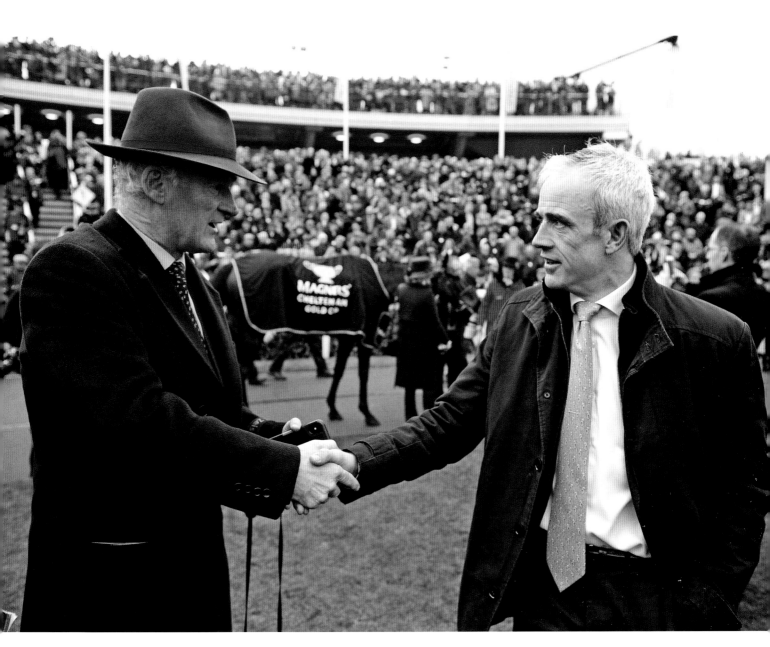

Tiger Roll and Davy Russell jump the final fence upsides *Magic Of Light* and
Paddy Kennedy, before going on to victory in the Aintree Grand National
for the second year running.

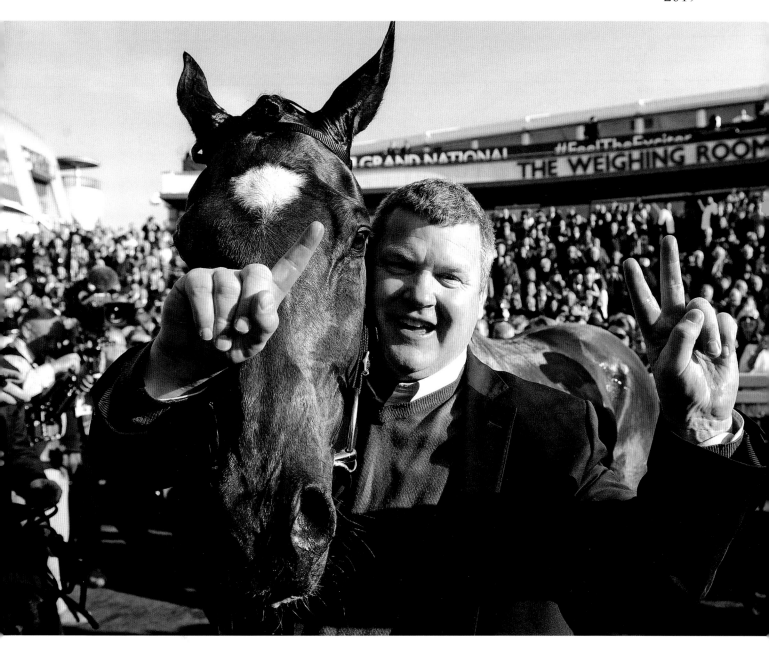

Trainer Gordon Elliott celebrates *Tiger Roll's* Grand National win. That's three Aintree Grand Nationals for the trainer, two (left hand) for *Tiger Roll* and one (right hand) for *Silver Birch*.

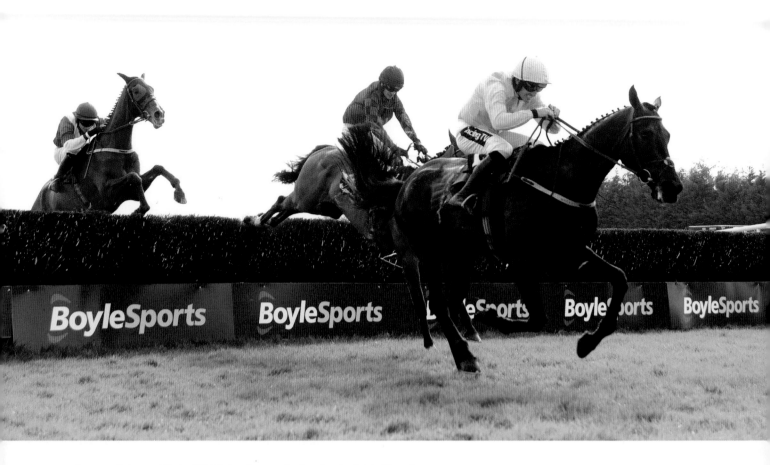

Burrows Saint and Ruby Walsh lead over the last in the Irish Grand National before going on to victory. They were chased home by *Isleofhopendreams* and Danny Mullins (black cap), who were finishing second in the race for the second year running, and *Acapella Bourgeois* and Jonathan Burke (just in picture jumping the last), a 1-2-3 in the race for trainer Willie Mullins.

Rachael Blackmore can't defy gravity at the second last fence on *Ellie Mac* in the Glencarraig Lady Francis Flood Mares' Handicap at Punchestown, as Moyhenna and Denis Hogan (yellow cap) go on to score.

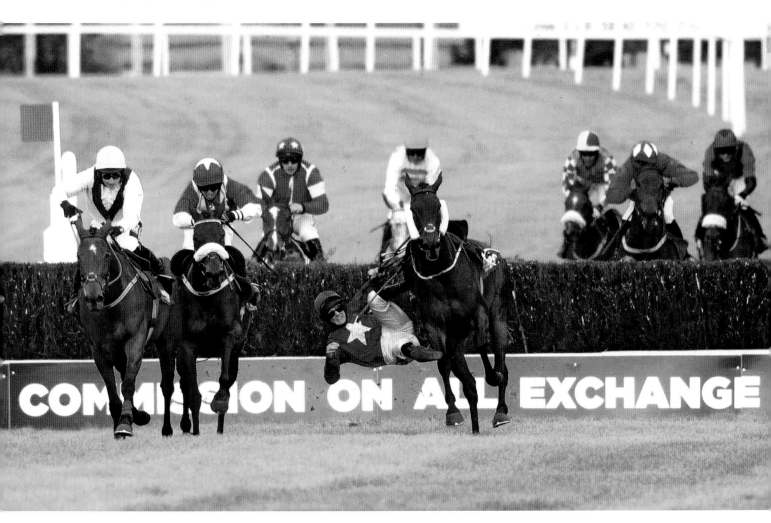

Ruby Walsh shakes hands with well-wishers after he has announced his retirement
from the saddle following *Kemboy*'s victory in the Punchestown Gold Cup.

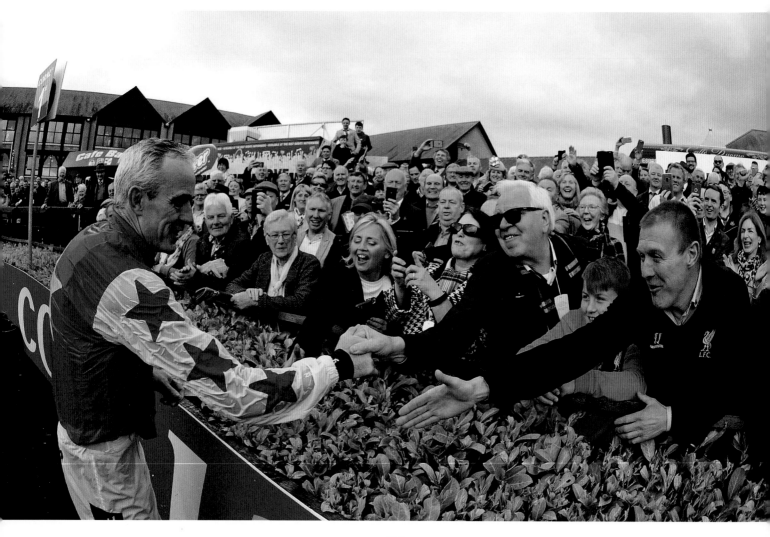

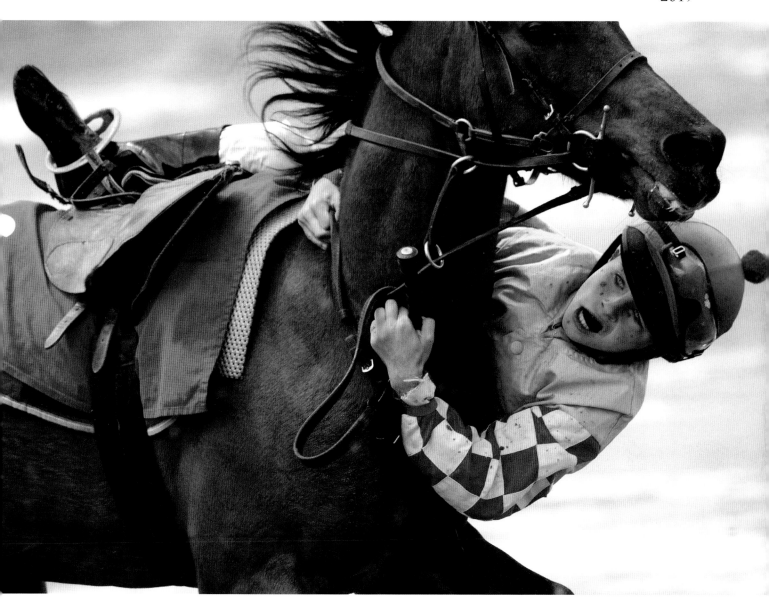

Patrick Verling holds on tight on *Here Come The Pain* during the 12.2 Hands Pony Race at Ballybunion, County Kerry. Gravity won in the end but, despite the horse's name, Patrick was fine after his fall.

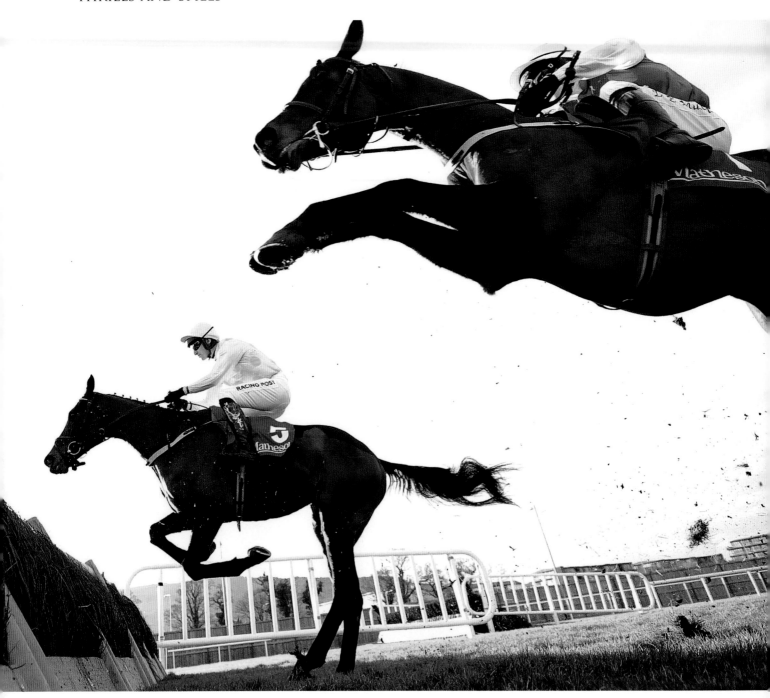

Sharjah and Patrick Mullins (far side, number 5) bide their time at the rear of the field with *Aramon* and Danny Mullins over the second flight, before going on to win the Matheson Hurdle at Leopardstown. Patrick Mullins also rode *Sharjah* to win the Galway Hurdle in 2018, and he rode *Aramon* to win the Galway Hurdle again in 2020.

Learning how best to fall is a necessary skill for any young jockey. *Little Quinty* jumps a rail at Glenbeigh Horse and Pony Races and unseats Calum Hogan as Pat O'Sullivan takes evasive action.

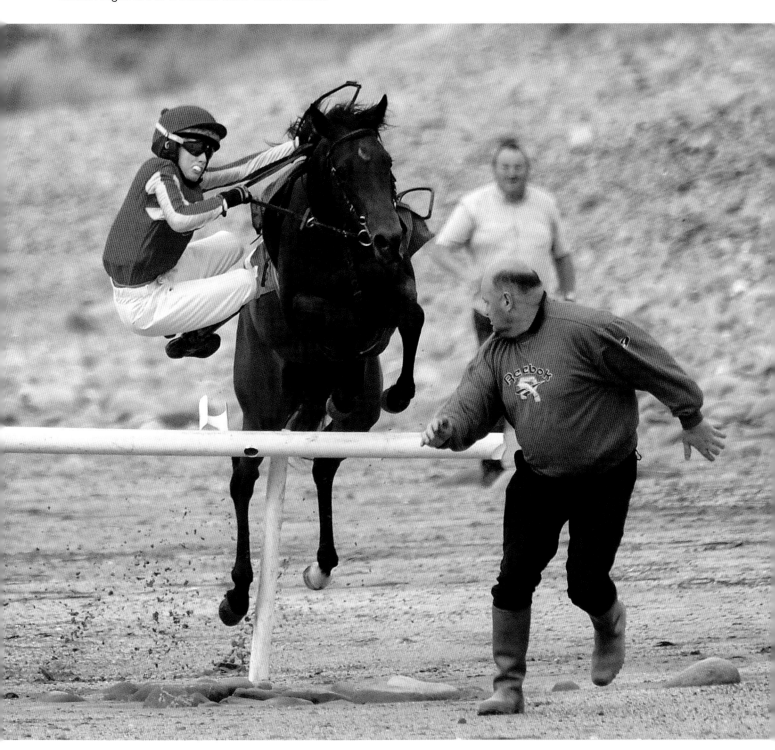

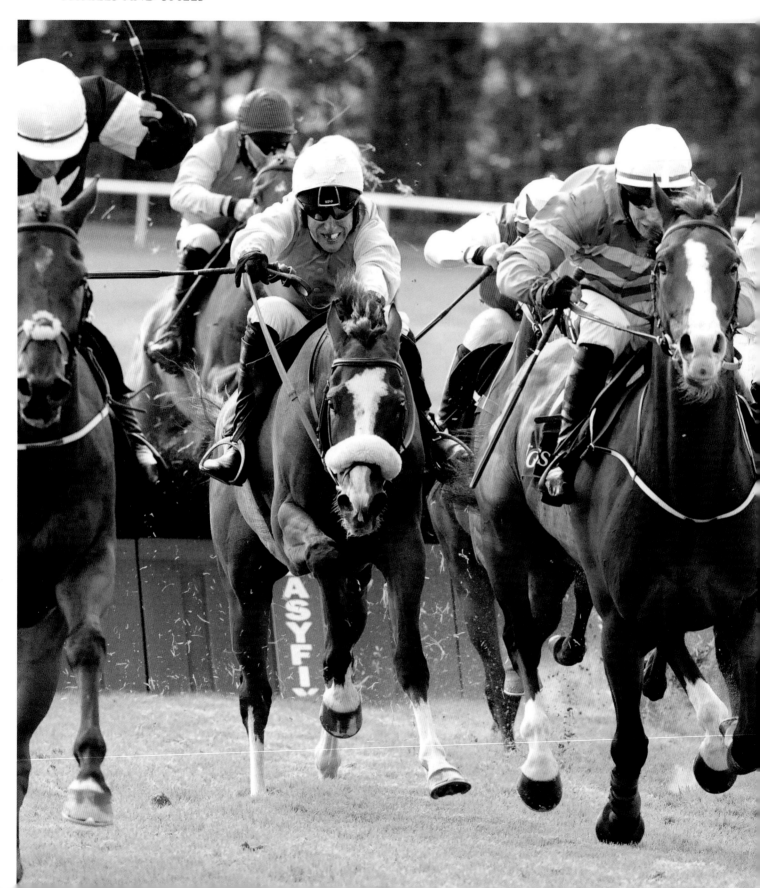

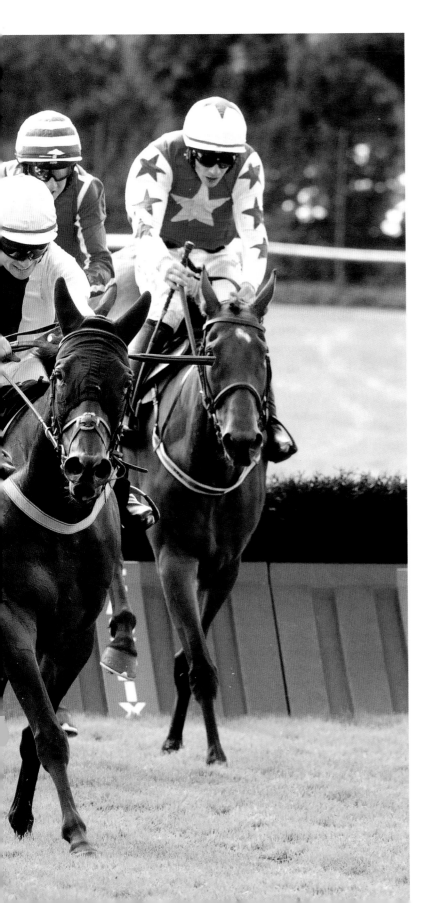

Robbie Power drives *Tudor City* (noseband) up between Mark Enright on *Dew Reward* (left) and J J Slevin on *Band Of Outlaws* to get up and win a thrilling Galway Hurdle.

Blue skies all round: A delighted Rachael
Blackmore after she and *Honeysuckle* have landed
the Hatton's Grace Hurdle at Fairyhouse.

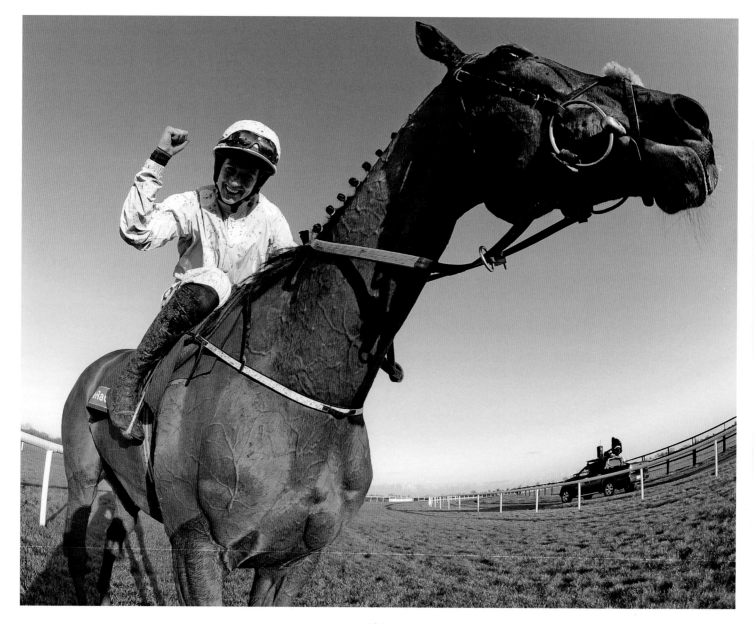

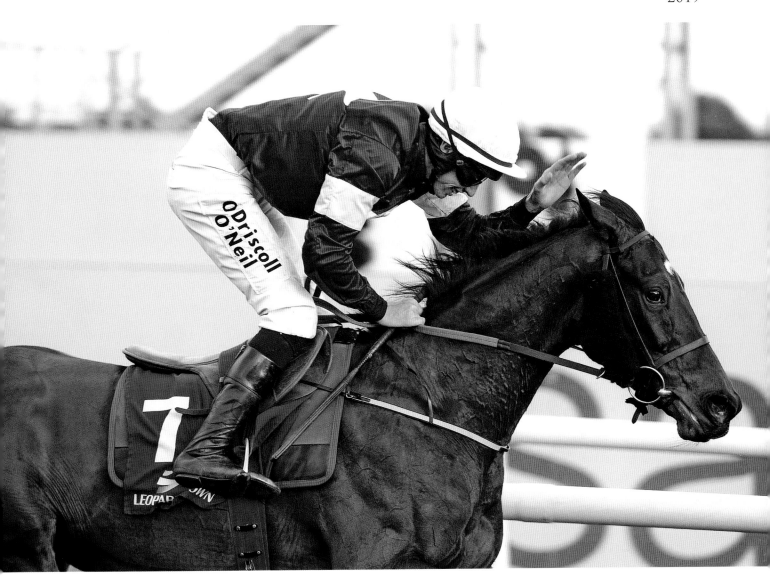

Jack Kennedy gives *Apple's Jade* a pat on the head as the pair of them cross the winning line in the Frank Ward Memorial Hurdle at Leopardstown, seventeen lengths clear of their closest pursuer.

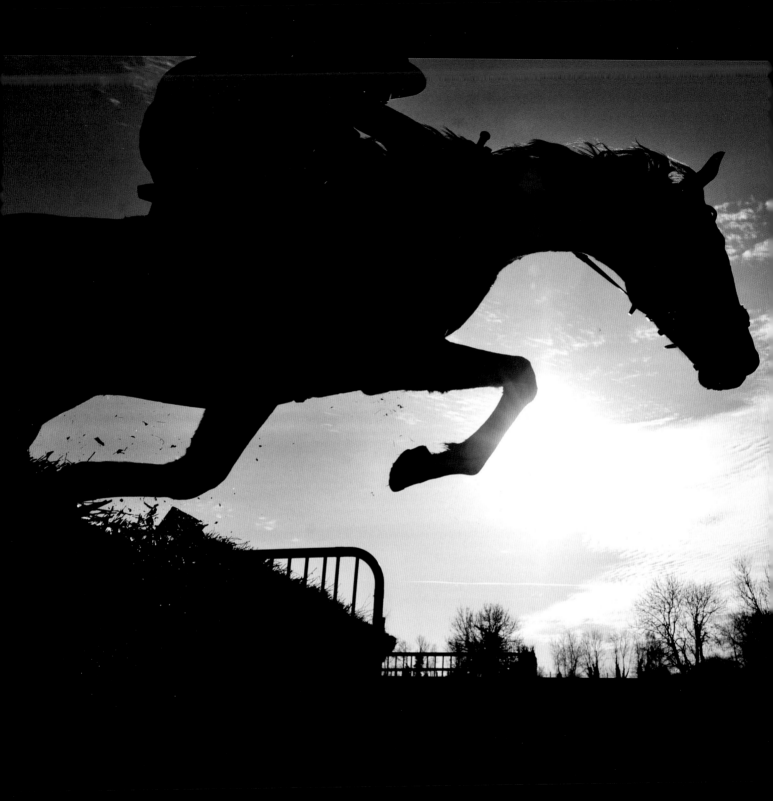

2020

Chasing shadows: *Pakens Rock* and Oakley Brown jump the final flight clear in the Matty Ryan Memorial Hurdle at Thurles.

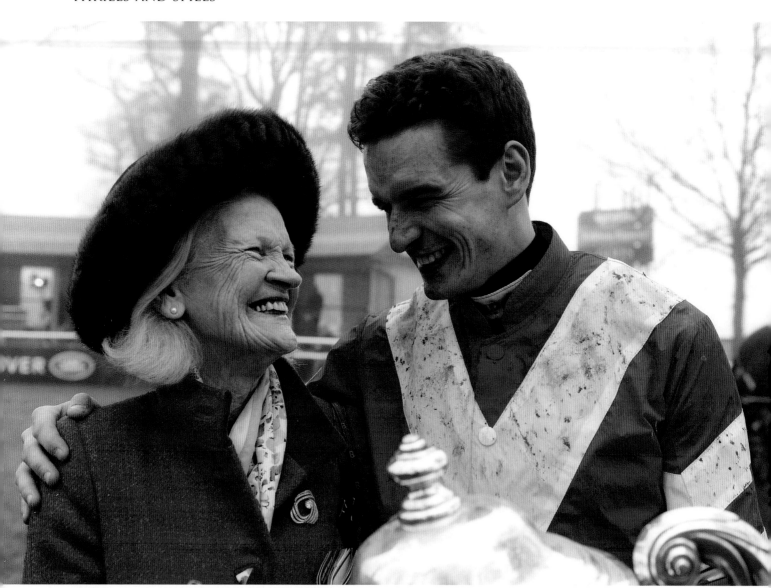

Keep it in the family: Danny Mullins celebrates with his grandmother Mrs Maureen Mullins after he has landed the Thyestes Chase on *Total Recall*, trained by his uncle Willie Mullins.

Faugheen (centre) receives a congratulatory pat on the head from Mikey Fogarty, on the back of stable companion *Castelbawn West*, after he and Paul Townend just got the better of another stable companion *Easy Game* and Robbie Power (left) to win the Flogas Chase at Leopardstown.

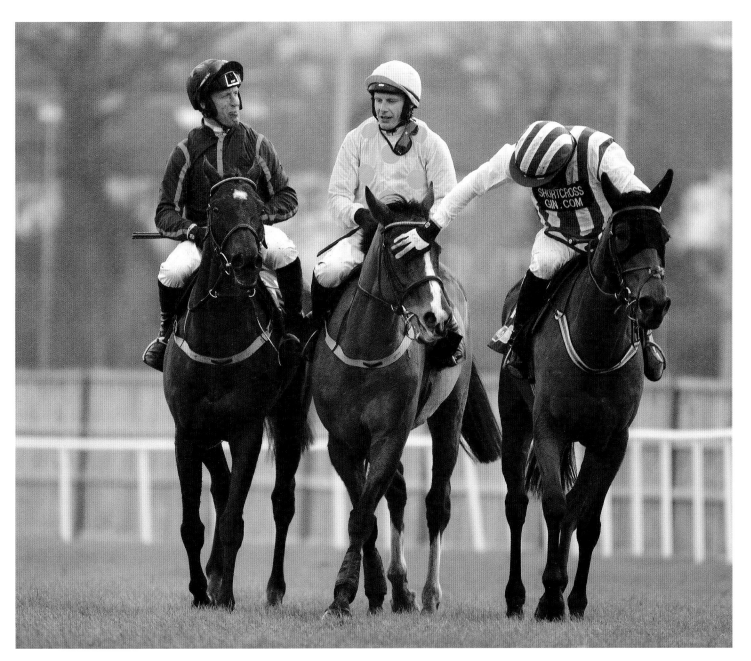

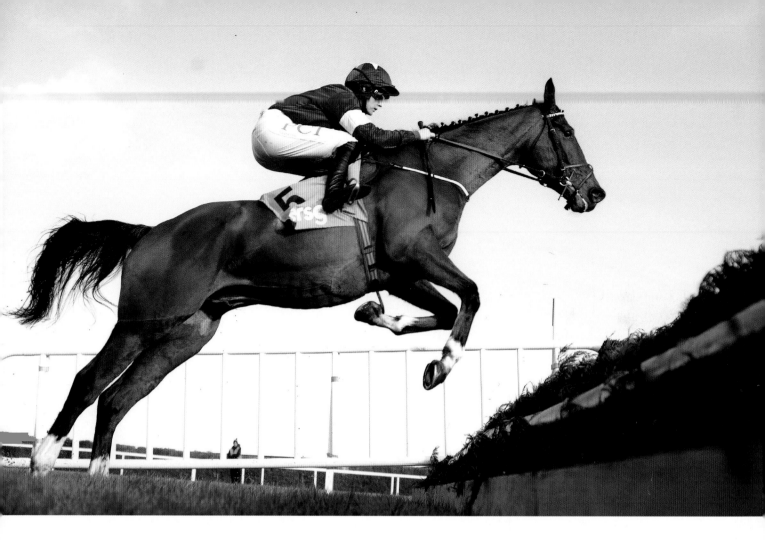

Notebook and Rachael Blackmore in unison on
their way to victory in the Arkle Novice Chase at
Leopardstown.

It's a thumbs up from Jack Kennedy and a kiss on the neck for
Delta Work after the pair have landed the Irish Gold Cup.

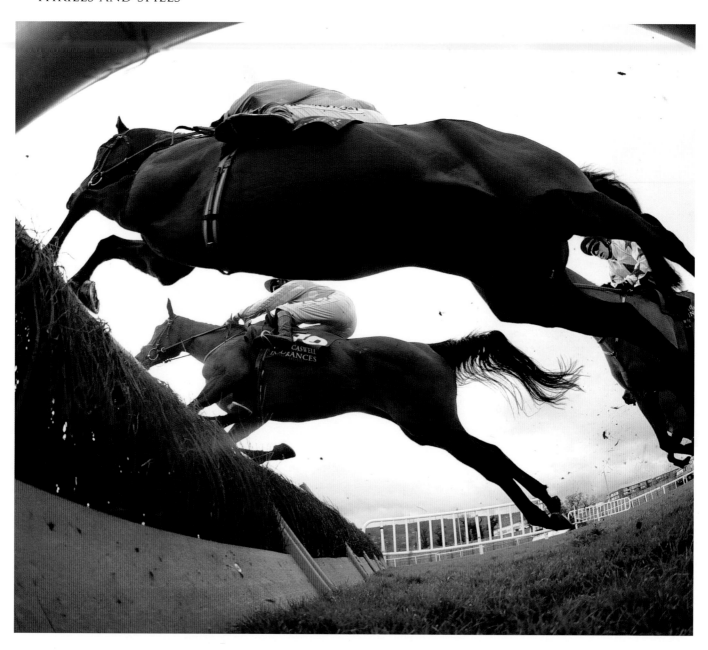

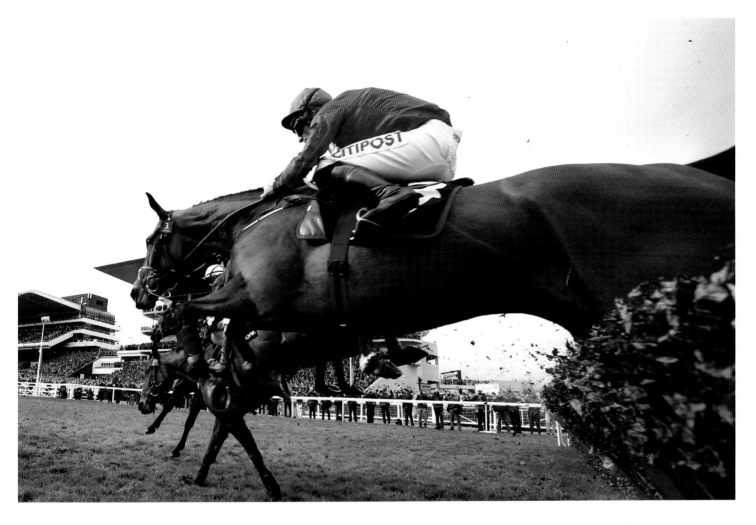

Just once more around for *Envoi Allen* and Davy Russell as they jump the flight in front of the stands with a circuit to go in the Ballymore Novices' Hurdle at Cheltenham.

Opposite: *Honeysuckle* (number 10) and Rachael Blackmore jump the second flight of hurdles in a share of second place with *Sharjah* and Patrick Mullins (nearest camera, pink silks) before going on to win the Irish Champion Hurdle. *Darver Star* and Jonathan Moore (white silks, red stars), who ran Henry de Bromhead's mare to a half a length in the end, sit just behind.

In one of the rides of the season, Barry Geraghty
conjures a run from *Champ* that takes him from fully
eight lengths behind the leaders jumping the final
fence to a length in front passing the winning line in
the RSA Insurances Novices' Chase at Cheltenham …

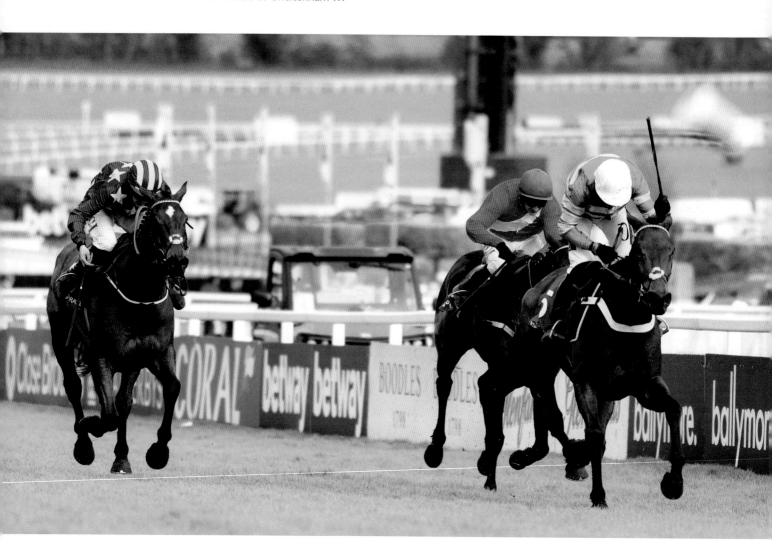

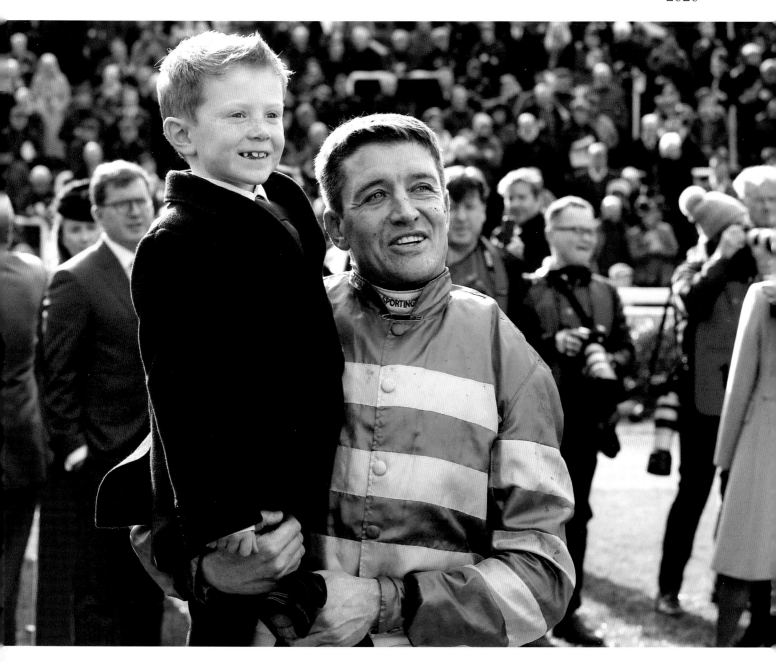

... and, afterwards, watches a replay of the race with one of his biggest fans, Archie McCoy, son of AP McCoy, after whom *Champ* is named.

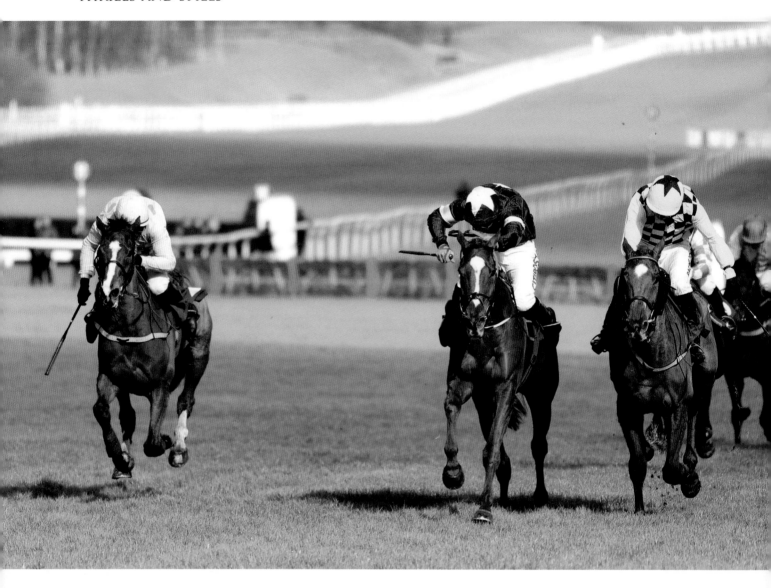

Samcro and Davy Russell (maroon and white silks) prove to be strongest in a gripping three-way finish to the Marsh Novices' Chase at Cheltenham, getting home by a nose from *Melon* and Patrick Mullins (yellow and black check silks), with *Faugheen* and Paul Townend (pink silks) just a length back in third.

It's another Irish thriller at Cheltenham, with the Willie Mullins-trained *Monkfish* and Paul Townend (centre) just getting home from the Paul Nolan-trained *Latest Exhibition* and Bryan Cooper (far side) and the Gordon Elliott-trained *Fury Road* and Davy Russell (near side) in the Albert Bartlett Hurdle.

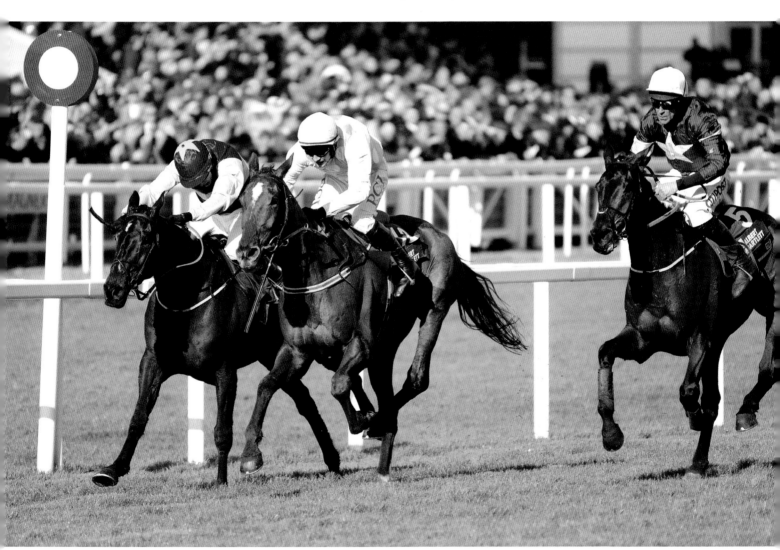

Maxine O'Sullivan gets a kiss from her dad and the horse's trainer
Eugene after she has ridden *It Came To Pass* to victory in the Foxhunter
Challenge Cup. It was a second win in the race for the trainer, twenty-
nine years after it had been won by *Lovely Citizen*, ridden by his brother
Willie.

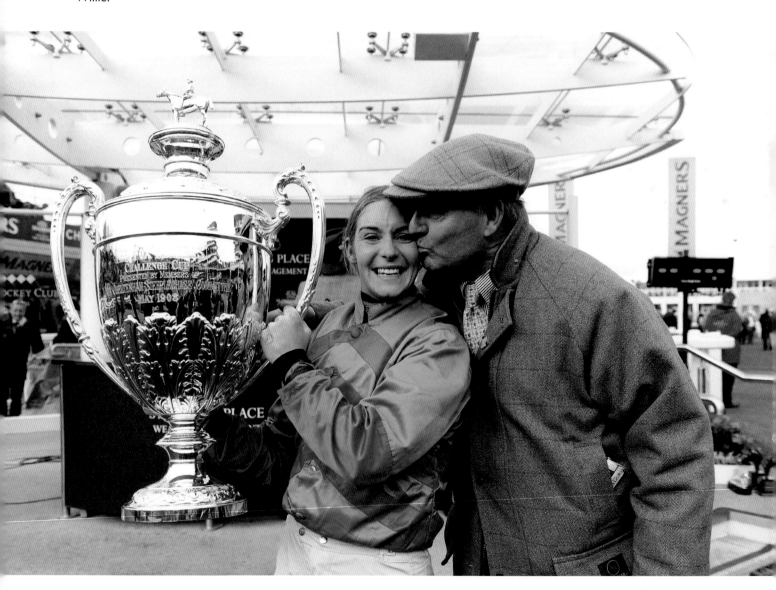

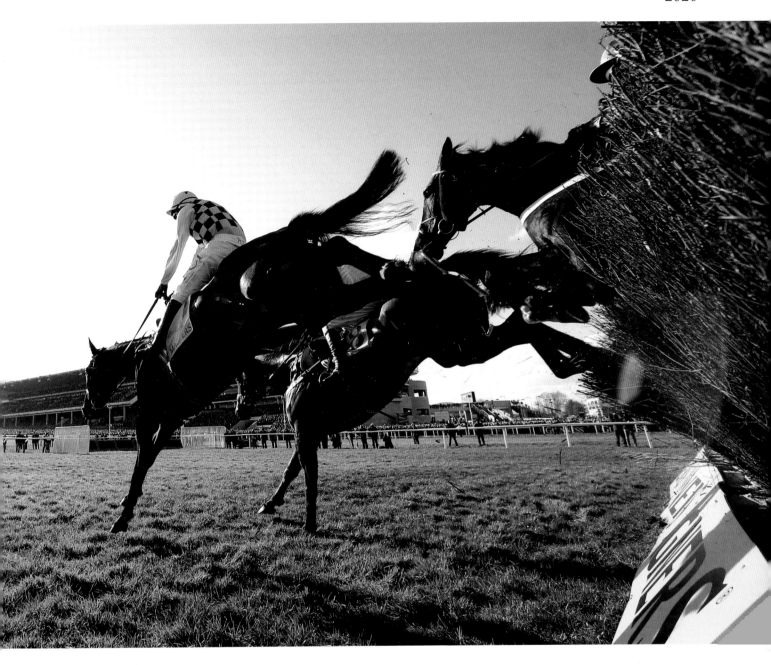

Al Boum Photo and Paul Townend (nearest camera) hold a slender lead at the final fence in the Cheltenham Gold Cup from eventual third *Lostintranslation* and Robbie Power (partially obscured), as runner-up *Santini* pokes his nose into the picture. Willie Mullins' horse stayed on strongly up the hill to win the race again, becoming the first horse since *Best Mate*, and only the third horse since *Arkle*, to land back-to-back renewals of the Gold Cup.

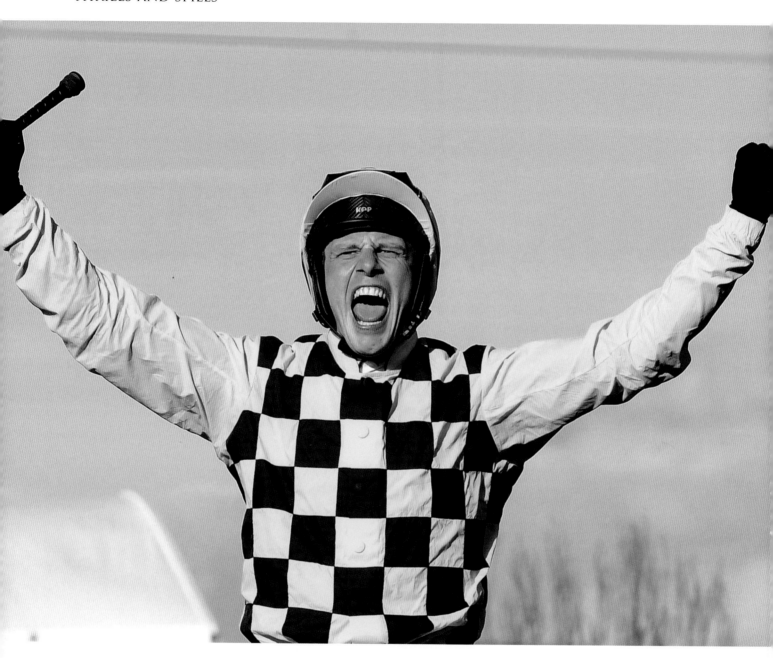

Above and opposite: Elation v Dejection: Paul Townend cannot
suppress that Gold Cup-winning feeling, while (opposite) a dejected
Jamie Moore leans on the rail after he and *Goshen* parted company at
the final flight in the Triumph Hurdle when clear.

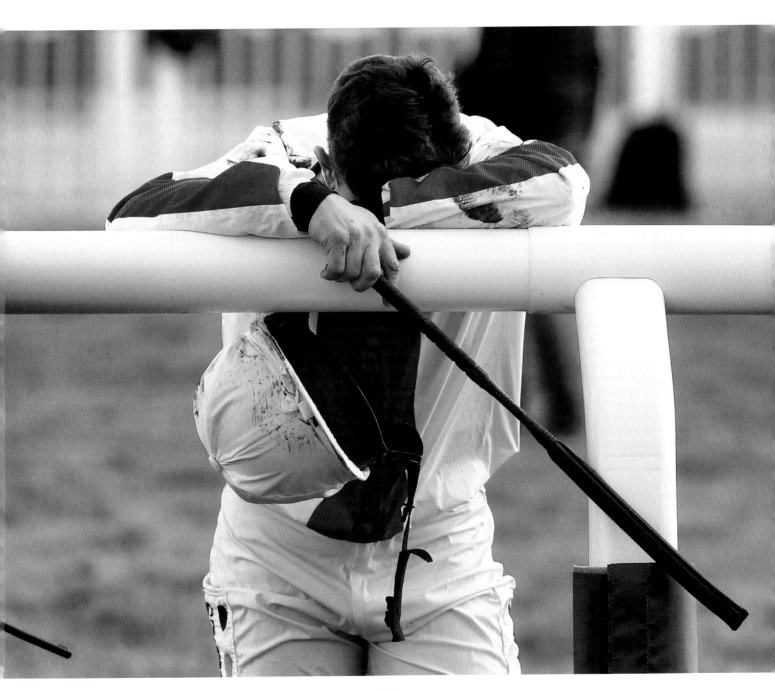

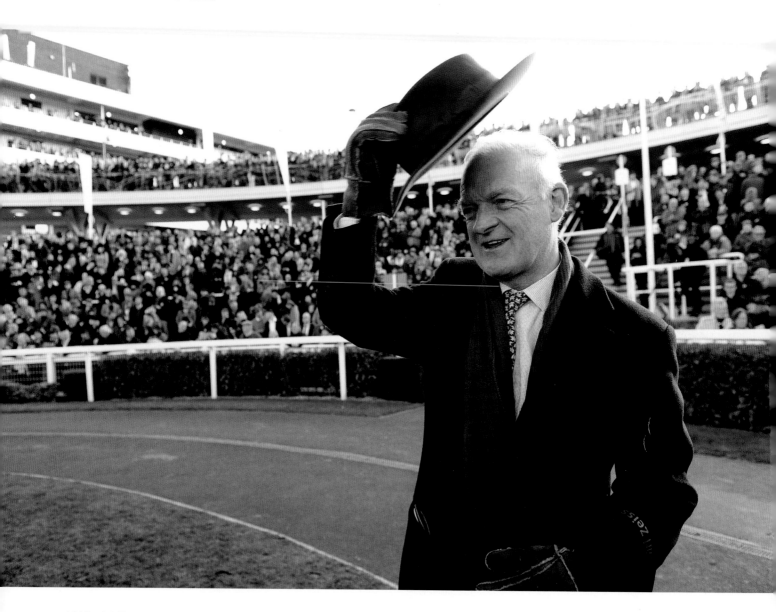

Willie Mullins doffs his hat after *Al Boum Photo's* second victory in the Gold Cup.

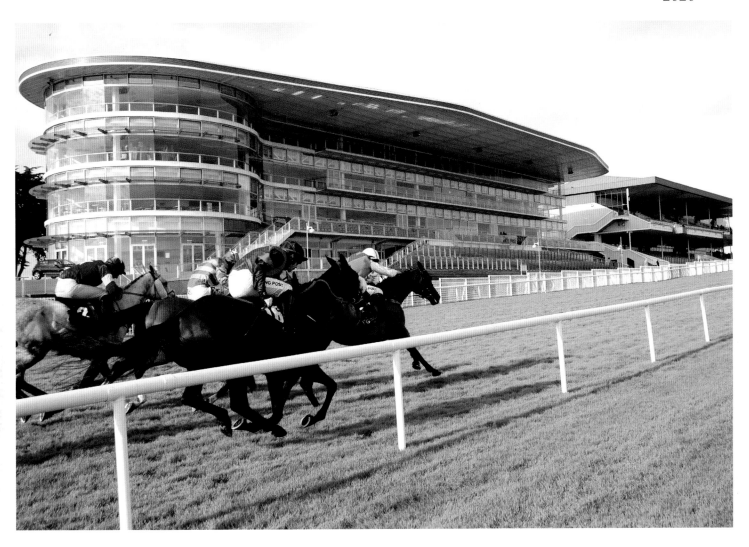

Aramon and Patrick Mullins come clear in the Guinness Galway Hurdle in front of an empty stand.

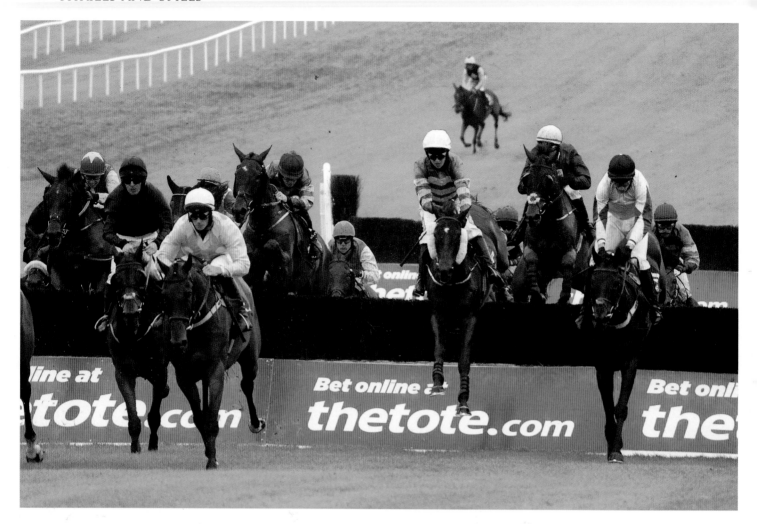

Early Doors and Mark Walsh (white cap) jump the final fence in the Tote Galway Plate in fifth place before staying on strongly up the hill to get home by three parts of a length from *Royal Rendezvous* and Paul Townend (right, black cap).